The Journal of Modern Craft

Volume I—Issue 3—November 2008

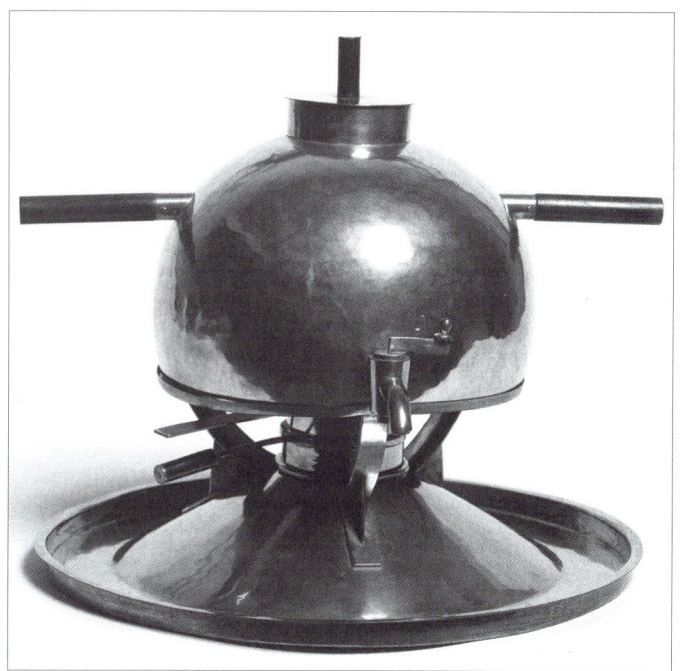

Editors
Glenn Adamson
Tanya Harrod
Edward S. Cooke, Jr.

Editors

Glenn Adamson
Victoria & Albert Museum, London (UK)

Tanya Harrod
Royal College of Art, London (UK)

Edward S. Cooke, Jr.
Yale University (USA)

Book Review Editor
Kevin Murray
Craft Writer (Australia)

Exhibition Review Editor
Louise Mazanti
Konstfack, Stockholm (Sweden)

International Advisory Board

Dapo Adeniyi
Position International Arts Review (Nigeria)

Carmine Branagan
American Craft Council (USA)

Charlotte Brown
Gregg Museum of Art & Design,
NC State University (USA)

Alan Crawford
Independent Scholar (UK)

Edmund de Waal
Ceramist and Historian (UK)

John Dunnigan
Rhode Island School of Design (USA)

Simon Fraser
Central St. Martins College of Art and Design (UK)

Alun Graves
Victoria & Albert Museum (UK)

Louise Hamby
Australian National University (Australia)

Fujita Haruhiko
Osaka University (Japan)

Bernard Herman
University of North Carolina (USA)

Gloria Hickey
Independent Scholar (Canada)

Rosemary Hill
Independent Scholar (UK)

Jyotindra Jain
Jawaharlal Nehru University (India)

Janis Jefferies
Goldsmiths (UK)

Rüdiger Joppien
Museum für Kunst und Gewerbe, (Germany)

Gerhardt Knodel
Former Director, Cranbrook Academy of Art (USA)

Janet Koplos
Independent Scholar (USA)

Henrietta Lidchi
National Museums of Scotland (UK)

Martina Margetts
Royal College of Art (UK)

Simon Olding
Crafts Study Centre, Farnham (UK)

Gerald L. Pocius
Memorial University of Newfoundland (Canada)

Venetia Porter
British Museum (UK)

Nakayama Shuichi
Kobe University (Japan)

Jorunn Veiteberg
University of Bergen and University of Oslo (Norway)

Anne Wilson
School of the Art Institute of Chicago (USA)

Aims and Scope

The Journal of Modern Craft is the first peer-reviewed academic journal to provide an interdisciplinary and international forum in its subject area. It addresses all forms of making that self-consciously set themselves apart from mass production—whether in the making of designed objects, artworks, buildings, or other artefacts.

The journal covers craft in all its historical and contemporary manifestations, from the mid-nineteenth century, when handwork was first consciously framed in opposition to industrialization, through to the present day, when ideas once confined to the "applied arts" have come to seem vital across a huge range of cultural activities. Special emphasis is placed on studio practice, and on the transformations of indigenous forms of craft activity throughout the world. The journal also reviews and analyzes the relevance of craft within new media, folk art, architecture, design, contemporary art and other fields.

The Journal of Modern Craft is the main scholarly voice on the subject of craft, conceived both as an idea and as a field of practice in its own right.

Submissions
To submit an article for consideration please contact Glenn Adamson at
g.adamson@vam.ac.uk

Subscription Information
Three issues per volume. One volume per annum. 2008: volume 1

Online
www.bergpublishers.com

By Mail
Berg Publishers
C/o Customer Services
Turpin Distribution
Pegasus Drive
Stratton Business Park
Biggleswade
Bedfordshire SG18 8TQ
UK

By Fax
+44 (0)1767 601640

By Telephone
+44 (0)1767 604951

Subscription Rates
Individual Print Subscription:
1 year: £25/US$48; 2 year: £45/US$87

Institutional Print Subscription (inc. free online access):
1 year: £155/$295; 2 year: £248/$472

Online Only (Institutional and Individual):
1 year: £125/$235; 2 year: £200/$376

Full color images available online
Access your electronic subscription through
www.ingentaconnect.com

Reprints for Mailing
Copies of individual articles may be obtained from the publishers at the appropriate fees. For information, write to

Berg Publishers
1st Floor, Angel Court
81 St Clements Street
Oxford OX4 1AW
UK

Inquiries
Editorial:
Julia Hall, email: jhall@bergpublishers.com

Production:
Ken Bruce, email: kbruce@bergpublishers.com

Advertising:
Corina Kapinos, email: ckapinos@bergpublishers.com

Berg Publishers is a member of CrossRef

The Journal of Modern Craft is indexed by Abstracts in Anthropology; DAAI (Design & Applied Arts Index).

© 2008 Berg. All rights reserved. No part of this publication may be reproduced or utilized in any form or by any means, electronic or mechanical, including photocopying and recording, or by any information storage or retrieval system without permission in writing from the publisher.

ISSN 1749-6772

Typeset by JS Typesetting Ltd, Porthcawl, Mid Glamorgan

Printed in the UK by Henry Ling

The Journal of Modern Craft

Volume I—Issue 3—November 2008

Contents

Editorial Introduction	**321**

Articles

Cleverest of the Clever: Coconut Craftsmen in Lamu, Kenya. Kristina Dziedzic Wright	**323**
Disavowing Craft at the Bauhaus: Hiding the Hand to Suggest Machine Manufacture. George H. Marcus	**345**
Russel Wright and Japan: Bridging Japonisme and Good Design through Craft. Yuko Kikuchi	**357**
British Interventions in the Traditional Crafts of Ceylon (Sri Lanka), c. 1850–1930. Robin Jones	**383**

Statement of Practice

Introduction: Ena de Silva and the Aluwihare Workshops. David G. Robson	**405**

Primary Text

Commentary. Alla Myzelev	**415**
My Life Impressions. Princess Maria Tenisheva (1867–1928)	**417**

Exhibition Reviews

Jean Prouvé: The Poetics of the Technical Object. Christopher Wilk	**423**
Hands on Movement: A Dialogue with History. Christina Zetterlund	**427**

Book Reviews

What Do Pictures Want? The Lives and Loves of Images. Reviewed by Justin Clemens	**431**
The Craftsman. Reviewed by Emmanuel Cooper	**435**
The Intangibilities of Form: Skill and Deskilling in Art after the Readymade. Reviewed by Joshua A. Shannon	**439**

Contemporary Crafts

Imogen Racz

224pp • 37bw illus • 234 x 156 mm
PB 978 1 84520 309 2 £17.99 • $34.95
HB 978 1 84520 308 5 £50.00 • $99.95

 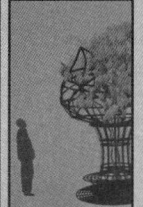

Contents

Introduction
1 Contemporary Crafts and Cultural Myths
2 Contemporary Arts and Crafts-makers in Rural England
3 The Artisan Tradition in Rural America
4 Critique and Embodiment in Rural England
5 Material, Space and Place in America
6 Urban Crafts in America
7 Urban Crafts in England
8 Crafts in the Environment (America)
9 Crafts in the Environment (England)
Afterward

Contemporary Crafts explores craft practices in both North America and Britain, revealing an astonishingly rich and diverse picture of artisanal work today.

The book ranges across both urban and rural crafts and analyses how the country/city dichotomy creates differing approaches, practices and objects. Analysed in the context of their environment and its localised history, crafted objects are shown to embody or critique particular urban/rural myths and traditions.

Covering both traditional and cutting-edge crafts from the small-scale domestic to large outdoor works, *Contemporary Crafts* demonstrates how craftspeople today are responding to the changing creative contexts of culture and history.

Order online at www.bergpublishers.com

Editorial Introduction

Agency, reciprocity, specialization and entrepreneurship: these are words we associate more with business studies and the social sciences than with the crafts. But it can be rewarding to look at these terms through the lens of craft and, in particular, in the context of a series of problematic craft encounters. What happens when elite individuals, institutions and governments take an interest in vernacular or traditional craft—either locally or in colonial situations? This is a theme running through the present issue of *The Journal of Modern Craft*.

One characteristic top-down impulse is to reconfigure traditional production, "preserving" the vernacular by making it conform to normative economics. This can involve bringing vernacular goods to market by creating well-publicized outlets for the work, or re-presenting the vernacular as worthy of philanthropic attention. Such well-meaning interventions, however, do not always do justice to nonindustrial ways of working.

Yuko Kikuchi takes us to Japan, where American designer Russel Wright picked his way through indigenous craft products, trying to determine which had potential for mass production. The article is usefully read in relation to Kikuchi's previous work on the *mingei* movement of the 1920s and 1930s. Sôetsu Yanagi and his circle had also concentrated on traditional Japanese craft objects, but certainly had not seen them as modern commodities in nascent form (rather the opposite, as repositories of premodern values). In a sense, though, Wright was like Yanagi: he saw these crafts not in their makers' terms, but his own.

Wright's foray into Japan exemplifies one characteristic version of modern craft agency: the displacement of control from maker to manager. Privileged outsiders rarely see the "folk" as the proper guardians of their own skills, objects, and ways of working. The vernacular maker is invariably hard pressed to retain agency if the authenticity of her or his mode of production is externally investigated, evaluated, and taxonomized. The very idea of traditional craft and commercial savvy comes to seem contradictory in such situations. The maker is expected to cleave to old ways of working (resisting change and hybridity) while the business of selling the timeless product is taken over by others.

So, although almost all production involves some degree of task sharing and skill sharing—division of labor—the

deliberate preservation or revival of craft production often seeks to prevent such interactions in the name of "authenticity." Craft is placed outside temporal development. Tensions emerge as a craft becomes static. Paradoxically, the objects produced lose their social functionality, being consumed as mementos of a pre-lapsarian world. These problematics are all central to Robin Jones's study of British colonial interventions in Sri Lanka (then called Ceylon) at the turn of the century, which sought to stave off a perceived decline in the state of indigenous craft production.

Recovering the (often ironical) responses of traditional makers caught in these unequal collaborations is an almost impossible task. Instead, we tend to get testimony from the managerial overseers of such activity. These perspectives have their own value, however, and two are presented in this issue's Primary Text and Statement of Practice. Maria Tenisheva and Ena da Silva lived several decades and many miles apart—in Russia and Sri Lanka—but had curiously parallel lives. Both were pioneering craft entrepreneurs. Born into well-to-do families, both were determined to use their status for charitable ends. Each developed a distinctive aesthetic, which was partly developed from local craft production, but partly imposed upon it. Their voices speak both to the attractions of the vernacular, and the frustrations that attended their attempts to translate it into a "viable" source of commercial goods.

Elsewhere in this issue, we find yet another framework for craft agency: industrial fabrication, both imagined and real. George Marcus sketches a brief but telling episode in the history of the Bauhaus, when the school's ambition (and for the most part, failure) to engage with mass production suddenly made the marks of handwork seem like a problem. As Christopher Wilk's review of a recent exhibition about Jean Prouvé demonstrates, however, modern design doesn't always work this way. Though the curators of this exhibition were disinclined to emphasize Prouvé's investment in craft technique, it is obvious that the designer himself never stopped considering it central to his practice.

In one final article, we arrive at craft agency in an unembarrassed, self-declarative mode. Kristina Dziedzic Wright's anthropological discussion of the contemporary Kenyan craft of coconut carving looks at the "clever" artisans of Lamu Island, who have managed to devise a craft that is taken as traditional by souvenir-seeking tourists. In this example, we have makers operating from a position of disempowerment, who took control of their own affairs using the tools at their disposal. The carvers of Lamu both saw clearly what the entrepreneurs documented elsewhere in this issue ignored, or only intuited: craft's power lies in its ability to speak from the margins.

The Editors
The Journal of Modern Craft

Cleverest of the Clever: Coconut Craftsmen in Lamu, Kenya

Kristina Dziedzic Wright

Kristina Dziedzic Wright received an MA in language, literacy and rhetoric in 1998, and an MA in art history in 2005, both from the University of Illinois at Chicago. Her research takes an ethnographic approach to the study of contemporary artists and craftsmen and focuses on informal sector artisans in developing countries as well as the intersections between art, culture, and community. She currently works as Exhibits and Publications Coordinator at the University of Illinois at Chicago, and is a freelance curator and practicing multimedia artist.

Abstract

Kenya's low GDP and high unemployment rates have led to widespread development of an informal economy known colloquially as *jua kali* (Swahili for "hot sun"). Field research conducted in Kenya focused on understanding the evolution of art forms within the informal sector, especially in response to the international tourism industry. Tourism is the primary non-extractive industry on Lamu Island and the presence of a touristic crafts market has nurtured a vibrant creative environment. One craftsman, Mũrage Ngani Ngatho, is credited by his peers as developing coconut crafts in Lamu, one of the most important genres of tourist art created on the island. By adapting woodcarving techniques to a more locally abundant raw material, Mũrage's innovation has become a recognized feature of the craft market in Lamu. Coconut crafts serve as important signifiers to consumers, reminding them of the place where they acquired the object, while also possessing intrinsic aesthetic merit. While explicating this type of carving as an emerging genre of modern craftsmanship, the article analyzes the cultural significance of coconuts to these artisans and contextualizes their work within the socioeconomic environment that shapes their creations.

Keywords: *jua kali*, informal sector artisans, tourist art, coconut carving, Lamu, Kenya.

> Making art works of any kind requires resources.
>
> Howard S. Becker, *Art Worlds*.

The economic climate of Kenya has spawned new genres of craft centered on recyclia and the creative reuse of found materials. Both the works and the processes of creating them are known as *jua kali*—Swahili for "hot sun." In Kenya, the phrase *jua kali* describes mechanics, welders, plumbers, and other workers who offer unlicensed services from temporary premises, i.e. outside in the heat. Artists and craftsmen who sell their work at street-side tables or open-air markets also call themselves *jua kali*. Such artisans are largely self-trained and work with a variety of media including paint, ceramics, textiles, basketry, and recycled or found materials. Based on ethnographic field research conducted in Kenya in 2001, 2004, 2006, and 2008, this article looks at *jua kali* craftsmen on Lamu Island who work with coconuts as their primary medium. While explicating this emerging genre of modern craftsmanship, my analysis focuses on the cultural significance of coconuts to these artisans as well as the socioeconomic and touristic contexts shaping their work.

Jua Kali and the Informal Economy in Kenya

The concept of *jua kali* initially gained recognition among government agencies and policy development researchers in 1971 when the International Labour Organization (ILO)—an agency of the United Nations—coined the term "informal sector" to describe the growing number of people working outside formal employment structures (Aboudha and King 1991; Aleke-Dondo 1993; King 1996). The ILO selected Kenya as the first site in Africa to pilot their development assistance programs for small-scale enterprises. The Kenyan informal sector's potential for growth was considered especially strong due to high unemployment and low gross domestic product (International Labour Organization 1972). The study concluded that Kenya's informal sector was highly productive and efficient, despite occupying the margins of the economy. The vocations originally associated with *jua kali* were blacksmiths, metalworkers, and auto mechanics, but the term quickly evolved to include anyone operating in the informal sector and eventually came to connote creativity and improvisation (King 1996).

Because goods and services produced by *jua kali* workers generally do not rely on foreign exchange and tend to be Kenyan dominated, international donor agencies, nongovernmental organizations and researchers continue to assist the Kenyan government in developing the informal sector as a basis for indigenous industries. Yet several studies have concluded that although considerable support exists for *jua kali* development, there is severely limited integration among the many governmental and privately sponsored programs, ultimately inhibiting any cumulative impact (Aleke-Dondo 1989, 1993; King 1996; Macharia 1997). Despite professed interest in the informal sector by the Kenyan government and significant funding by multilaterals such

as the World Bank to develop micro- and small-scale enterprises, harassment of so-called "hawkers" continues today throughout the country, illustrating the ambivalence with which the informal economy is widely regarded.

Government entities tasked with the responsibility of developing Kenya's informal sector have changed over the years in tandem with the dynamic political climate. Currently, the Department of Micro and Small Enterprise Development (DMSED) within the Ministry of Labor and Human Resources oversees governmental endeavors to facilitate *jua kali* growth.[1] As part of their efforts to expand market potential for *jua kali* artists and craftsmen, the DMSED works with the East African Community (a coalition of governmental agencies in Kenya, Uganda, Tanzania, and Rwanda) to organize annual group exhibitions that occur in the capital of each country on a rotating basis. The DMSED also sponsors training programs for artists and hosts smaller exhibits in various locations around Kenya, though such outreach efforts have not reached peripheral areas of the country such as Lamu Island (Ojiambo 2006).

While government agencies and nongovernmental organizations in Kenya as well as abroad have allocated significant resources to studying the country's informal sector and stimulating micro-enterprise development, little attention has focused on the actual works of art produced by *jua kali* craftsmen.[2] The urban informal sector encompasses a majority of recent art forms throughout Africa, which have materialized where former traditions did not exist (Kasfir 1999b). Over half of Kenya's population works in a *jua kali* setting (Republic of Kenya 2005), and the crafts created within the informal sector comprise a majority of the products available in the country's tourist art market. In Lamu, a group of *jua kali* craftsmen work with coconuts and primarily sell their handmade items to tourists. These artisans operate on the fringes of Lamu society, both economically and culturally, and my analysis will situate their work within the environment that shapes its creation.

Setting and Cultural Context

Lamu is an island of Kenya located in the Indian Ocean about 63 miles (100 km) south of the Somalian border. Dating back to at least the twelfth century, Lamu was one of myriad Swahili city-states along the East African coast that were essential ports for trade networks extending to India, China, Persia, and the Arabian Peninsula. In 2001, Lamu Town was named a UNESCO World Heritage Site because it "is the oldest and best-preserved Swahili settlement in East Africa retaining its traditional functions" (UNESCO 2001: 44). A newspaper article about the UNESCO honor describes Lamu as "a focal point for Swahili and Arab art" (Oluoch 2002). The "Swahiliness" of Lamu is often emphasized in such a way that implies homogeneity and focuses on Islamic and Arabic identity (Figure 1). However, the groups of people living along the East African coast have never been isolated communities, and Swahili culture has always included an influx of traditions from the African interior as well as elsewhere in the Indian Ocean littoral.

The ethnicity of Swahili-speaking peoples is a contested topic, and much scholarship has been devoted to the question of who constitutes the group known as the

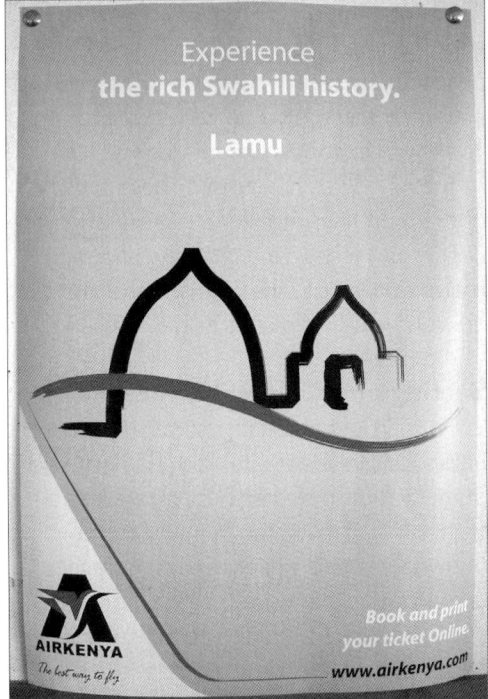

Fig 1 This photograph of an Air Kenya promotional poster, taken in Wilson Airport, Nairobi, exemplifies how Lamu's history as a Swahili city-state continues to represent the island into the present day. Photograph taken by the author.

Waswahili (e.g. Allen 1993; Caplan 1997; Eastman 1971, 1994; Kusimba 1999; Le Guennec-Coppens and Caplan 1991; Mazrui and Shariff 1993; Middleton 1992; Spear 2000). As Spear (2000: 257) notes, in the last few decades "some 270 books, theses, and articles" have been written about the identity and history of Swahili-speaking people on the East African coast. Arguments revolve around exogenous versus indigenous origins of the ethnic group, and attempt to define what it means to be Swahili by considering factors such as ascribed social status, cultural traits, and linguistic practices.

Research has shown that the Swahili historically negotiated between African and Arab identities, upholding Islamic religious practices and settlement models while participating in marriage alliances within upcountry African lineages (Allen 1993; Kusimba 1999; Mazrui and Shariff 1993; Spear 2000). Although Swahili people can trace their lineage to both Arab and African ancestry, many prefer to emphasize exogenous sources of identity, which may be a residual effect from the British colonial policy of taxing "natives" in Kenya (Cooper 2000; Mazrui and Shariff 1993). Much of the current confusion and ambiguity about defining the Swahili as an ethnic group has roots in the colonial period, when the practice of separating and categorizing different groups of people was artificially imposed by the British (Cooper 2000). Fair (2001: 29) highlights how ethnic identities in post-abolition colonial East Africa were "self-consciously deployed ... in strategic ways" as ethnic definitions became more important under colonialism.

The strategic positioning of ethnicity is no less relevant in contemporary Africa. There are many ways in which people broadly characterized as Swahili distinguish themselves from one another with local labels such as Bajuni, WaSiyu and WaAmu, but such nuanced specificities are beyond the scope of this article. What is more significant to my consideration of coconut carvers in Lamu is whether an artisan has historical roots in the East African coast or is a more recent migrant to the area. For the purposes of my discussion, I use the ethnic label

"Swahili" to describe natives of the coast who practice Islam and speak a dialect of Swahili as their first language (although many are fluent in Arab too).

None of the *jua kali* craftsmen I studied in Lamu was born on the island, and all belong to non-Swahili ethnic groups. The majority of these artisans are Kikuyu, a Bantu people who migrated to Kenya centuries ago. Many came to the coast as part of the settlement schemes devised by Kenya's first president after independence, Jomo Kenyatta. The first settlement program in Lamu District was developed in 1976 near the then small town of Mpeketoni on the mainland, and others soon followed nearby (Hoorweg 2000). Although the resettlements officially followed specific procedures of application for land rights, personal favoritism was common and Kikuyus were the primary recipients of land designated by the government as "unoccupied" (Hoorweg 2000). The Swahili and other coastal peoples already inhabiting these regions resented such migration for what they perceived as an invasion of their land without compensation (Middleton 2000). Animosity that originated decades ago continues to manifest in the daily interactions of people in Lamu Town and is particularly acute among the island's artisans, who compete with each other for patronage from tourists.

Tourism is one of the primary industries in Lamu (Republic of Kenya 1997, 2002), and the island's current reputation as a cultural destination is largely dependent on its history as a Swahili city-state despite increasing numbers of non-Swahili residents. Many of the buildings in Lamu Town date back to the eighteenth century, lending the island an air of timelessness. Swahili architecture, with its coral stone walls and carved wooden doors, is one of Lamu's most distinct features. Swahili woodcarving traditions have given rise to an array of souvenirs that are a cottage industry for many craftsmen on the island. Woodcarving shops along the seafront and the main street through town create souvenirs such as boxes, frames, and plaques in a style reminiscent of the island's ubiquitous carved wooden doors (Figure 2). These items are almost exclusively created by craftsmen who identify themselves as Swahili. Other Swahili craftsmen in the tourist industry include silversmiths and tailors who make clothes to order from local fabrics.

The island's non-Swahili artisans make other items for the tourist market such as paintings, beaded jewelry, and carved coconuts. Because shopping for souvenirs is equated to a cultural experience by guidebooks and local merchants alike, Lamu's craftsmen habitually employ the concept of "culture" in their business names and signage (Figure 3). Many of the coconut carvers whom I interviewed in Lamu described their craft as a "coastal art, but not Swahili." One carver explained, "Coconuts are only found on the coast and many tourists like them because they don't have coconuts where they come from. Coconut art is very Lamu." Aesthetically and culturally, these non-Swahili artisans define themselves against the traditions most often associated with the East African coast, and coconuts are a symbol of what sets them apart from the Swahili wood carvers, silversmiths and tailors who dominate the island's touristic art market.

Most of Lamu's coconut carvers work in an informal setting, though distinctions between informal and formal enterprises in Lamu Town are less clear than is implied by

Fig 2 On the left, a Swahili-carved wooden door commonly found in Lamu Town and one of the island's most notable features for visitors. On the right, a miniature reproduction of the Swahili door created as a souvenir for tourists. Photo courtesy of Karen Levy, 2008.

academic literature and policy discussions on the subject. According to criteria such as licensing, the payment of taxes and formal employment contracts, many of the island's well-established and highly successful businesses would not fit the definition of "formal." As Levy (2008: 59) notes, "Until very recently, there was no permanent tax-collection infrastructure in Lamu. When the tax collector made periodic visits to Lamu from his office in Malindi, word spread about his imminent arrival and most businesses simply shut down for a few days."

Nonetheless, there are varying degrees of formality among Lamu's commercial enterprises, and the island's *jua kali* artists are on the informal end of the spectrum, with most working from within their homes and/or outside—as the name "hot sun" suggests (Figure 4). Street-side enterprises are usually tolerated in Lamu if the craftsmen are respectful to passers-by, but occasionally the County Council will force them to pack up their wares and vacate the location. One *jua kali* craftsman described "days of cleaning, when art is thought of as dirt or an obstacle." It is not uncommon for *jua kali* artisans to receive fines or even be arrested for so-called "hawking." Although some Swahili craftsmen also work in informal settings, the street-side tables around Lamu Town are primarily set up by non-Swahili artisans, wheareas the permanent premises for craft production

Fig 3 Signs of Culture. Lamu's artisans are well aware of touristic expectations, and the commoditization of culture is characteristic of the island's tourist art market. Photograph taken by the author.

on the main street and seafront are largely Swahili owned and operated.

Origins and Production of Coconut Craft on Lamu

Coconut shell is a popular material among Lamu's *jua kali* craftsmen because it is readily available, inexpensive or even free, and functions for the artisans as a symbol of island culture that is not tied to Swahili traditions. Objects handcrafted from coconuts in Lamu include purses, teapots, bracelets, barrettes, earrings, and buttons (Figure 5). A craftsman named Mūrage

Fig 4 *Jua kali* workspaces in Lamu Town. Photograph taken by the author with consent of the person(s) photographed.

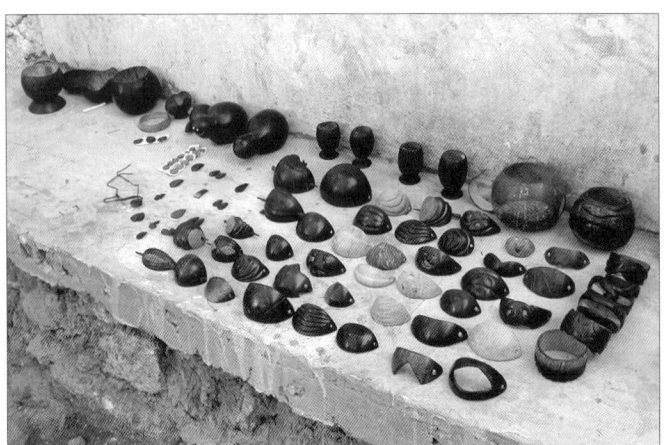

Fig 5 Mūrage's display table of coconut crafts includes carved bracelets, barrettes, earrings, buttons, cups, bowls, and animal figurines, all of which he designed himself and created from coconut shells. Photograph taken by the author.

Ngani Ngatho (hereafter Mūrage) is generally recognized among Lamu's *jua kali* artistic community as the island's "pioneer of coconut art," or *mjanja wa wajanja* (Swahili for "the cleverest of the clever"). Almost every craftsman on Lamu who works with coconuts today was either trained by Mūrage or learned from someone who was at one time his apprentice (Figure 6). Mūrage is originally from Karatina in the Mount Kenya region, but he migrated to Lamu in 1988 to look for work.[3] He began his artistic career on the island as an apprentice to a Kamba carver named Kioko, who himself trained at the large cooperative in Mombasa that was the subject of Jules-Rosette's (1984) study. After learning the basic skills of woodworking from Kioko for almost a year, Mūrage began his foray into coconut crafts by making bracelets from discarded shells that he collected from the marketplace and trash piles around town.

As Mūrage explains the evolution of his craftsmanship, he fortuitously came upon the idea to carve coconut shells through an encounter with an Australian tourist visiting Lamu. This particular tourist asked Mūrage to reproduce a coconut bracelet she had purchased in Mombasa. He told me that he was struck by the cleverness of using coconut shell as a carving material: "Here, we pay so much money for wood and the carver's profit is low. But these coconuts are everywhere in Lamu. It is a great thing to carve what other people throw away."

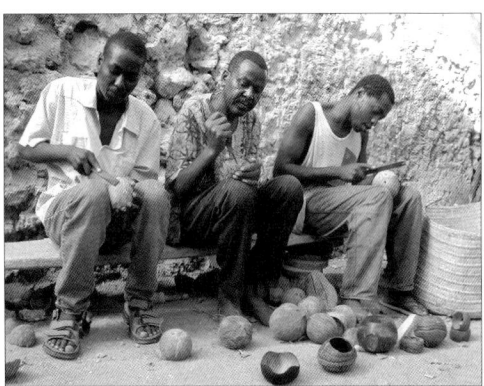

Fig 6 Mūrage (center) sharing techniques with two of his apprentices. Photograph taken by the author with consent of the person(s) photographed.

Mūrage said he enjoyed transferring what he knew about woodworking to this new medium, although coconut shell is more unyielding than wood. When Mūrage was relating his first experience with coconut crafts, he said in reference to the tourist's bracelet, "I know now that it wasn't even a very well made piece, but it was the beginning of work with coconuts."

Although this account of the origins of coconut crafts in Lamu is admittedly anecdotal, many of my informants echoed a version of the tale. Mūrage is widely credited with introducing coconut carving to Lamu's craftsmen through an anonymous tourist who provided the idea. He started by making bracelets, which he sold for 50 Kenya shillings each (about US$1 at the time) to tourists on the Lamu seafront. Eventually his customers began asking for different items such as barrettes, candleholders, bowls, belts, teapots, buttons, and statues of animals, all of which Mūrage figured out how to create from coconut shells. The influence that tourists have had on Lamu's coconut carving industry illustrates the syncretic innovations that can arise out of "cultural transactions" between Western tourists and non-Western artists (Steiner 1994).

Mūrage fashions his own designs and teaches other aspiring carvers his craft in an informal apprenticeship arrangement that is predicated on the specialized skill set of the master craftsman. Kasfir (1987) examines variations among African societies regarding the ways in which artists acquire styles, and ways that patronage can determine how these styles do or do not change. Although Kasfir's analysis is specific to mask-making cultures, which is not entirely applicable to *jua kali* art in Kenya, her distinction between training by enculturation versus apprenticeship is relevant to my discussion in many ways. Among the societies from which Kasfir (1987: 26) cites examples of artists learning through enculturation rather than apprenticeship, "there is the implicit assumption that anyone can learn to carve, just as anyone can learn to thatch or make yam heaps or dance." In contrast, societies with apprenticeship models tend to recognize carvers as specialists with a set of skills that few people are able to master. Despite the fact that patronage in the *jua kali* art world of Lamu is very different from that of the masking cultures discussed by Kasfir, these societies share a use of apprenticeships to acquire skills and an emphasis on the artisan's specialized role.

The apprenticeship systems found in Lamu are not as formal as those described by Kasfir, but aspiring artisans nonetheless seek training from their elders, whom they recognize as masters of a particular skill set. Lamu's apprenticeships are typically organized through sociocultural networks rooted in ethnicity, with particularly evident divisions between Swahili and non-Swahili craftsmen. Mūrage, for example, has never trained a Swahili artisan in coconut carving and most of his apprentices are from his own Kikuyu ethnic group. Likewise, Swahili woodcarvers in Lamu have their own apprenticeship system and tend to transfer skills within their families or extended kinship network. A 2003 survey of Lamu businesses indicated that all twenty operational woodcarving workshops in town were owned by Swahili people;[4] at the time of the survey these twenty owners employed a total of seventy-one workers, only twelve of whom were non-Swahili and

of this twelve, only one was Kikuyu (Levy 2004).

Majid Said El-Mafaazy is a well-known Swahili craftsman in Lamu, who hails from a long lineage of woodcarvers. Majid corroborated my observations about ethnic-based preferences for materials, explaining that Swahili carvers never use coconuts. "Although hardwood is getting more and more expensive and hard to find," he said, "Swahili craftsmen will only use wood. It is what we have always used and this kind of carving is our cultural heritage. These coconuts [that are carved] are newer to Lamu than woodcarving and it is mostly Kikuyus who make them" (El-Mafaazy 2008).

Mūrage works in the courtyard of his residence, where there is some shade to provide relief from the hot sun. His apprentices typically come to his workshop for a few hours each day to observe him in action while they attempt to make their own coconut crafts. In exchange for their training, Mūrage's apprentices sell his work down by the seafront and on street-side tables around town. Mūrage himself has not hawked in the streets since the early 1990s, instead relying on his extended network of fellow coconut craftsmen to sell items for him and occasionally bring potential customers back to his workshop.

Mūrage's apprentices come to him with varying levels of experience, but many have done at least some woodcarving in primary school as part of the technical training curriculum in Kenya's public school system. Mūrage usually teaches by "doing," demonstrating new techniques while he works on his own carvings. He also provides feedback on his apprentices' work and offers numerous suggestions for improvement.

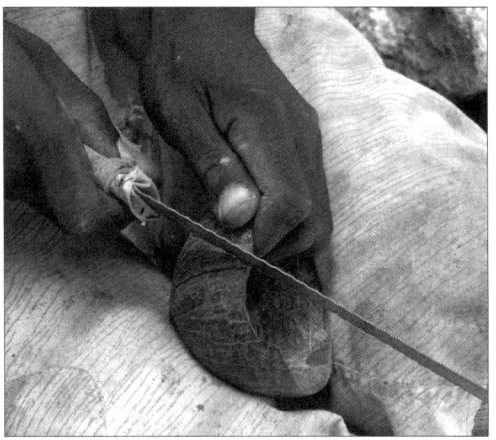

Fig 7 A craftsman using a hacksaw to cut coconut shell into suitable pieces for buttons. Photograph taken by the author with consent of the person(s) photographed.

Criteria that the craftsmen employ for judging the quality of a work include originality of design, execution of the steps required to create an item, and how smooth the shell's surface is after it has been sanded.

Artisans must execute a variety of procedures in order to create a coconut craft, and the way an individual performs each task directly relates to the experience and skill level he has in that particular technique.[5] Buttons, barrettes, bracelets, earrings, and other jewelry necessitate cutting the shell into different shapes (Figure 7). Certain designs are dependent on a specific thickness of coconut shell, and so the artisan must choose his material carefully. For example, the flower design that Mūrage uses for earrings, buttons, and pendants can only be fashioned from an especially thick coconut shell (Figure 8). Another design of Mūrage's that requires a thick coconut and particular acumen in craftsmanship is

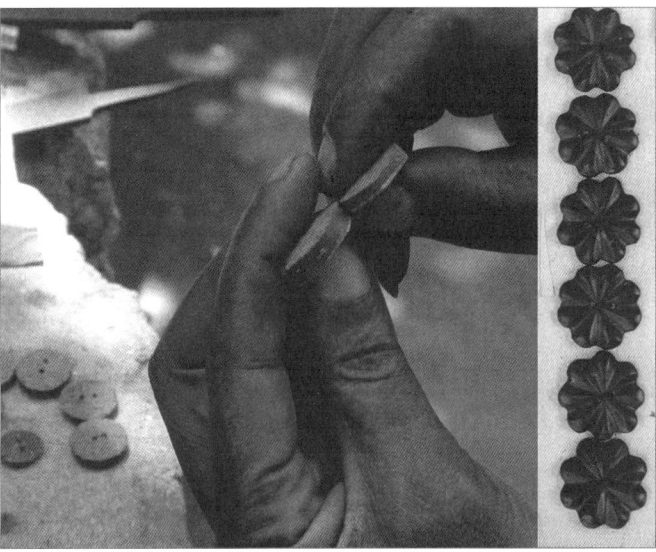

Fig 8 On the left, Mūrage comparing two pieces of coconut shell to demonstrate the thickness required for making flower-shaped buttons (the piece in his right hand is too thin). On the right, Mūrage's flower shape is one of his more challenging designs to create. Photograph taken by the author with consent of the person(s) photographed.

his twisted bracelet (Figure 9). Mūrage can cut out the design without drawing it first, but most coconut carvers need to sketch the pattern first. Using a metal file, Mūrage painstakingly removes sections of shell to create the twist design. He then files down the edges into grooves and, finally, sands the whole piece smooth.

Lamu craftsmen obtain discarded shells from the marketplace and trash piles around town, but they also collect coconuts that have washed ashore on the beach. Mūrage pointed out one purse that was larger than usual, which he had made from a coconut found on the beach (Figure 10). "In Lamu," he said, "the coconuts are not that big. This size can only be found washed up on the beach. They come from Indonesia." The *jua kali* sector throughout Kenya is renowned for creative reuse of materials and in Lamu, beachcombing is a regular part of most craftsmen's routine. The seasonal winds known as *Kusi*, which have brought sailors from across the Indian Ocean to trade in East Africa since the advent of the Common Era, are now locally called "scavenging winds" because of all the debris they bring to shore.

Large coconuts are ideal for making into teapots, bowls, and purses. Such items typically require only a minimal amount of cutting because discarded shells are usually broken in half before the fruit inside is eaten.

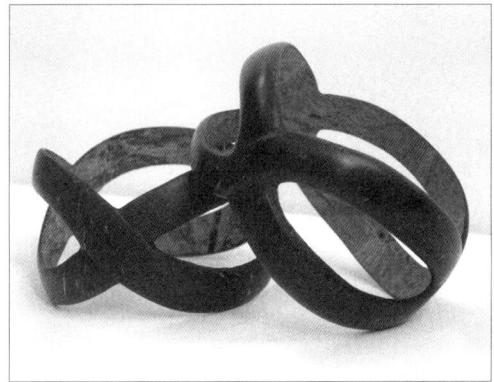

Fig 9 Twisted bracelets by Mūrage, diameter 2¾ in. (7 cm). Photograph taken by the author.

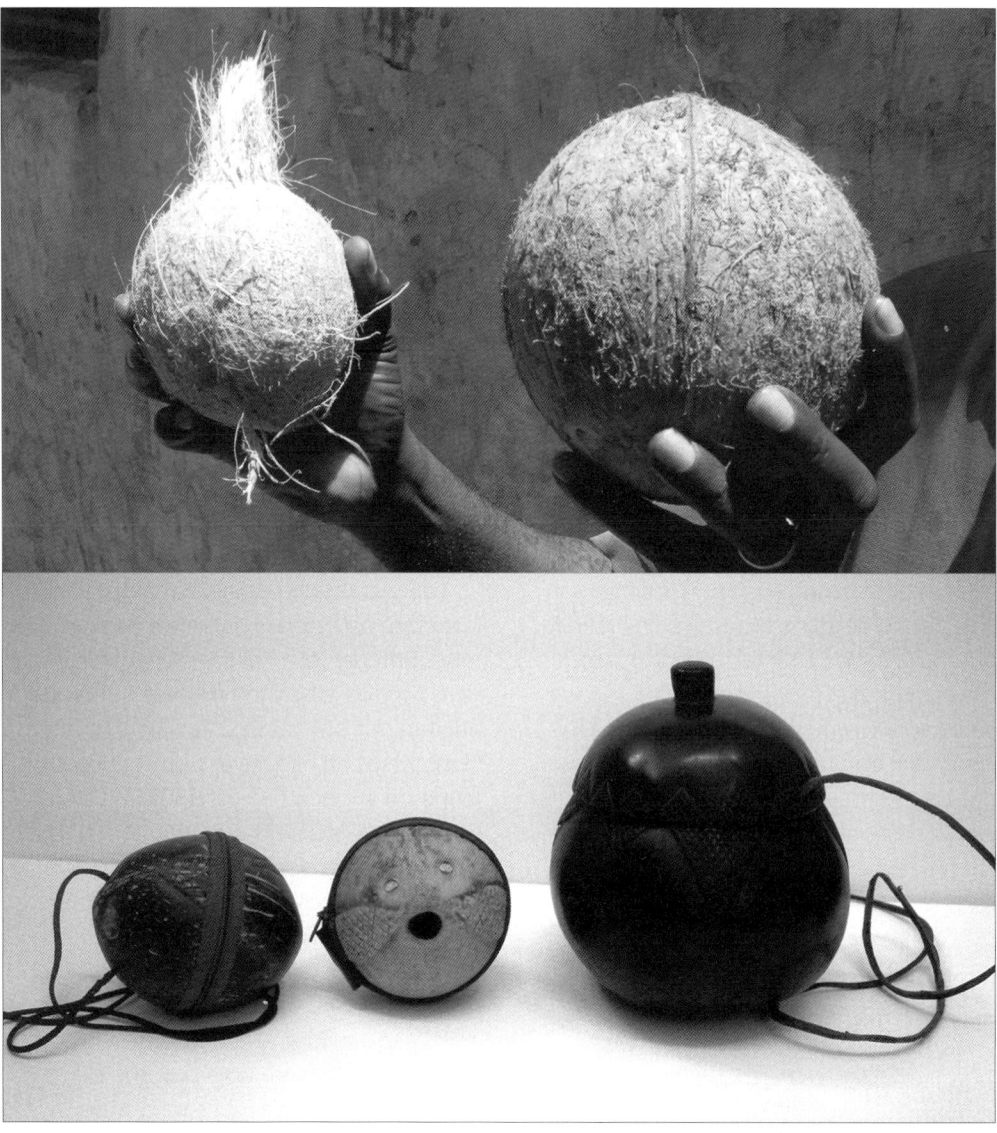

Fig 10 In the top photo, a craftsman compares the size of two coconuts. Locally grown coconuts tend to be small, such as the one featured on the left, but occasionally the Lamu market will sell larger fruits that are grown on the mainland near Kipini (top right). Lamu craftsmen regularly search the beach for large coconuts that have washed ashore. The bottom photo shows three purses: the two on the left were created from coconuts grown on Lamu Island and the large one on the right was made from a shell that Mūrage collected on the beach. Photograph taken by the author with consent of the person(s) photographed.

However, filing off the jagged edges that result from cracking the shell is often more difficult than cutting them off with a hacksaw. The most labor-intensive step in making almost any item from a coconut is smoothing the shell's surface to a glossy, soft finish. This is achieved through a series of steps:

1. Using a file, the "fuzzy" skin is cleaned off the shell. Some designs, however, incorporate sections of the fuzziness as an aesthetic element of contrast to the glossiness usually achieved (Figure 11).
2. File marks are smoothed away with medium-grain sandpaper.
3. After removing all traces of file scratches using the medium-grain sandpaper, the surface is further smoothed with fine-grain sandpaper.
4. Once the surface is entirely smooth, its glossiness can be increased by rubbing a natural oil, such as linseed, into the shell. Some craftsmen also use shoe polish in brown, black, or neutral—depending on the desired color.

Lamu's craftsmen place great emphasis on sanding the coconut shell until it is satiny smooth in order to highlight the inherent beauty of the material. As Mūrage explained, "Carving shows the greatness of the coconut." In contrast, the coconut crafts typically found elsewhere along Kenya's coast, namely in Malindi and Mombasa, are created in a notably different style with paint and varnish applied to the shell's surface (Figure 12). Patterns on the shell are almost never carved, but rather are painted, usually in black and gold. When I showed one Lamu craftsman a coconut bracelet with black and gold geometric shapes painted on it under a layer of shellac, he correctly noted that it had not been made in Lamu. "Mūrage taught us how to work with the natural beauty of coconuts," he explained. "These people in Mombasa and Malindi are lazy and cover up their work with varnish so they do not get blisters from sanding. But varnish rubs off after a while and becomes ugly. The Lamu style of natural coconut crafts looks better and lasts longer." Lamu craftsmen often incorporate design elements of the coconut shell into their carving patterns, for example, creating stripes from the shell's natural ridges or using the fruit's naturally occurring holes to attach the strap onto a purse (Figure 13).

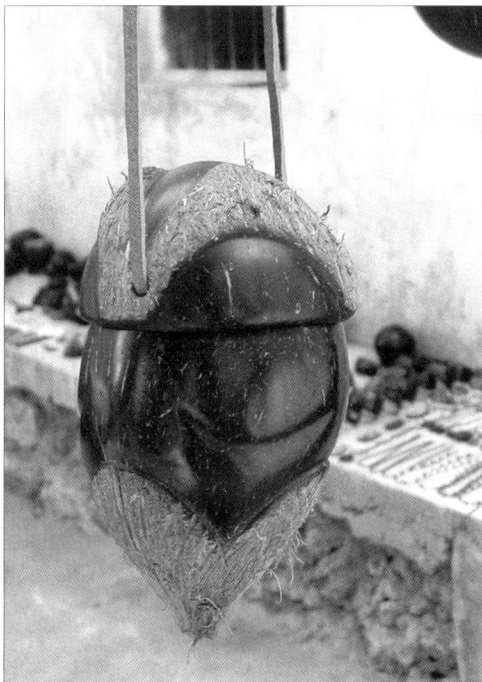

Fig 11 Coconut purse with fuzzy/smooth contrast as an aesthetic element. Photograph taken by the author.

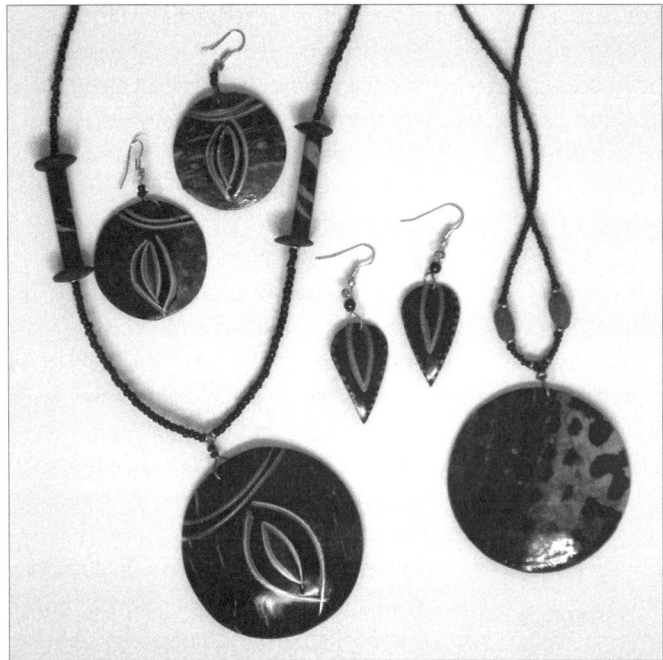

Fig 12 Coconut jewelry made in the signature style of Malindi and Mombasa, with paint and varnish applied to the shell's surface. Photograph taken by the author.

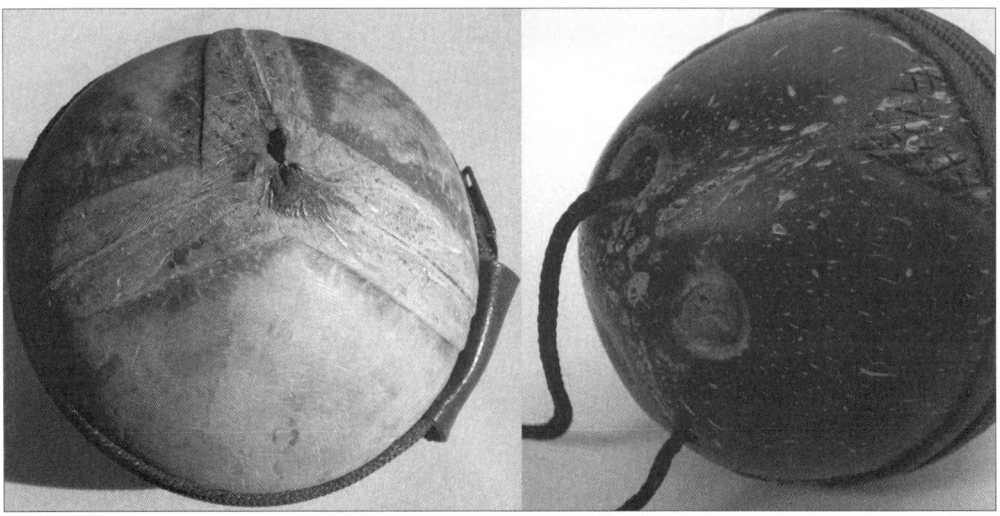

Fig 13 Close-up photographs of carved coconut purses show how craftsmen incorporate design elements of the shell into their creations. On the left, the coconut shell's ridges form a striped pattern and, on the right, naturally occurring holes have been used to attach a strap. Photograph taken by the author.

Coconut shell is a difficult material to work with, requiring a great deal of time and expertise to craft. During participant observation in Lamu one day, I became a student of Mūrage's myself and experienced firsthand the challenges of manipulating this unyielding material. After four hours of trying to sand away the file marks on a bracelet, my hands blistered and I eventually abandoned the project out of frustration. This experience provided me with a renewed sense of respect and admiration for the work of *jua kali* craftsmen like Mūrage.

Mūrage's tools exemplify the ingenuity and resourcefulness that have come to represent the *jua kali* sector and the craftsmen's ability to work with whatever is available at hand. Figure 14 illustrates all of the tools, except for sandpaper, that Mūrage uses for crafting coconuts. The brush, files, and saws on the right were all purchased in Lamu Town at whichever of the two hardware stores happened to be carrying them when he last needed new ones. Mūrage made the other three tools in the photograph to perform specific tasks for which no tool was available at the hardware store. The first of these (far left) is an awl that he fashioned by sharpening a bicycle spoke and sticking it into a wooden handle. Mūrage uses this tool to bore holes in buttons and pendants, and for creating polka-dotted designs. The next tool (second from left) is called a *jobe* in Kikuyu. Mūrage made the *jobe* by bending a blade into a curve and inserting it into a stick wrapped with strips of rubber. He uses this to scrape out any remnants of coconut meat left inside the shell and to carve away the inside layer of skin. Mūrage created the stiletto knife (third from left), called *ngūrimbū* in Kikuyu, by scraping a metal file into a blade with another metal file, and hammering the blade into a handle carved from wood. This tool is used for a variety of tasks, and Mūrage constantly sharpens the blade edge with a metal file. When I commented on Mūrage's ingenuity in creating these tools, he replied "Yeah, *jua kali*. There are many obstacles, therefore we are clever."

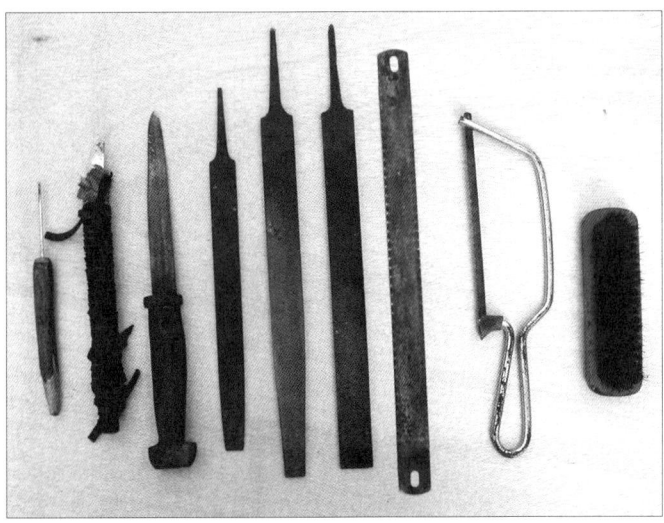

Fig 14 Mūrage's tools—he fashioned the first three from the left himself. The rest were purchased at a local hardware store. Photograph taken by the author.

The Art and Culture of Souvenirs

To some people, *jua kali* denotes low-quality, tourist knick-knacks or industrial products made of scrap metal such as charcoal stoves and cooking pots (Figure 15). But to dismiss all *jua kali* craftsmanship as manufactured for strictly utilitarian purposes or as non-artistic trinkets is to overlook a vast array of objects with much aesthetic merit and cultural significance. Using rudimentary tools made from bicycle spokes and discarded blades, Mūrage and the craftsmen he has trained create exquisitely carved items from discarded coconut shells. Their primary audience is comprised of tourists, but not exclusively Westerners. Kenyans from the mainland and visitors from other African nations also frequent Lamu and purchase coconut crafts as souvenirs of their island vacation.

Fig 15 *Jua kali* metalworkers. The term *jua kali* is often associated with locally made cooking pots and charcoal stoves such as the ones shown in this photograph, but the label has also been embraced by artists and craftsmen who sell their work outside of formal venues. Photograph taken by the author with consent of the person(s) photographed.

For the consumers of coconut crafts, the value of such objects lies as much in the ingenuity of their construction as in their representation of the exotic. Coconut crafts as souvenirs embody the place where they are purchased, and in Kenya such artwork is only produced along the coast and in Lamu. A seminal text on the function and symbolism of souvenirs, which relates to this discussion, is Susan Stewart's *On Longing* (1993). Using semiotic analysis, Stewart analyzes the sign of a souvenir as operating not object-to-object, but object-to-event/experience. For example, a coconut purse from Lamu may represent a range of experiences: walking to the beach, the coconut tree outside one's hotel window, drinking coconut juice, and eating coconut rice. After leaving Lamu, the souvenir functions to remind its owner of the island and all that was experienced there, particularly as these experiences relate to life on an island as embodied in the coconut.

Simultaneously, however, Stewart (1993) argues that such an object also speaks of the loss of these experiences. In Chicago, looking at my coconut purse, I am unable to walk outside my apartment and pick up a coconut recently dropped from a tree. I can purchase one in the grocery store, but it would not be as fresh as that which I cracked open in Lamu. I am reminded of this fact by the very act of buying coconuts in a store instead of outside in the market where piles of freshly picked fruit are piled atop blankets spread on the ground. Although my coconut purse can be viewed as a beautiful object in its own right, as a souvenir of my island experiences, it requires a "supplementary narrative discourse that both attaches to its origins and creates a myth with regard to those

origins" (Stewart 1993: 136). According to Stewart, such a narrative of origins is not a story of the object itself, but rather of its possessor.

Stewart (1993: 136) focuses on objects after they have been reclassified in the Western category of "souvenir," such that the object "as bibelot or curiosity has little if any value attached to its materiality." However, my study suggests that coconut crafts' value as souvenirs is inextricably linked with their materiality. Mūrage's coconut carvings exhibit the mastery of specialized skills independent from the items' function as souvenirs. Furthermore, almost every consumer of Lamu's *jua kali* crafts whom I interviewed commented on the materiality of the objects they purchased: "It was unique-looking," and "I thought it'd be a real conversation piece" are among the most common remarks I heard. One tourist said she purchased coconut crafts in Lamu because they are made from a "sustainable resource."

Stewart's (1993: 135) analysis of a souvenir focuses on its representation of "the 'secondhand' experience of its possessor/owner" rather than "the lived experience of its maker." For *jua kali* artisans in Lamu, however, coconut crafts are very much about the experiences of the people who make them—to the extent that the coconut itself functions as a symbol of their cultural heritage. Almost every coconut carver in Lamu is a Kikuyu, and the centrality of ethnicity to these artisans was apparent in a card-sorting exercise I employed to better attain an emic perspective on their use of the word "culture." As explained by James Spradley (1979) in *The Ethnographic Interview*, card sorts involve asking informants to list words—in this case, "examples of culture"—on individual cards and then sort the terms into groups based on affinity. The exercise enables researchers to better understand how their informants define and use terms.

Two coconut carvers and three *jua kali* painters participated in my card-sorting exercise; four were Kikuyu and one a Giriama. Their examples of culture consisted entirely of specific customs and practices of different ethnic groups. The four Kikuyus listed a variety of traditions such as Maasai circumcision ceremonies, Kikuyu dowry requirements, Turkana polygamy, Kamba food, Swahili styles of dress, Kikuyu religion and Luo teeth removal. The Giriama artist provided examples of culture that are all specific to his ethnic group, such as the style of dress that women wear and certain kinds of food.

The importance of ethnicity to these artisans was further highlighted when I asked them to categorize their examples of culture. They initially organized their cards by ethnic group: Maasai culture, Kikuyu culture, Swahili culture, Luo culture, Turkana culture, Kamba culture, Giriama culture, etc. This sorting method demonstrates that ethnic differences are the primary means by which they construct notions of "culture." When I asked if there were any other ways that the examples of culture could be sorted, they eventually came up with the categories of food, styles of dress, daily work, religion, marriage, birth and age-grade rituals. Rearranging the cards according to categories other than ethnicity was a much more difficult task for them, however, and they all agreed that ethnic groupings made the most sense.

Culture, as these *jua kali* artisans define the term, includes a variety of customs,

traditions, values, and lifestyle choices that are largely tied to differentiations of ethnicity. In Lamu, non-Swahili carvers distinguish themselves from their Swahili counterparts through their use of a material that is indigenous to the island but not tied to Lamu's long history of cultural traditions. They recognize the coconut as a symbol of Lamu that they have claimed as their own.

Conclusion

Kenya's informal sector is renowned for utilizing recycled materials that can be obtained at little or no cost, and the very term *jua kali* carries connotations of ingenuity and resourcefulness (King 1996). It is important to note that "recycling" in an African context is more a process of recuperation than is usually implied by the Western use of the term. In most developed countries, "recycling" typically means to collect refuse that can be broken down into raw substances by industrial processes and manufactured into different products (Roberts 1989). Although this does happen in some of Africa's urban centers, Third World recycling in general tends to involve recuperating an object from its original context and manually modifying it to serve another purpose. Such processes of recuperation are central to Igor Kopytoff's (1986) analysis of commodities as having a "social life," through which their value, uses, and meaning change over time. Kopytoff shows how the mapping of a commodity's biography can reveal the historical, political, and aesthetic dimensions of a society's value structure. The cultural biography of many *jua kali* items illustrates varying stages of merchandise versus trash, which in turn communicates a user's perception of utility.

Kasfir (1999a: 104) compares *jua kali* recyclia to *bricolage*, referring to a *fundi* (craftsman) as "the East African equivalent of Claude Lévi-Strauss's *bricoleur*, mending what is broken with whatever materials come to hand." When *jua kali* artists cannot afford to buy materials for their art, they find innovative ways to creatively use debris that has been pushed to the fringes of utility. Mũrage and the artisans he has trained create a variety of decorative and functional crafts from coconuts, which begin as food in the marketplace and later become trash once the fruit inside is eaten. After being used by *jua kali* craftsmen, cast-off coconut shells reenter a network of commodity exchange as art objects. Demonstrating the propensity toward recyclia and the ingenuity that is emblematic of *jua kali*, Mũrage explained, "I have a use for every part of the coconut tree except for the roots, and that is only because they are impossible to dig out of the ground." Like other artists who use found materials, Lamu's coconut craftsmen, "the cleverest of the clever," transform that which would otherwise be discarded into pieces with great aesthetic and often also functional value.

The enclaves of *jua kali* craftsmen who work in Lamu are formed by common bonds of ethnic background, a sense of shared culture and their use of materials. As migrants to the island, the non-Swahili coconut carvers have informally organized themselves along ethnic lines to participate in apprenticeship-based training and cooperate with one another in the processes of creating and selling their artwork. The availability of resources to craftsmen is paramount to what they produce and how they represent culture. The objects created and sold by the

coconut carvers in Lamu reflect not only the supplies they are able to acquire but also the materials' symbolic value. The work of these craftsmen debunks the myth of a timeless, unchanging culture in Lamu and reveals instead a dynamic, ever-evolving network of cultural exchange and artistic innovation.

Acknowledgments

I would like to thank the Office of the President of the Republic of Kenya and the Ministry of Education, Science and Technology for granting me permission to conduct my research, and Winnie Karingithi in the Department of Micro and Small Enterprise Development for her ongoing support of my work. For their hospitality during my time in Kenya, thanks to Karen Levy, Hadija Bwanaadi Ernst, Majid Said El-Mafaazy, and Thweba Athman. I would also like to thank David Wright, the best research assistant and partner that a person could have. My informants are too numerous to name here, but I am grateful to all the *jua kali* artisans who so generously shared their time, talents and experiences with me ... *shukrani, marafiki*.

Notes

1 This information was current when the article was submitted for publication, but the Kenyan government at that time was also in the midst of restructuring its cabinet after controversial 2007 elections. It is likely that the Ministry of Human Resources and Labor could change as part of this process.

2 Out of the 333 pages of *Jua Kali Literature: An Annotated Bibliography* (Mutua, Aleke-Dondo and Oketch 1993), only five pages contain entries related to "handicrafts," and these publications focus more on policy development and the sociological aspects of craft production than consideration of the objects themselves. Among Western academic surveys of art in present-day Africa, *Contemporary African Art* by Sidney Littlefield Kasfir (1999b: 22) is the only one that mentions *jua kali*. The April 1992 issue of *African Arts* features a group of *jua kali* artists on the cover, and includes two articles (Kasfir 1992; Roberts 1992) that refer to Africa's informal sector in their discussion of recycled materials in African craftsmanship, though neither utilizes the term "*jua kali*." The Fall 2000 edition of *African Arts* includes an article by Heike Behrend about *jua kali* photographers in Mombasa, Kenya, which was republished in *Photography's Other Histories*, edited by Christopher Pinney and Nicolas Peterson (Durham, NC: Duke University Press, 2003). "Streetwise: The Mafundi of Dar es Salaam" was an exhibition at the UCLA Fowler Museum of Cultural History that highlighted street artisans in Tanzania, and is included in the museum's publication *The Cast-Off Recast: Recycling and the Creative Transformation of Mass-Produced Objects* (Livengood 1999).

3 Although many Kikuyus moved to the coast of Kenya in the 1970s and 1980s because of President Jomo Kenyatta's settlement schemes as described earlier in this article, Mūrage came directly to the island of Lamu rather than first moving to one of the government-sponsored settlements on the mainland.

4 Levy's survey indicated that these twenty owners identified themselves as either Bajuni or Swahili-Arab, which I subsume under my use of the ethnic label "Swahili."

5 My use of the pronoun "he" is not an oversight grounded in sexist language usage. Without exception, I did not meet a single female coconut craftsman in Lamu and when I asked Mūrage why this was, he simply replied "*Hawafanyi*." (Women don't do this.)

References

Aboudha, Charles and King, Kenneth. 1991. *The Building of an Industrial Society: Change and Development in Kenya's Informal (Jua Kali) Sector*,

1972–1991, a Summary Report. Edinburgh: Centre of African Studies, University of Edinburgh.

Allen, James de Vere. 1993. *Swahili Origins*. London: James Currey.

Aleke-Dondo, C. 1989. *Financial Services for the Jua Kali Sector in Kenya*. Nairobi: Kenya Rural Enterprise Program, Occasional Paper No. 5.

Aleke-Dondo, C. 1993. *Assisting the Informal Sector: Comparing Methodologies and Performance*. Nairobi: Kenya Rural Enterprise Program.

Becker, Howard S. 1982. *Art Worlds*. Berkeley: University of California Press.

Behrend, Heike. 2000. 'Feeling Global,' The Likoni Ferry Photographers of Mombasa, Kenya. *African Arts* 33(3): 70–77, 96.

Caplan, Pat. 1997. *African Voices, African Lives: Personal Narratives from a Swahili Village*. London and New York: Routledge.

Cooper, Frederick. 2000. Colonial History. In J. Hoorweg, D. Foeken and R. A. Obudho, eds. *Kenya Coast Handbook: Culture, Resources and Development in the East African Littoral*. Leiden: African Studies Center.

Eastman, Carol M. 1971. Who are the Waswahili? *Africa* 41: 228–236.

Eastman, Carol M. 1994. Swahili Ethnicity: A Myth Becomes Reality in Kenya. In D. Parkin, ed. *Continuity and Autonomy in Swahili Communities: Inland Influences and Strategies of Self-Determination*. London: School of Oriental and African Studies.

Fair, Laura. 2001. *Pastimes and Politics: Culture, Community, and Identity in Post-Abolition Urban Zanzibar*. Athens: Ohio University Press.

Ghaidan, Usam. 1975. *Lamu: A Study of the Swahili Town*. Nairobi: East African Literature Bureau.

Hoorweg, Jan. 2000. The Experience with Land Settlement. In J. Hoorweg, D. Foeken and R. A. Obudho, eds. *Kenya Coast Handbook: Culture, Resources and Development in the East African Littoral*. Leiden: African Studies Center.

International Labor Organization. 1972. *Employment, Incomes and Equality: A Strategy for Increasing Productive Employment in Kenya*. Geneva: ILO.

Jules-Rosette, Bennetta. 1984. *The Messages of Tourist Art: An African Semiotic System in Comparative Perspective*. New York: Plenum Press.

Kasfir, Sidney Littlefield. 1987. Apprentices and Entrepreneurs: The Workshop and Style Uniformity in Subsaharan Africa. In C. D. Roy, ed. *Iowa Studies in African Art: The Stanley Conferences at the University of Iowa*. Iowa City: University of Iowa.

Kasfir, Sidney Littlefield. 1992. African Art and Authenticity. *African Arts* 25(2): 40–56.

Kasfir, Sidney Littlefield. 1999a. African Art and Authenticity: A Text with a Shadow. In O. Oguibe and O. Enwezor, eds. *Reading the Contemporary: African Art from Theory to the Marketplace*. London: Institute of International Visual Arts.

Kasfir, Sidney Littlefield. 1999b. *Contemporary African Art*. London: Thames and Hudson.

King, Kenneth. 1996. *Jua Kali Kenya: Change and Development in an Informal Economy 1970–95, Eastern African Studies*. London: James Currey.

Kopytoff, Igor. 1986. The Cultural Biography of Things: Commoditization as Process. In A. Appadurai, ed. *The Social Life of Things: Commodities in Cultural Perspective*. Cambridge: Cambridge University Press.

Kusimba, Chaparukha M. 1999. *The Rise and Fall of Swahili States*. Walnut Creek, CA: AltaMira Press.

Le Guennec-Coppens, Françoise and Caplan, Pat (eds.). 1991. *Les Swahili entre Afrique et Arabie*. Paris: Crédu-Karthala.

Levy, Karen. 2004. Personal communication.

Levy, Karen R. 2008. *Ethnicity Matters: Ethnic Identity and Economic Inequality in Lamu Town*. London: Development Planning Unit, University College London.

Livengood, R. Mark. 1999. Streetwise: The Mafundi of Dar es Salaam. In T. C. Correll and P. A. Polk, eds. *The Cast-Off Recast: Recycling and the Creative Transformation of Mass-Produced Objects*. Los Angeles: UCLA Fowler Museum of Cultural History.

Macharia, Kinuthia. 1997. *Social and Political Dynamics of the Informal Sector in African Cities: Nairobi and Harare*. Lanham, MD: University Press of America.

El-Mafaazy, Majid Said. 2008. Personal interview, February 25.

Maundu, John N. 1997. Toward Meeting Local Training Requirements of Jua Kali Artisans in Kenya: Some Lessons of Experience. Paper read at Association for the Development of Education in Africa (through Florida State University), at Harare, Zimbabwe.

Mazrui, Alamin M. and Shariff, Ibrahim Noor. 1993. *The Swahili: Idiom and Identity of an African People*. Trenton, NJ: Africa World Press.

Middleton, John. 1992. *The World of the Swahili: An African Mercantile Civilization*. New Haven, CT and London: Yale University Press.

Middleton, John. 2000. The Peoples. In J. Hoorweg, D. Foeken and R. A. Obudho, eds. *Kenya Coast Handbook: Culture, Resources and Development in the East African Littoral*. Leiden: African Studies Center.

Mutua, Kimanthi, Aleke-Dondo, C. and Oketch, Henry Oloo. 1993. *Jua Kali Literature: An Annotated Bibliography*. Nairobi: Kenya Rural Enterprise Program.

Ojiambo, Aloys. 2006. Deputy Director, Department of Micro and Small Enterprise Development. Personal interview, November.

Oluoch, Fred. 2002. Lamu Wins Accolade from Unesco. *Daily Nation*, August 25.

Republic of Kenya. 1992. *Sessional Paper No. 2 of 1992 on Small Enterprise and Jua Kali Development in Kenya*. Nairobi: Government Printer.

Republic of Kenya. 1997. *Lamu District Development Plan 1997–2001*. Nairobi: Government Printer.

Republic of Kenya. 2002. *Lamu District Development Plan 2002–2008*. Nairobi: Government Printer.

Republic of Kenya. 2005. *Sessional Paper No. 2 of 2005 on Development of Micro and Small Enterprises for Wealth and Employment Creation for Poverty Reduction*. Nairobi: Government Printer.

Roberts, Allen. 1989. Some Ironies of African Innovation: The Arts of Recycling and Recuperation. Paper read at "Redefining the 'Artisan': Traditional Technicians in Changing Societies," at The Center for International and Comparative Studies with the University of Iowa Libraries.

Roberts, Allen. 1992. Chance Encounters, Ironic Collage. *African Arts* XXV(2): 54–66.

Spear, Thomas. 2000. Early Swahili History Reconsidered. *International Journal of African Historical Studies* 33(2): 257–290.

Spradley, James P. 1979. *The Ethnographic Interview*. New York: Holt, Rinehart and Winston.

Steiner, Christopher B. 1994. *African Art in Transit*. Cambridge: Cambridge University Press.

Stewart, Susan. 1993. *On Longing: Narratives of the Miniature, the Gigantic, the Souvenir, the Collection*. Durham, NC: Duke University Press.

UNESCO. 2001. Twenty-fifth Session of the World Heritage Committee: Convention Concerning the Protection of the World Cultural and Natural Heritage. Helsinki, Finland: United Nations Educational, Scientific and Cultural Organization.

Disavowing Craft at the Bauhaus: Hiding the Hand to Suggest Machine Manufacture

George H. Marcus

George H. Marcus is Adjunct Assistant Professor of the History of Art at the University of Pennsylvania. He is coauthor of a major survey of the field of design, *Landmarks of Twentieth-Century Design* (1993), and his other publications include *Masters of Modern Design* (2005), *Le Corbusier: Inside the Machine for Living* (2001), and *Functionalist Design: An Ongoing History* (1995). For over thirty years he was the director of publications and graphic design at the Philadelphia Museum of Art.

Abstract

When in 1923 Walter Gropius called for a redirection of the Bauhaus curriculum toward industry, he dismissed the school's nineteenth-century aesthetic of hand craftsmanship and promoted a new, twentieth-century aesthetic of the machine, introducing the elements of what would later be recognized as a "Bauhaus style." To advance the conceit that the Bauhaus workshops were being directed toward industrial production, Gropius supported stratagems to make the school's products appear to have been made by machine, regardless of how they were actually manufactured. This article looks at ways in which evidence of the hand was minimized in order to make Bauhaus metalwork seem as if it were factory made. This is demonstrated by comparing examples by Wilhelm Wagenfeld and Marianne Brandt from the metal workshop, and by studying the way metal objects were selectively chosen for reproduction in early Bauhaus publications, including some that were misleadingly pictured or even retouched to emphasize machinelike qualities.

Keywords: Bauhaus, Marianne Brandt, Wilhelm Wagenfeld, craft aesthetic, machine aesthetic, Walter Gropius, metalwork

When the Bauhaus design school was founded in Weimar, Germany, in 1919, craft was at the core of its curriculum, a fact that is often downplayed by those who herald the institution's interactions with industry. Following William Morris's ideal of the joys of individual workmanship, the Bauhaus harked back to the utopian ideology of a unified craft community based on a medieval model. Walter Gropius's founding manifesto for the school announced this straight out: "Architects, sculptors, painters, we all must return to the crafts! For art is not a 'profession.' There is no essential difference between the artist and the craftsman. The artist is an exalted craftsman. In rare moments of inspiration, transcending the consciousness of his will, the grace of heaven may cause his work to blossom into art. But proficiency in a craft is essential to every artist. Therein lies the prime source of creative imagination. Let us then create a new guild of craftsmen without the class distinctions that raise an arrogant barrier between craftsman and artist!" (Gropius 1919: 31). This was the ideological basis of the early years of the Bauhaus experiment, as the fledgling school built up its faculty, its workshops, and its curriculum under Gropius's direction, following a guild-like organization. It embraced self-expression and individuality, and honored the mark of the maker's hand, all under the sway of the experiential philosophy of the Swiss painter Johannes Itten, creator of the famed Preliminary Course. This course was the school's great legacy to design education, introducing students to the basic elements of design as it gave them the tools with which to explore form, materials, and their own creativity.[1]

That Gropius, who owed so much to his time in the office of the architect Peter Behrens, a leading advocate of a machine-age style, and whose own architectural works (notably, his Fagus factory of 1911–13) had explored the radical vocabulary of industrial modernism, should place such emphasis on craft is a complex story, admirably told by Marcel Franciscono in his study *Walter Gropius and the Creation of the Bauhaus in Weimar*: "There can no longer be any doubt, despite his repeated assertions to the contrary," Franciscono concludes, "that at the start Gropius intended the handicrafts to be ends in themselves, whatever else he may have had in mind with respect to designing for industry. The inclusion in the Bauhaus program of such traditional craft occupations as metal chasing, enameling, and stucco and mosaic working is in itself sufficient proof. Contemporary accounts, moreover, amply testify to the strong crafts orientation of the early Bauhaus" (Franciscono 1971: 16–17).

But by 1923, only four years after the Bauhaus had been founded, crafts were disavowed. No longer were they thought of as ends in themselves. Gropius had reconsidered the future direction of the school, and craft was not to be an essential component of it. As he wrote in his essay "Theory and Organization of the Bauhaus," published that year in the catalogue of the first comprehensive Bauhaus exhibition, the "Bauhaus does not pretend to be a crafts school. The teaching of craft," he explained, "is meant to prepare for designing for mass production," and the school's workshops were to be seen as laboratories devoted to the making of models for industry (Gropius 1938: 27). Veering away from the belief in the centrality of craft that he had declared

in his founding manifesto, Gropius adopted a new philosophy based on industrial cooperation, which was expressed succinctly in the motto: Art and technology, a new unity! He entrusted the carrying out of much of this new vision of design to László Moholy-Nagy, the Hungarian Constructivist artist who in 1923 came to the Bauhaus to replace Itten as teacher of the Preliminary Course and also as Form Master of the metal workshop (where he worked alongside Christian Dell, who had become its Technical Master in 1922).

In calling for a redirection of the curriculum toward industry, Gropius dismissed the nineteenth-century craft-based aesthetic of irregular, handmade construction of natural materials with which the Bauhaus had achieved its first flowering. In its place he promoted a new, twentieth-century aesthetic, that of the machine, with its geometric forms, shiny surfaces, industrial materials, and especially, its precision. These became the elements of what would later be recognized as a "Bauhaus style" (Droste 1993: 78–9), although with his emphasis on function as the determinant of form, Gropius could not accept style as a significant part of the design equation (Schwartz 1996: 213). Craft, however, was not dismissed, and would not be challenged until after the school had moved in 1925 to Dessau, where the situation was more conducive to collaboration with industry. But in order to advance the conceit that the Bauhaus workshops were being directed toward industrial production, as he outlined in his essay, Gropius supported stratagems to make the school's products appear to have been made by machine, regardless of how they were actually manufactured. This article looks at ways in which, during the transitional period of 1923–4, evidence of the hand was minimized in order to make Bauhaus metalwork seem as if it were factory made. The deliberate masking of the traditional signs of handcraft can be demonstrated by comparing critical examples from the school's metal workshop and by studying the way metal objects were selectively chosen for reproduction in early Bauhaus publications, including some that were misleadingly pictured to emphasize machinelike qualities.

With Moholy-Nagy at the helm, the metal workshop was a prime site for introducing such changes to the school's products, especially since metal was one of the materials most closely associated with the machine aesthetic. "When Gropius appointed me to take over the metal workshop," Moholy-Nagy recollected in his essay in the catalogue of the 1938 Bauhaus exhibition at the Museum of Modern Art, "he asked me to reorganize it as a workshop for industrial design. Until my arrival the metal workshop had been a gold and silver workshop where wine jugs, samovars, elaborate jewelry, coffee services, etc., were made. Changing the policy of this workshop involved a revolution, for in their pride the gold- and silversmiths avoided the use of ferrous metals, nickel and chromium plating and abhorred the idea of making models for electrical household appliances or lighting fixtures. It took quite a while to get under way the kind of work which later made the Bauhaus a leader in designing for … industry" (Moholy-Nagy 1938: 136). If one looks at the array of objects produced in the workshop during 1923 and 1924, it is apparent that the revolution did not come easily and, as

Moholy-Nagy said, it took "quite a while" to bring the Bauhaus metal workshop to the point at which the students would direct their work to industrial production. But while the types of products that were made in the workshop changed only gradually during the first years of Moholy-Nagy's direction, there was a rapid change in the aesthetic they projected, from one that emphasized the individual expression of the craftsperson to one that reflected the concept of the impersonal modern machine that had developed in European design over the past decades.

The transition of the Bauhaus from the craft aesthetic to the machine aesthetic is clearly reflected in the early works of Wilhelm Wagenfeld (1900–90) and Marianne Brandt (1893–1983), two students who entered the metal workshop after the 1923 exhibition and after Gropius had announced his new direction for the school. Wagenfeld was already a master silversmith accomplished in the techniques of the hand craftsman when he arrived at the Bauhaus late in 1923, having been apprenticed to a silverware manufacturer and studying the design of metalwork at the academy in Hanau. His early works at the Bauhaus, such as his copper mocha machine of 1923–4 (Figure 1), demonstrate his skill in the basic technique of raising vessels from metal with a hammer, which he had learned during his apprenticeship. The decorative all-over pattern of hammer marks clearly distinguishes the large hemisphere of the mocha pot as a work crafted by hand. Soon, however, Wagenfeld was altering his approach, as can be seen by comparing two sauceboats from 1924 made in new silver

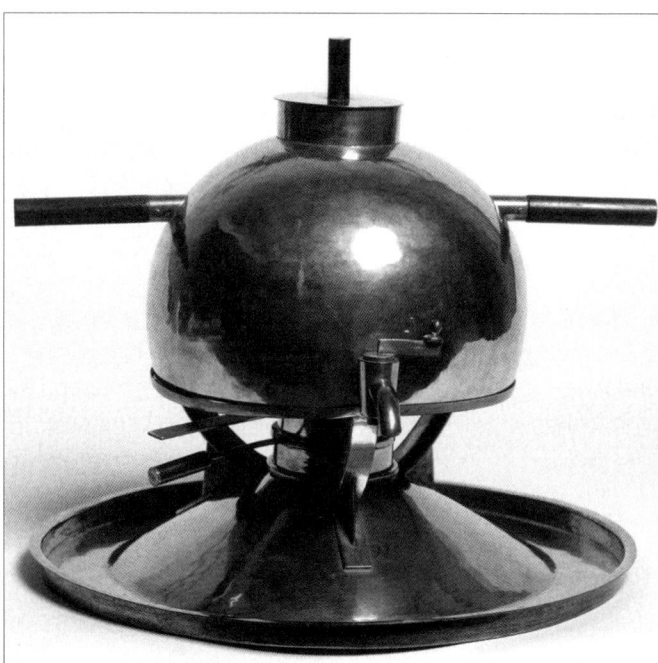

Fig 1 Wilhelm Wagenfeld. Mocha Machine, 1923–24. Copper and ebony. Height 10¼ in. (26 cm). Germanisches Nationalmuseum, Nuremberg. © 2008 Artists' Rights Society (ARS), New York/VG Bild-Kunst, Bonn.

(or nickel silver, an alloy of copper, zinc, and silver), both having the same unusual form with two different spouts for separating fat from lean (which had originated with Christian Dell). The first (Figure 2), like the mocha machine, was raised by hammering and proudly displays a multitude of pebbly

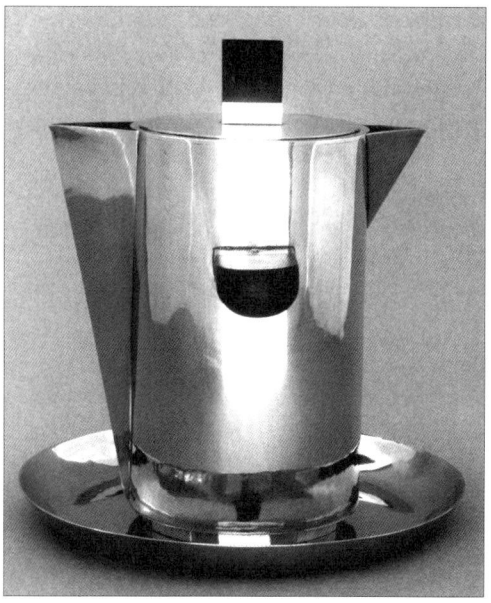

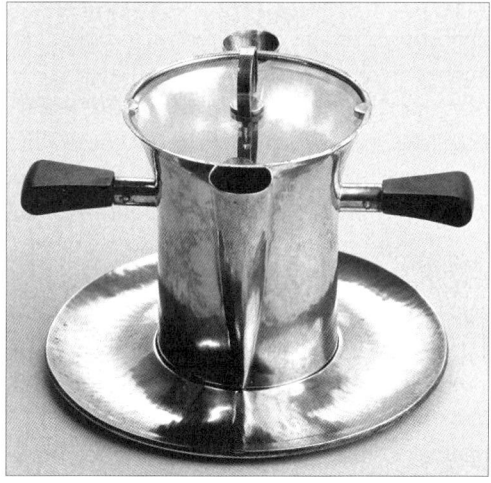

Fig 2 Wilhelm Wagenfeld. Sauceboat and Saucer, 1924. New silver, ebony, and glass. Height 5 in. (12.5 cm). Germanisches Nationalmuseum, Nuremberg. © 2008 Artists' Rights Society (ARS), New York/VG Bild-Kunst, Bonn

marks on its body and its stand. The second, while close to the first in overall conception, is entirely different (Figure 3). It has a smooth, shiny surface and a fluid, uninflected form, looking to all regards as if it were a mechanical production although it is still every bit as much the product of hand craftsmanship. Under the sway of Moholy-Nagy's new policy, Wagenfeld translated the irregular, flaring body of the beaten sauceboat into a flawless geometric form, in this case by adopting a different technique

Fig 3 Wilhelm Wagenfeld. Sauceboat and Saucer, 1924. New silver and ebony. Height 6½ in. (16 cm). Bauhaus-Archiv/Museum für Gestaltung, Berlin. © 2008 Artists' Rights Society (ARS), New York/VG Bild-Kunst, Bonn.

for his piece. Rather than raising the vessel with a hammer, he assembled it from a sheet of metal, which he soldered lengthwise into cylindrical form, as Siegfried Gronert has shown (Gronert 2000: 16), and gave it a mirror-smooth finish that hides any indication of its hand manufacture and alludes symbolically to the precision of machine manufacture.

A similar change in aesthetic—if not in technique—under the influence of Moholy-Nagy can be seen in the metalwork of Marianne Brandt. Older than most of the other Bauhaus students and already a painter with considerable experience, she joined the Bauhaus at the beginning of 1924, having been won over by the 1923 exhibition.

Brandt completed the mandatory half-year Preliminary Course, and on Moholy-Nagy's advice, entered the metal workshop in the summer of 1924. This was more than a year after Moholy-Nagy had taken over as Form Master of the workshop, but according to Brandt's recollections, "they had just begun to produce objects capable of being mass-produced though still fully handicrafted. The task was to shape these things in such a way that even if they were to be produced in numbers, making the work lighter, they would satisfy all aesthetic and practical criteria." First, though, she had to learn the techniques of metalsmithing from the ground up. She later marveled at the intensity and repetition of the "dull, dreary work. How many little hemispheres did I most patiently hammer out of brittle new silver" (students would not be entrusted with precious metals as they were learning their craft). But, "I was not allowed a long period of instruction in handicrafts," she added. "Very soon I was told to help design, produce, get busy" (Brandt 1970: 97–99). As she became adept at metalwork, and following the injunction to design and produce, she created a variety of tableware forms for the Bauhaus, most famously the series of geometric tea and coffee vessels that were to become prime examples of the school's machine-style design. Crafted in both silver and base metals, they included full coffee and tea services on trays as well as small individual teapots, or infusers, used for making a strong brew that would then be diluted with hot water. Their designs were all influenced by the Constructivism of her teacher Moholy-Nagy, as their opposing circular, semicircular, and rectangular shapes were borrowed from the geometric vocabulary of that movement.

Along with many of the other singular pieces designed at the Bauhaus, Brandt's tea and coffee vessels have been customarily discussed as symbols or ideas rather than as actual objects, as Klaus Weber has noted in his essay deconstructing the iconic reputation of Brandt's tea infusers (Weber 2001). Thus they have come to be regarded as types, all with the same attributes, all projecting a uniform statement of geometric formalism and an image of machine modernism. But if one studies the seven tea infusers that are now known, it becomes clear that these diminutive objects were not all crafted to the same perfectionist specifications and are, in fact, not exactly alike, but vary somewhat in their details and their finishes. The tea infuser in the British Museum (Figure 4), for example, rather than sharing the uninflected surfaces of the others in the group, still reveals the signs of Brandt's hand as she most patiently hammered out the hemispherical body from silver. The hemisphere ripples with the slight irregularities of hammer marks that bespeak her tedious methods of hand production. The signs of the planishing hammer are clear but subtle, as she diligently minimized, but did not totally eliminate, their impact on the otherwise machinelike image of the piece.

Like the rest of the series, a second tea infuser, which was sold in New York in 2007 and is made of silver plate (Figure 5), is much more suggestive of industrial production. No ripple, no irregularity, no flaw (save for the slightest scratches and signs of use) mars its form and finish. The vertical, semicircular handle of ebony is the only discordant and non-machinelike element, its riveted attachment to the body with an irregular band an awkward transition for an object that wants to speak of seamless construction.

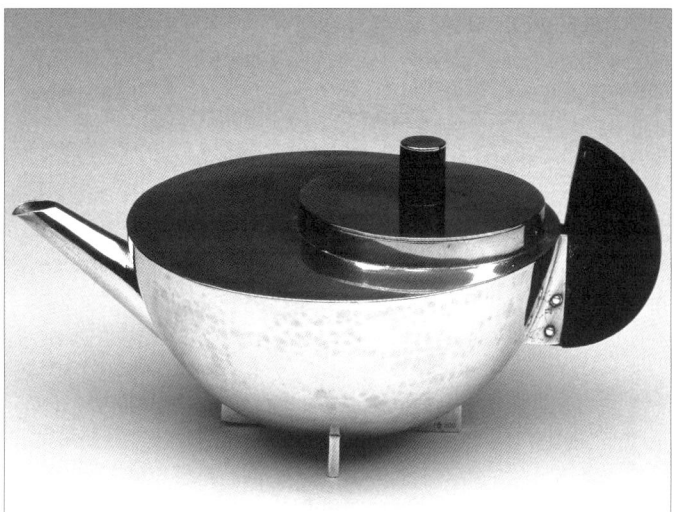

Fig 4 Marianne Brandt. Tea Infuser, 1924. Silver and ebony. Height 2⅞ in. (7.3 cm). The British Museum, London. © 2008 Artists' Rights Society (ARS), New York/VG Bild-Kunst, Bonn.

When one looks at the vessel, when one cups its small bowl in one's hand, feeling its smooth, round surface and the crisp edge where the bowl meets the top, one could easily imagine that it had been manufactured with precision machinery from a flat sheet of metal. That is what the journalist F. K. Fuchs mistakenly thought when he wrote about one of Brandt's tea infusers in the *Deutsche-Goldschmiede-Zeitung* in 1926, telling his readers that a machine "presses out the half-sphere in a single process" (Whitford 1993: 222). But its tea-stained interior tells quite another story. Removing the small, offset circular lid and looking inside reveals a bowl that clearly was not made by machine; it is entirely blanketed in hammer marks, as if the British Museum vessel were turned

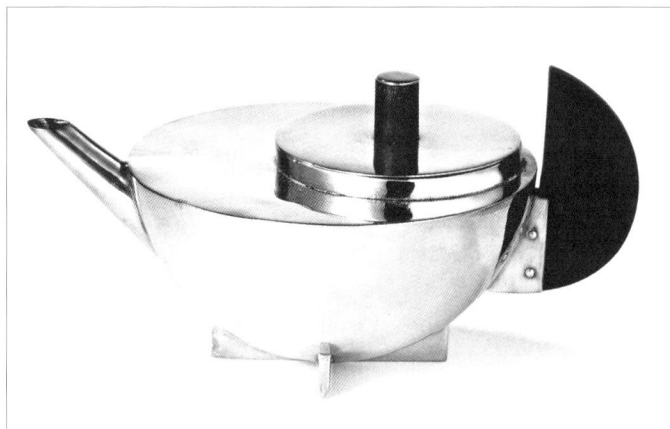

Fig 5 Marianne Brandt. Tea Infuser, 1924. Silver-plated brass and ebony. Height 3 in. (7.6 cm). Courtesy Sotheby's, New York. © 2008 Artists' Rights Society (ARS), New York/VG Bild-Kunst, Bonn.

inside out. Only here the marks are more pronounced, since no attempt was made to smooth its surface and hide the story of its fabrication (Figure 6). The irregularity of the perforated tea strainer that fits neatly into the infuser also reveals its hand manufacture, but again, being set inside the vessel, it was not an element that would detract from the new machine aesthetic of the Bauhaus.

Fig 6 Marianne Brandt. Interior of Tea Infuser, 1924. Silver-plated brass and ebony. Courtesy Sotheby's, New York. © 2008 Artists' Rights Society (ARS), New York/VG Bild-Kunst, Bonn.

Aside from the novelty of their modern, Constructivist forms, Brandt's tea infusers are quite ordinary pieces of metalwork. They were made with the most basic handcraft techniques that any metalsmith over the centuries would have learned during an apprenticeship. The bowl of the infuser would have been beaten first from within to create its general shape, and then from without, to regulate the surface and achieve the profile and precision of form that was desired. Smoothing the surface with files,

emery, and polish would follow, and any desired degree of refinement could readily be attained, from a rough, hand-hammered look to a machinelike finish. Had Brandt wanted to give an unblemished surface to the British Museum's tea infuser, she could easily have done it, but this was probably a transitional work and her close adherence to the machine look was not yet set. By the time these infusers began to be produced in series in the metal workshop, the new style would have been more clearly defined, and the other infusers, including this late example, acquired from the Bauhaus in 1927, were made to reflect it more closely.

Favoring the look of the machine over the reality of handcrafted construction was continued when the school's administration authorized the serial production of Wagenfeld's first lighting device, a sleek metal table lamp of 1924 (Figure 7), but to little success. Made by hand in the Bauhaus metal workshop in considerable quantities, but looking as if they were industrially produced, these lamps were exhibited in 1924 at the trade fair in Leipzig, one of the first commercial ventures for the school. The report that Wagenfeld wrote on his return from the fair described the Bauhaus stand and the students' frustrations with their experiences there: "Some 30 lamps were placed in two rows between two illuminated lamps ... We had expected that this arrangement of the manual products of our workshop would implicitly indicate machine work processes but we had completely disregarded the inevitable collisions with the prices we had fixed ... My notes showed that we could immediately expect sales of between 1,500 and 2,000 items on the electrical market, if cheaper

Fig 7 Page from *Neue Arbeiten der Bauhauswerkstätten*, 1925, showing Wilhelm Wagenfeld's table lamp from 1924. University of Pennsylvania, Fisher Fine Arts Library, Rare Books Collection.

production methods could reduce the price" (Manske 2000: 28). Being told of a potential market that they did not have the means to satisfy must have been very disconcerting to Gropius and Moholy-Nagy, who had not yet concluded the types of contracts with the metal and lighting industry that would come in the following years and make industrial production possible for a number of the school's designs.

By emphasizing the machine style, however, Gropius could make it seem as if industrial production had been achieved. He favored that look in the school's workshop production as well as in his selection of objects for illustration in Bauhaus publications, where he found it expedient in some cases to use exaggerated images, or even altered ones, to give the impression that more of the school's products participated in that ideal. When pieces from the metal workshop were illustrated in *Neue Arbeiten der Bauhaus Werkstätten*, a survey of new work from the school compiled in 1924 (but not published until 1925), Josef Albers, Marianne Brandt, Karl Jucker, and Wilhelm Wagenfeld had already designed their notable machine-style pieces, and many were reproduced in the book. But in order to include Wagenfeld's early mocha machine as part of his new vision, Gropius chose a photograph with arbitrary, exaggerated highlights that virtually hid its heavily mottled surface (Figure 8). He had already used extreme lighting in reproductions in the 1923 exhibition catalogue, *Staatliches Bauhaus, Weimar, 1919–1923*, where objects from the pottery workshop were photographed with such shiny surfaces that they almost appear to have been made of metal (Figure 10). And he went a step further in *Neue Arbeiten*, where an even more deceptive image of Wagenfeld's early sauceboat was chosen: the entire object has seemingly been altered by airbrushing (Figure 9) and nothing at all can be seen of its heavily mottled surface (Figure 2).[2]

In emphasizing the machine look in Bauhaus products and in illustrations of them, Gropius was not in fact hiding the handmade, he was simply hiding its signifiers—tool marks, irregularity of form, rough finish—that had been introduced in the middle of the nineteenth century by John Ruskin and adopted as elements of the craft aesthetic

Fig 8 Page from *Neue Arbeiten der Bauhauswerkstätten*, 1925, showing Wilhelm Wagenfeld's mocha machine from 1923–24. University of Pennsylvania, Fisher Fine Arts Library, Rare Books Collection.

Fig 9 Page from *Neue Arbeiten der Bauhauswerkstätten*, 1925, showing Wilhelm Wagenfeld's sauceboat and saucer from 1924. University of Pennsylvania, Fisher Fine Arts Library, Rare Books Collection.

Fig 10 Page from *Staatliches Bauhaus, Weimar, 1919–1923*, 1923, showing Otto Lindig's coffee service from 1923. University of Pennsylvania, Fisher Fine Arts Library, Rare Books Collection.

by William Morris and his followers in the Arts and Crafts movement. Objects crafted by hand can have many forms and finishes and many different aesthetics, as is demonstrated by the work of Brandt and Wagenfeld themselves. Gropius simply chose the look that suited his new plans for the Bauhaus. Revealing a craft sensibility at this moment would have subverted the school's new image of technology as it took its first steps toward establishing the elements of a machine style, even though creating that style depended entirely on the skills of the hand itself. In suppressing the signs of the hand by favoring the machine aesthetic, he did not recognize the irony of his endeavor, which Lewis Mumford described in his book *Technics and Civilization:* "No matter what the occasion," he wrote, "the criterion of successful mechanical form is that it should look *as if* no human hand had touched it. In that effort, in that boast, in that achievement the human hand shows itself, perhaps, in its most cunning manifestation" (Mumford 1934: 358–59).

Notes

1 I am grateful to the silversmith Christopher Trollen for sharing his knowledge of metalwork techniques with me.

2 This is not the only example of Gropius using photographic deception to give objects a modernist appearance. In discussing the experimental House am Horn, Reyner Banham describes "a photograph of the dressing-table by [Marcel] Breuer in which reflections in its circular and oval mirrors have clearly been deliberately contrived to resemble the overlaps and transparencies of one of Moholy-Nagy's [Constructivist] paintings" (Banham 1980: 285).

References

Banham, Reyner. 1980. *Theory and Design in the First Machine Age.* 2nd edn. Cambridge, MA: The MIT Press.

Brandt, Marianne. 1970. Letter to the Younger Generation. In Eckhard Neumann, ed. *Bauhaus and Bauhaus People*, pp. 97–99. New York: Van Nostrand Reinhold Company.

Droste, Magdalena. 1993. *Bauhaus, 1919–1933.* Cologne: B. Taschen Verlag.

Franciscono, Marcel. 1971. *Walter Gropius and the Creation of the Bauhaus in Weimar: The Ideals and Artistic Theories of Its Founding Years.* Urbana, IL: University of Illinois Press.

Gronert, Siegfried. 2000. From Material to Model: Wagenfeld and the Metal Workshops at the Bauhaus and at the Bauhochschule in Weimar. In Beate Manske, ed. *Wilhelm Wagenfeld (1900–1990)*, pp. 12–23. Ostfildern-Ruit: Hatje Cantz Publishers.

Gropius, Walter. 1919. *Program of the Staatliche Bauhaus in Weimar.* Reprinted in Hans M. Wingler, 1969. *The Bauhaus: Weimar Dessau Berlin Chicago*, p. 31. Cambridge, MA: The MIT Press.

Gropius, Walter. 1938. The Theory and Organization of the Bauhaus. In Herbert Bayer, Walter Gropius and Ise Gropius, eds. *Bauhaus: 1919–1928*, pp. 22–31. New York: The Museum of Modern Art.

Manske, Beate. 2000. A Design Makes History: Wilhelm Wagenfeld's Bauhaus Lamp. In B. Manske, ed. *Wilhelm Wagenfeld (1900–1990)*, pp. 24–37. Ostfildern-Ruit: Hatje Cantz Publishers.

Moholy-Nagy, László. 1938. Metal Workshop: From Wine Jugs to Lighting Fixtures. In Herbert Bayer, Walter Gropius and Ise Gropius, eds. *Bauhaus: 1919–1928*, pp. 136–38. New York: The Museum of Modern Art.

Mumford, Lewis. 1934. *Technics and Civilization.* New York: Harcourt, Brace and Co.

Schwartz, Frederic J. 1996. *The Werkbund: Design Theory and Mass Culture before the First World War.* New Haven, CT: Yale University Press.

Weber, Klaus. 2001. Functionalism? Formalism?: Questioning Marianne Brandt's Tea-Infuser. In *Modern Art of Metalwork*, pp. 32–35. Berlin: Bröhan-Museum.

Whitford, Frank. 1993. *The Bauhaus: Masters and Students by Themselves*. Woodstock, NY: The Overlook Press.

Russel Wright and Japan: Bridging Japonisme and Good Design through Craft

Yuko Kikuchi

Yuko Kikuchi is a historian of craft and design, and Reader at TrAIN (Research Centre for Transnational Art, Identity, and Nation), University of the Arts London. Her works include *Japanese Modernisation and Mingei Theory: Cultural Nationalism and "Oriental Orientalism"* (RoutledgeCurzon, 2004) and *Ruskin in Japan 1890–1940: Nature for Art, Art for Life*, coauthored with Toshio Watanabe (Cogito, 1997). Recently, she has also edited *Refracted Modernity: Visual Culture and Identity in Colonial Taiwan* (University of Hawai'i Press, 2007).

Abstract

Russel Wright was an American designer who promoted the "American Modern" design and the "Good Design" movement from the 1930s through the 1950s. While he is familiar in the Western design context, his postwar involvement in Asia through the American foreign aid program promoting the idea of "Asian Modern" is little known. Wright and his associates gave the Japanese government advice on the promotion of handcraft, and informed the selection and modification of handcrafts for export to the United States. His advice pushed forward the official launch of the "Japanese Good Handcrafts Promotion Scheme," and subsequent implementation of design policy and system. This process also contributed to the development of the "Japanese Modern" style for craft-based design. In the context of the United States, Wright's Asian project can be seen not only as an extended experiment of the Good Design movement, but also a reflection of Japonisme, which formed an integral part of the modern American cultural identity. This article investigates the nature and extent of Wright's intervention in Japan with a particular focus on the way that the crafts

facilitated cross-fertilization between ideas of nationality and the Good Design movements both in the United States and Japan.

Keywords: Russel Wright, Japan, craft, the Good Design movement, Japonisme, Cold War.

Introduction

Russel Wright (1904–76) was arguably the most influential American designer for modern American homes in the 1930s–1940s—a lifestyle guru, perhaps that period's equivalent of Martha Stewart. Helped by his wife's talent for business management, he promoted the "American Way" lifestyle through a series of designs that were meant as a rediscovery and celebration of American tradition. While he is familiar in the American design context, his role in promoting the idea of Asian Modern in the postwar period is little known. This article investigates the nature of Wright's project in Japan, with a particular focus on the role that crafts played in facilitating cross-cultural relations between national design identity and the Good Design movements both in the United States and Japan. First, it discusses the economic and cultural context of USA–Japan relations in the 1930s–1950s, and Wright's interventions concerning modern Japanese craft design in the Japanese context; second, it looks at the significance of Wright's design in the context of modern American design as well as its relevance to American Japonisme. Subsequently, it argues that these parallel but seemingly separate design developments in Japan and the USA are inextricably related, each nurturing both the national and international agenda of modern craft.

Japanese Crafts and Culture in the USA before Russel Wright's Visit: 1930–1950s

Before examining Russel Wright's intervention in Japan in detail, some explanation of the economic and cultural background of craft within USA–Japan relations is useful. Japan's primary relationship with the USA in the 1930s was as a major trade partner on an unequal basis. From 1930 until 1937, when Japan's war with China began, the Japanese export of crafts to the USA increased consistently (Naigai Kōgei Sangyō Jōhō 1935b: 29; MITI 1949; Kawashima 1941). In 1934 Japan had the fifth largest total of exports in the world; their exports to North America represented 15 percent of this total, ranking third after Europe (41 percent) and Asia (22 percent). These were predominantly light industry products and approximately 60 percent appear to have consisted of crafts, with ceramics the dominant material. In the 1930s, the quantity of ceramic products that Japan exported was the highest in the world, with exports to the USA forming the largest portion (30 percent) (Tesaki no Kiyōna Nihonjin no Tokugi ... 1934). Japan was accused of dumping and various regulations including import taxes were imposed on Japanese products in the USA to protect American manufacturers. The boycott of cheap ceramic tableware in Pittsburgh (Naigai Kōgei Sangyō Jōhō 1936a: 36) and New Jersey (Waga Tōjiki Haiseki Undō ... 1936) suggests the degree to which American manufacturers were threatened; in ceramic tableware Japanese imports

accounted for as much as 30 percent of the American market.

Japan's interest in exporting crafts already had a long history by the 1930s. Promoting export of crafts had been on the national agenda since the Meiji period in the nineteenth century, and annual export craft exhibitions to promote design and production for export were organized domestically by the government from 1913 until well into the Second World War in 1942[1]. In cooperation with the Ministry of Trade and Industry, Kōgei Shidōsho (Industrial Arts Research Institute [IARI]/Industrial Arts Institute [IAI]), established in 1928, and the Japan Export Craft Association, founded in 1933, played a major role in facilitating this national agenda. IARI led the development of new design and the restyling of regional crafts, as well as the marketing and promotion of crafts for export. They also invited foreign designers such as Bruno Taut and Charlotte Perriand to give advice on the improvement and restyling of craft products (Kikuchi 2004, 82–122). This consultative advice from Western designers became a customary practice, which continued in the postwar period when a large number of foreign designers were invited to visit Japan, including Russel Wright.

In the cultural field, there were various efforts made by the Japanese government to promote and propagate the image of Japan through crafts trading and exhibitions. Japan continued to attend international exhibitions, including those in Chicago (1934), New York (1939), and San Francisco (1939). These international exhibitions certainly created some interest in Japanese crafts; it was reported for example that Aizu lacquerware sold well at the Chicago exhibition (Naigai Kōgei Sangyō Jōhō 1935a: 30). In addition to participation in international exhibitions, Kokusai Bunka Shinkōkai (The Society for International Cultural Relations) and its New York offshoot, the Japan Institute, sponsored a number of English-language publications and cultural venues including exhibitions and performances, while the Japanese Chambers of Commerce and the Japan Export Crafts Association opened showrooms in New York, San Francisco, and Chicago to exhibit and sell craft products including bamboo and lacquerware, and porcelain dinnerware. The Japanese crafts sales exhibition held in 1936 at the New York showroom was the first of its kind in the USA. A morning set in the "Japanese taste" (*Nihon Shumi*) was the most popular item (Naigai Kōgei Sangyō Jōhō 1934: 26; Naigai Kōgei Sangyō Jōhō 1936b: 35). Following the success of the first Japanese crafts sales exhibition, two further shows were held in 1937 and 1938 at the Drake Hotel in Chicago. Even during the Second World War, propaganda magazines such as *Nippon*, which was published in four languages and disseminated worldwide, featured Japanese traditional arts and crafts using modern photography and graphic design (Weisenfeld 2000).

However, though there was a small body of intellectuals and connoisseurs who had a taste for things Japanese, in general the public image of Japan in the USA was not favorable. Within the USA, Japanese immigrants suffered severe racism and discrimination. The Asiatic Exclusion League mounted a campaign in 1905 to exclude Japanese and Koreans from the USA, and as part of the Immigration Act of 1924 immigration from Japan was cut off until 1952. Historian John Dower

has documented Americans' racist image of Japan in the prewar period as well as during the Second World War. Japan was generally regarded as "a little country with a shallow cultural heritage," albeit with some artistic traits (Dower 1986: 97–8), and the associated stereotypical images of Japanese were "subhuman" and often linked to apes and vermin. They were seen in extreme terms, either as marked by "primitivism, childishness and collective mental and emotional deficiency" or as "[supermen], possessed of uncanny discipline and fighting skills," a "formidable foe who deserved no mercy and virtually demanded extermination" (Dower 1986: 9).

After the war, however, the American image of Japan was diametrically transformed in a very short time. Japan became a "good loser" with whom the USA could work cooperatively for peace. Americans successfully imposed paternalistic views in order to overwrite prewar racial rhetoric. To the victors, "the simian became a pet, the child a pupil, the madman a patient." Racializing patterns of thought were refocused toward the new enemies of the Cold War era: the Soviet and Chinese communists and their allies (Dower 1986: 14). The Occupation period (1945–52) was a crucial time for cementing USA–Japan cultural and economic relations and for the development of the craft industry. Japan was totally dependent on the American economic recovery policy and food supplies; the USA encouraged Japan to develop exports in return. Crafts were among the main types of these *mikaeri busshi* (collateral products). They were regarded as an ideal peaceful industry and an effective way to project the new image of Japanese culture (Kōgei Nyūsu 1946: 24–25; Kunii 1946). Crafts, especially ceramics, were viewed with high expectations because their export market had already been established in the West during the prewar period. The General Headquarters (GHQ) of the Supreme Commander for the Allied Powers led by Douglas MacArthur also took the initiative by creating building and design projects for Japanese companies and designers. They built 16,000 houses for US personnel and dependent families stationed in Japan and commissioned the Japanese designers of IARI to design all the furniture and household and kitchen utensils used in these houses (Akioka 1990; Koizumi 1999). During this process, Japanese designers and policy makers learned about American lifestyle, design, and taste under the GHQ designers, which became important in the development of design for the export craft industry in the 1950s[2]. The GHQ's taste favored Scandinavian design, Japanese wood materials, and folkcrafts, rather than the cold European modernist style (Akioka 1990; Toyoguchi 1946). As design historian Kashiwagi Hiroshi has noted, it was in fact this American "Japanese taste" that served as the prototype of Japanese Modern (Kashiwagi 1979: 31–4). GHQ-approved crafts marked "Made in Occupied Japan," including decorative dolls and dinnerware, were exported to the USA beginning in 1947[3] (Yushutsu Tōki no Dai Ichijin 1947).

Japan's economy was boosted by the Korean War, for which Japan provided the USA with most of its supplies. Meanwhile, the Japanese government and associated quangos organized trade exhibitions in North America—twenty-five during the 1950s, including the Japan Trade Exhibition

at Seattle (1951, 1955), the Canadian International Trade Fair at Toronto (1951, 1952, 1953), the Washington State Fourth International Trade Fair (1955), and the first United States World Trade Fair in New York (1957). In the cultural field, the New York MoMA built in its courtyard a Japanese house and garden designed by Yoshimura Junzō, which was presented by the America–Japan Society of Tokyo (1954). These events were followed by performances of Azuma Kabuki Dancers (1954), Gagaku performers (dancers and musicians of the Japanese Imperial Household, 1959) and the Grand Kabuki (1960) in New York. The Walker Art Center organized the exhibition "Japan: Design Today," which ranged from traditional and modern crafts to television and train design (1960).

In the 1950s Americans had a voracious appetite for culture from non-communist countries. They were encouraged by the Cold War cultural "containment" policies under the slogan "getting to know you" (Klein 2003). Regional design development directed by American intervention was therefore not limited to Japan. Italy and Scandinavia went through similar experiences. In Italy, traditional crafts were transformed after the war by American investment under the Marshall Plan to produce modern exports for American consumption (Sparke 1998). Similarly, the designs of the Nordic countries including Sweden, Denmark, Finland, and Norway were promoted collectively as "Scandinavian design" through influential exhibitions including "Design in Scandinavia" (1954–57) and "Scandinavian Design in Use" (1954). Both America and the Nordic countries propagated the utopian myth of "Homo Scandinavians" (Davies 2003; Selkurt 2003). Edgar Kaufmann Jr. simultaneously curated the "Good Design" exhibitions (1950–55) at home and "American Design for Home and Decorative Use" for travel in Scandinavia (1953–55) (McDonald 2006). The examples of Italian and Scandinavian Modern became benchmarks for the Japanese designers to develop their own national design approach.[4]

The Context of the International Cooperation Administration (ICA) Project

Russel Wright's intervention in Asia came at the time of these close political and cultural relations with non-communist countries, which had been shaped by American Cold War policy. As part of a foreign aid program totaling US$3.3 billion, the US government allocated US$600,000 to the International Cooperation Administration (ICA), a State Department unit, to study and provide aid for native handcrafts in developing countries—a project that started in June 1955. The program was comparable to the Marshall Plan in Europe in that it would propagate the American idea of modernism as the "formal cultural expression of a nation that confidently assumed the moral and material leadership of the non-communist 'free world'" (Meikle 2005: 175). On the other hand, the project was also motivated by a desire to offer humanitarian and economic aid through modernization using indigenous materials, rather than creating "an unhappy, piecemeal imitation" of the American way of living. One ideal image was "a sewage system with bamboo pipes, and sinks of native basketry coated with native resin" (Wright, Not Published: 3).

Russel Wright's Proposals for Japan

The ICA commissioned Russel Wright and two other American designers to travel to Asia for two and a half months from December 1955 to February 1956. They visited Japan for a week in December prior to their tour in order to survey the situation there (Russel Wright Associates 1956; Gold Mine in Southeast Asia 1956). Their research trip had the objective of helping Asian countries improve and expand the production of handcrafts for their own domestic use and for export sale, in order to increase their foreign exchange earnings (ICA 1956). After the trip, an exhibition of 1,500 quality handcrafts—mostly small items from Cambodia, Taiwan, Hong Kong, Thailand and Vietnam—was exhibited at the

Fig 1 "The Designer as Economic Diplomat"—Russel Wright disembarking on the banks of the Mekong, Vietnam, from *Industrial Design* 3–4, 1956, 68.

Coliseum, New York on June 25–29, 1956, in an attempt to attract American traders and retailers.

During his first visit, Wright found many Japanese traditional products that were not known to the American market, which he thought could be promoted (Nihon Seisansei Honbu 1957: 40–42). Wright submitted a paper entitled "The Promotion of Japanese Good Handcrafts" to the Japanese government sometime between 1955 and 1957.[5] In summary, his proposal suggested the following actions:

1 The Japanese should persuade leading American department stores to register and give indications of order quantities of Japanese handcrafts.
2 These stores should send American experts in fashion, interior design, and merchandising to Japan to investigate and select Japanese products and organize sales exhibitions in each store.
3 American stylists should be sent to Japan to suggest improvements to the design of Japanese products.
4 Museums in the vicinity of these stores should be encouraged to organize complementary exhibitions on Japanese traditional and modern crafts to coincide with the sales.
5 This series of events should be effectively publicized, in order to impress trend-leading American families with a view toward changing the public's mindset with respect to Japanese products (Kankoku Repōto o Setsumei … 1958; Shukōgeihin Yushutsu Saku … 1958).

This proposal was further discussed during Wright's second and third visits to Japan in December 1957 and January 1958. On these occasions he passionately stressed the excellence of Japanese handcrafts, and the importance of promoting them for both economic and cultural reasons (Kankoku Repōto o Setsumei … 1958; Shukōgeihin Yushutsu Saku … 1958). Japanese officials agreed for the most part, but declined to involve American stylists, and rejected the idea of exhibitions at museums and the making of promotional films. They made it clear that their intention was to emphasize the "excavation" (*hakkutsu*) rather than the "restyling" of marketable Japanese handcrafts by designers and merchandisers. Apart from these disagreements, the Japanese officials more or less agreed to implement the program (Shukōgeihin Yushutsu Saku … 1958).

Japan Project

Visiting Designers and Merchandisers

Following Wright's proposal, the Ministry of Foreign Affairs, Ministry of Industry and Commerce, the Small and Medium Enterprise Agency, Industrial Arts Institute (IAI), Japan External Trade Organization (JETRO) and the Japan Productivity Center (JPC, a liaising sub-office of ICA), jointly organized a committee for the "Promotion of Japanese Handcrafts Export to the USA" in 1957. The large-scale official project— popularly known as *Marute* (the Chinese character of "hand" circled) and later called *Maruyū* (the Chinese character of "good" circled), an abbreviation of "Japanese Good

Handcrafts Promotion Scheme"—was launched by the committee, and continued to promote Good Design for export until around 1975.

The first step in the implementation of Wright's proposal was taken by the Small and Medium Enterprise Agency, IAI, and JPC, with particular focus on the "excavating" of Japanese handcrafts which might have potential for American export. Many designers were invited to participate in this task. For example, two employees of Russel Wright Associates, the designers Walter Sobotka and Alfred Girardy, were invited by the JPC to travel around Japan during 1957–58. Freda Diamond and Paul Otto Matte were invited by the Small and Medium Enterprise Agency in 1957 and 1958 respectively. ICA, through JPC, planned a budget of US$36,000 for up to four American designers to visit Japan in 1958, which was supplemented by a budget of 11,500,000 Yen (US$32,000) from the Japanese government in 1959, enabling them to invite up to four American merchandisers. Subsequently, in 1960, five designers and three merchandisers from the USA visited to travel around Japan in three groups.[6]

Each American designer left a report or recommendation paper after their visit (Nihon Shukōgeihin 1961: 9–50). They expressed different ideas about what Americans wanted and how Japanese products could be improved and restyled, while also offering strategies on how Japanese products might be marketed in the USA. Among the reports, those by Walter Sobotka on wood, bamboo, and lacquer products, and Alfred Girardy on electric products, deserve close examination because they were the designers sent on behalf of Russel Wright Associates, and their views seem to have been shared by Wright. Their reports were also the most systematically written. Sobotka praised the "impressive refinement of many objects made by apparently simple people in the pursuit of their rich tradition" and the "unadulterated Japanese character" of handcrafts from rural areas of Japan (Sobotka 1957: 26, 5). He advised on restyling for the American market without losing these distinctive Japanese characteristics—in particular, naturalness and simplicity in shape and decoration—while giving advice on technical improvement. He detected problems such as inadequate finish on bamboo and lacquer products, the splitting which occurs over time in bamboo, as well as the use of poor-quality adhesive. He suggested that collaborative research would solve these technical problems. He also recommended the use of professional designers, and stressed the importance of efficiency and rationalization of the workplace. Girardy also observed a high potential in terms of the manufacture of goods, but identified a lack of management and designers themselves as a problem. He strongly reiterated Wright's point that designers should play a major part in production management as well as merchandising.

"Excavation" and Exhibitions in the USA

These designers selected Japanese products that they believed to be suitable for the American market according to the following four categories:

A: Products that could be exported without redesign.

B: Products that could be exported with minor redesign (i.e. design, size, finish).
C: Products that would need major redesign.
D: Products that would need to be newly designed using selected materials and techniques (Nihon Shukōgeihin 1961: 9–50; Satō 1961: 16).

A total of 1,788 items, most of which were selected for category A, were exhibited in the USA. The first exhibition was held in February 1961 at the Japan Trade Center in New York and in March of the same year at the Japan Trade Center in San Francisco. The most represented object types among the exhibits were ceramics, dolls, wood and lacquer products, and bamboo products, in that order. It is reported that they received favorable reaction from American buyers and retailers and 24 percent of the exhibits in San Francisco generated enquiries about price, with further sales negotiations that continued for a while after the exhibitions (Kurusu 1962). According to JETRO's survey, the wood and bamboo products

Fig 2 (a) Akita Magewappa, hors d'oeuvre set, 1961. (b) Bamboo laundry basket, 1962. (c) Wooden salad servers designed by IAI, 1962. (d) Ceramic garden lamp designed by IAI, 1962. (a) and (d) from "Shōwa 36 nendo Nihon Shukōgyōhin Taibei Yushutsu Suishin Keikaku Hōkokusho" (1961 Report on the Program for the Promotion of Japanese Handcrafts Export to the USA), 1962; (b) and (c) from "Amerika Shijō Shinshutsu o mezasu Nihon Shukōgeihin" (Japanese Handcrafts Aiming to Enter the American Market), *Kōgei Nyūsu* (IAI News), 1962.

generated the highest interest, followed by glass and ceramics. The products inducing the least interest were metalwares, while popular items included bamboo napkin rings, an Akita *Magewappa* hors d'oeuvre set, lacquerware *teoke* for an ice bucket, and a *mingei*-style ceramic vase. The survey attests to the American taste for simple forms, natural materials, large scale, and subdued colors—which was contrary to the Japanese popular image of American taste for bright primary colors. They also received criticism about high prices and functionality with some discussion of how they might be adapted, or how the public might be educated about unfamiliar functions, presentation, design, color, and packaging (Nihon Shukōgeihin 1961; Kurusu 1961). A second exhibition was held in March of 1962, once again at the Japan Trade Center in New York and at the Japan Trade Center in San Francisco. The second exhibition focused on exhibits of objects that were redesigned by Japanese designers and manufacturers for the show (the report's categories B and C). The most popular items included household bamboo and woodenware for practical use, heavy sculptural pottery for functional use, and ball-shaped ornaments.

Russel Wright's Own Design Projects

While Wright was promoting the implementation of design policy and system with Japanese officials, he was also involved in designing his products using Japanese cottage industry sources (Elegant n.d.). Wright wrote a letter to Paul Schmid of Schmid International, Boston[7] about the purpose of his trip to Japan from March to June in 1964,

Fig 3 Japan Trade Center exhibition, New York, 1962, from *Kōgei Nyūsu* (IAI News), 1962.

when he was to be accompanied by his daughter Eve Ann Wright:

> For the purpose of examining production facilities available there and the designing of the products in conformance with these facilities, I will supervise the making of the samples and you will persuade producers to cooperate in making. I will furnish the producers with drawings, models, etc., adequate for the factories to produce my designs. I will check production samples, making changes when necessary to bring the cost of products toward your price targets. (Wright 1963)

An advertisement leaflet entitled "Elegant Informal Dining Service of Japanese Good Products Styled by Russel Wright" states Wright's intention of restyling Japanese handmade crafts for the American market in "the contemporary modern style" … and having "an overall oriental character." The service, for example, includes tablecloths and napkins of woven Japanese ramie, "covered ramekins dinner plates and coffee

Fig 4 Russel Wright in Japan in the pleasure boat on Nagara River, 10 May 1964. Ōkubo Hiroshi Collection.

cups of Japanese earthenware of the type of body and glazes used for Japanese tea service made at Sato [sic][8] and Hokkaido," salad bowls and a serving set of Japanese woodenware, dessert plates, bowls and after-dinner coffee cups in Japanese porcelain, serving pieces for all types of foods, basketry for toast baskets, bread servers, tray holders, handles; and handmade glassware making use of the overlay and other techniques being developed in Japan (Elegant n.d.). More detailed design ideas for "formal dinnerware" were also stated in a letter addressed to Mizutani Takashi, a representative of Schmidt International Japan in Nagoya,[9] which includes a porcelain dinner plate with "The Rice Pattern"; glassware consisting of footed tumblers, one plate and three or four bowls with colors that are gradated "from white to transparency." Particularly interesting is Wright's fascination with lacquerware consisting of "a plate, an after-dinner cup and saucer, a service plate, a small bowl, a platter, a tray, and some larger serving bowls with covers" for which he wanted to experiment with inlaid metal, Japanese leaves, and Japanese grass paper and rice paper over a metallic background (Wright 1964a).

To realize this project of Japanese folkcraft design, Wright stayed mostly in Nagoya for three months, and was guided by Mizutani Takashi.[10] Mizutani recalls that he took Wright to many manufacturing companies, including Yamato China, Shinkō Shikki[11] and a woodenware company in Shizuoka. There are few examples left in Japan, but a Wright-designed white porcelain dinnerware set still exists in the old showroom of Yamato China. According to Ōkubo Hiroshi, a former employee of Yamato who at that time assisted Wright by making models according to design drawings he had supplied, the dinner plate has multiple curves on the rim to fit the thumb in order to serve the plate properly as required by Western tradition, but also has a deep curve in the middle of the plate, which was inspired by Japanese bowls. As both Mizutani

Fig 5 Yamato China porcelain dinnerware set, coffee pot set, and dinner plates (Katō Keiichi and Yamato China Company, Ltd.).

and Ōkubo remember, however, his designs were too difficult to make because there were too many organic curves; he failed to attract any manufacturer to take his design into mass production due to the high cost of the molds. Ōkubo also pointed out that his organically curvy design was a little outdated in Japan, where straight, geometric forms in Western-style ware were coming into fashion. The "Theme Formal" glassware, examples of which are in the collection of the Cooper-Hewitt Museum in New York, are also Wright's design manufactured in Japan. While the museum records the line as produced by Yamato in 1965, the company has confirmed that they have never made glassware. Further investigation on where this was manufactured is therefore required.

Japan's Implementation of Design Infrastructure and the Development of the Japanese Modern

Designers and merchandisers who came as part of the Russel Wright project denounced the existing cheap and ugly Japanese export products, which were mostly copies of American and European goods. Examples include colorful birds and animal ornaments, religious figures, dolls, teacups, and some oriental stereotype objects, as can be found in the 1962 catalog of ENESCO, one of

Fig 6 Theme Formal glassware designed by Russel Wright, 1965. Cooper-Hewitt National Design Museum Collection.

Fig 7 Shoddy Japanese products: (a) Hemmel dolls; (b) piggy bank. *Source:* Enesco Imports, Inc. *1962 Catalog 106*, 1962, 8; *1971 Giftware Catalog*, Chicago, 1971, 64.

the major importers based in Chicago with a branch office in Nagoya. The American team were disgusted by these shoddy products, which also raised the issue of design plagiarism that America and European countries had already identified as a concern in the late 1930s. The Japanese government was faced with the challenge of needing to implement regulations for controlling piracy while changing the image that had been created by the shoddy Japanese export items that had flooded the Western markets.

The influence of Wright's project is most visible in the creation of organizations to implement design policy and system. The Japanese government undertook a series of measures to create design infrastructure. In order to combat plagiarism, the Design Promotion Council was established within the Patent Office in 1956. The Council was charged with promoting original, high-quality design and disseminating the concept of design copyright. In 1957 the Japanese government established the "Good Design Product Selection System," by which selected products which met the criteria of modern form and functionality, originality of design, suitability for quantity production, adoption of scientific technology, and affordability were given the "G-mark" (Nihon Sangyō (ed.) 1996). A design department that would oversee and regulate export was created

in the Ministry of Trade and Industry in 1958 and JETRO expanded its activities to support the government. The establishment of professional bodies of designers and new exhibitions of modern crafts and export design also contributed to this systematization of the design world.[12]

Development of Kurafuto and the Japanese Modern

The new design infrastructure also boosted the development of "kurafuto," which became the central element in the Japanese version of Good Design. The craft-based products called kurafuto design, as distinct from industrial product design, saw rapid development, which peaked in the 1960s–1970s. The term "kurafuto" emerged in the late 1950s, and the fact that it is written in *katakana* (which is used to transcribe foreign words) indicates that the concept is borrowed from foreign sources, in particular modern Scandinavian and Italian crafts. According to the Craft Center Japan, "'Kurafuto' is a modern genre of 'craft,' primarily handmade with carefully selected materials which have close connection with daily life" (Craft Center Japan website). Kurafuto products are mainly household objects, which were greatly inspired by traditional Japanese handcrafts, but were designed for the modern lifestyle and produced in quantity, partially or mostly handmade in factories or workshops.

Kurafuto and a series of new furniture designs became vehicles for propagating the idea of Japanese Modern, a national postwar design discourse that corresponded with the international Good Design movement, just as American Modern boasted both national and international significance. The leading figure of this Japanese Modern design was Kenmochi Isamu. He worked for the government-led IAI as a designer of chairs, and also assisted Bruno Taut in the 1930s as well as Isamu Noguchi in the 1950s when they were invited to IAI. He was exposed to Western modernists' attitudes toward distinctively Japanese products, in particular handcrafts, during his formative period. Japanese Modern could be considered an internalization of this gaze (Kenmochi 1954: 2–7). He was also sent to the USA in 1952 and studied the American idea of Good Design as well as the presence of Italian and Scandinavian design in the American market, returning the following year to lead the government-sponsored Japanese Modern project at IAI (Kenmochi 2007; Niimi 2005). Another designer who promoted Japanese Modern is Yanagi Sōri, the eldest son of Yanagi Sōetsu, the leader of the *mingei* movement. Both Kenmochi's Rattan Chair and Yanagi's Butterfly Stool were selected as Good Design products of 1966, and their Japanese Modern design successfully united the modern national style and the international idea of Good Design.

American Way Program and Products

It is clear that Russel Wright's project accelerated and intensified the postwar development of Japanese modern national design to accord with the global ideal of Good Design. However, how does this relate to Wright's project in the USA prior to his intervention in Japan? What was the significance for his own design development? To address these issues, it is necessary to look at his experience in developing American national design through the

Fig 8 Kenmochi Isamu, cane lounge chairs and table, 1960. Collection of Museum of Modern Art, Tokyo; photo Utsunomiya Museum of Art.

"American Way" program of the prewar era and the Good Design movement of the 1950s.

Russel and his wife Mary's American Way program had been launched at Macy's department store in New York in 1940, in the form of a series of sales exhibitions of new home furnishings by leading American designers who had been inspired by traditional crafts. The core research of the project was the American Way Regional Handcraft Program, which involved research on the American craft tradition in seven regions. The *American Way Sales Manual* stated:

> The desire for American crafts is springing up as the result of growing interest and curiosity concerning our own country. At last, we are beginning to appreciate and evaluate our own outstanding native craft skills, in the realization that they are a living commentary on American modes of life—from Indian times through the period of our Pilgrim fathers and earliest known Spanish settlers, right up to present day existence. (Wright n.d. *American Way*: C1)

As an outcome of this research a "veritable travelogue of crafts" was submitted, and this became a sort of master catalog that offered information about indigenous materials, forms, color etc. Designers could extract the essence of American design from this authentic record of American tradition. Thus, the aim of the American Way program was twofold: first, to raise awareness of a rich American tradition of crafts through the marketplace; and second, to sell American Modern products inspired by these traditional crafts but tailored to suit the modern lifestyle. Wright stated that the purpose of the program was "to develop successful home furnishings merchandise of modern design by American designers, to stimulate the public interest in the names of these designers and the public's pride in merchandise made and designed by Americans in a manner that will fit our needs today" so as to ultimately realize "a good American way of living in the home" (Wright 1941). This American Way was defined in opposition to the formal European lifestyle, the eighteenth-century style "kept by Emily Post." It was to be an easygoing, casual

lifestyle centered on "practical" things such as dishwasher-safe tableware, to suit modern housewives (*Time* 1946).[13]

The American Way project was propagated mainly through furniture and dinnerware. In 1935 Wright designed maple furniture called Modern Living, manufactured by Conant Ball Company for Macy's; this line later came to be called American Modern. The bleached "blond" maple furniture was described in the media as possessing "the charm of simplicity" (Modern Maple Furniture … 1935) and "a blending—but a happy one—of modern and early American designs" (Hughes 1935). In the same year, the free-form Oceana woodenware line was produced by Klise Manufacturing Co., and was followed by his first full-scale ceramic dinnerware line: American Modern—released in 1939 and produced by the Steubenville Pottery Co. American Modern was the first mass-produced "designer" dinnerware and greatly attracted middle-class American consumers.

Fig 10 Russel Wright, American Modern dinnerware, 1937. Courtesy of Yuko Kikuchi.

As Kristina Wilson suggests, the design of this period characterizes the American version of modernism, which reveals the ambivalent mixture of traditional English and American colonial style on the basis of the ideals of International-Style modernism. It was a "livable modernism," which suited the American taste for friendly comfort and distanced itself from the cold European modernist style (Wilson 2004). Wright was a designer who mediated the crossroads of tradition and modern in the American context; his mission was to graft American tradition with modernism to create an American national visual language. He tried to create a meaningful connection with the past through the use of materials and styles as well as through marketing languages and images.

Fig 9 Russel Wright, Oceana line products, 1935. As shown on the cover of *The Bulletin of the Museum of Modern Art*, 1940, featuring the "Useful Objects Under Ten Dollars" exhibition.

From the American Way Project to the Good Design Movement

The American Way project became one impetus for the development of the American national design movement. The idea of American national design was disseminated through popular consumerism and was promoted by the design exhibition activities centered on the Museum of Modern Art (MoMA). During 1938–48, a traveling exhibition "Useful Objects under $5" (changed to "under $10" in 1940) was held to exhibit modest, anonymously designed industrial products: plastic bowls and plates, a plastic brush and comb set, fiberglass curtains, a pocket knife, glasses from Woolworth's, a travel iron, as well as the wooden serving plates from Wright's Oceana line. In 1950, the "Good Design" exhibition was organized by Edgar Kaufmann Jr. in cooperation with the Merchandise Mart in Chicago. In his booklet *Introductions to Modern Design*, Kaufmann asked "What is Good Design?" in American terms. He argued that it had to demonstrate "integrity, clarity, harmony," the "oneness of form and function," and the modern human values of everyday cleanliness, comfort, durability, easy care, scientific and rational production methods, and democratic value (Kaufmann 1950: 9). This idea of Good Design was clearly consistent with Wright's American Way program, which had also merged the national with the universal ideal. It is not difficult to see the parallel between this American project and the Japanese one; what Wright had done in the USA suggests the origins of his method for Japanese craft reform.

Asia's Role in Shaping the American Way

There is another side to this story, however: the American Way, which promoted a progressive idea of American informal living, also involved an idea of Asian crafts as modern. Wright wrote passionately about Asian traditional crafts, their unique materials, techniques, and craftsmanship, which impressed and appealed to him given their potential for marketing in the USA (Wright 1956). For Wright, bamboo, woven grass, and lacquer were challenging but excitingly new materials for design, and it is evident that he fully intended to develop these materials collected for him from Asia. Bamboo was particularly important for Wright, and could be said to symbolize the essence of the ICA's foreign aid program. Wright's essay "Bamboo Bridge" describes his dream of building infrastructure such as the bamboo pipe sewage system noted earlier, by using local materials and introducing modern convenience, sanitation, and rational living in Asian developing countries (Wright n.d. A Bamboo).

Wright also designed bamboo drink-serving carts for use outdoors at suppers and barbecues. The main structure of these carts was made of circular bamboo; their trays were lacquered in a brilliant Chinese red with a liquid-proof finish, and they were equipped with rubber tires to absorb bumps. The bells of the Jingle Cart, strung to the handles, sound with the motion of the cart to announce approaching refreshment (Wright n.d. Accessories; Wright n.d. Carts). These carts moved between indoors and outdoors; the bamboo is lightweight,

Fig 11 Russel Wright (a) Jingle Cart, n.d. and (b) Rolly Cart, n.d. Both from Special Collections Research Center, Syracuse University Library.

inexpensive, and natural as well as being of an exotic non-European tradition—all of these characteristics invoke a sense of novelty while expressing the "modern." The combination of Asian and high-tech American materials can also be found in Wright's aluminum Informal Modern series: an aluminum lamp with bamboo; an aluminum vase, and a flower arrangement tube. The merging of indoor and outdoor space, similarly, was a consistent interest of Wright's. He achieved the effect of "closeness to nature" by placing plants indoors and using natural materials, which can be seen in a series of articles featuring "Japanese style" in *House & Garden*.

Wright's use of orientalist ideas also had a romantic, playful, and often stereotypical aspect. Wright seemed to enjoy the boyish fantasy of exotic adventure that is associated with the world of "Arabian Nights" (Wright 1958). One of the most surprising examples of this kind is a series of lamps called Opium Lamps, which he designed in 1959. These were appropriated from a Hong Kong original, but in Wright's design would light up a coffee table and also function as "a romantic cigarette lighter" (Carter 1956). Each lamp was made of metal and brass, with a glass "chimney." Decorative embellishments included designs of a birdcage, a lotus, or openwork of a Chinese character.

Wright also presented a model room with an oriental theme in 1959. Again, the interior space opened and joined with the outdoor garden space, and both are full of exotic oriental accessories including Japanese lanterns, a *hibachi* (Japanese charcoal brazier) planted with marigolds, a large stone Buddha head, an Opium Lamp, a tiger skin and

Fig 12 Russel Wright, Aladdin Opium Lamps, 1959. One of the designs was inspired by a musical birdcage that Russel Wright saw in Japan. Special Collections Research Center, Syracuse University Library.

oriental silk, and various oriental dishes in a buffet style (Wright 1959).

American Japonisme

Russel and Mary Wright wrote in their best-selling 1950 book, *Guide to Easier Living*:

> The Japanese living room is a model of planning: a bare room, into which you bring, from closets in the walls, the seats for people to sit on, the books for them to read, the paintings for them to enjoy. Though we are never likely to live like the Japanese, actually the idea makes sense for a room that must serve so many uses: uncluttered space, a few comfortable and easily moved seats, and the rest stored away in the walls to be brought out as needed. (Wright, M. and R. 2003: 12)

When this book was published, the "Japanese style" was booming in America. For example, Joseph Guillozet, who first came to Japan as part of the Russel Wright project in

1960, was invited back again for the specific purpose of finding marketable products and giving advice on the improvement of design to target the "Japanese taste boom" in America. According to Guillozet, this phenomenon began during the postwar American Occupation period, but as visitors to Japan increased in the postwar period, it developed into a interest in genuine Japanese things which satisfied a yearning for "primitive, wild, and natural beauty and uniformity" as a reaction against the conformity brought about by matured capitalism. Guillozet also observed that new American apartments and office space had low ceilings, which created a similar space to Japanese houses (Kuramochi 1962: 3–4).

During the 1950s and 1960s, American interior magazines such as *House & Garden* were full of articles featuring Japan. The topics include the idea of Japanese *fusuma* and *shōji* screens and the forty-four creative ways to interpret them in American homes (Forty-four Wonderful New Ways … 1956); the freedom to mix and match dinnerware as the Japanese do (Piece by Piece 1957); Japanese-style houses and decorations, and how Japanese philosophy can be translated for American homes (Why the Japanese Look is Here to Stay 1957); twenty-one "fresh" and "charming" ideas for using bamboo (Count on Bamboo 1958); and adaptations of Japanese folk toys and crafts for American homes (Japan's Fanciful Folk

Fig 13 Pages from "Why the Japanese Look is Here to Stay." *House & Garden* (US edition) June 1957.

Toys 1959; Going Places, Finding Things in Japan 1959; From Japan's Great Folk Crafts ... 1959).

Of course, this 1950s vogue for Japan was not a new development but a revival. As the architectural historian Clay Lancaster has observed, Japan was a "determining factor" in modern American architecture, in which International Style, American vernacular and Japanese elements often merged—as for example in the work of Frank Lloyd Wright and Richard Neutra (Lancaster 1963; Nute 1993).[14] Russel Wright's American–Oriental designs and American Way can be interpreted as a new chapter in the story of American Japonisme. This is also exemplified in his own home in Manitoga in New York, which combined Japanese elements of interior space with a Japanese-style garden including a moss garden and a dramatic waterfall. The latter was created jointly with a Japanese gardener, Masami Maeda, hired from Tokyo for one year.[15] The house epitomizes the integration of American Japonisme with Russel Wright's American Way.

Conclusion

Russel Wright's work in Japan was part of a politically oriented foreign aid program which aggressively expanded the American sphere of economic and cultural influence in Asia. For Wright, this official program was an opportunity to test the formula of his American Way program in new and challenging territory. The accommodation of Asian materials within this project can be seen as a reflection of twentieth-century American Japonisme, and also indicates Americans' desire to dissociate themselves from European culture. Japan's situation was somewhat similar in its pursuit of "Japaneseness." Unlike other Asian countries, Japan had already advanced the modernization of traditional handcrafts into design products for export. In Japan, crafts have long been the centre of politico-cultural concerns, and a national agenda existed for establishing a national craft industry (Kikuchi 2004). Unlike Wright's similar design projects in Taiwan and Vietnam, his product design in Japan did not successfully lead to mass production and was only restricted to samples. However, as Wright and his colleagues had recommended, Japan took the opportunity to implement an American-style design infrastructure with policy set at an official level. Individual manufacturing companies established design departments and product design systems as well as an appropriate management style.

American Way and Japanese Modern were comparable in the way that they intersected with ideas of Good Design. Both were national movements trying to establish their own distinct cultural identity. Both were rooted in handcrafts and developed modern design from regional examples as the ultimate source for national tradition. These parallels in the prewar period cross-fed and enriched trends in postwar design, via American Japonisme and the Japanese adoption of a pragmatic American product design system. Russel Wright played a pivotal role in bridging these two design cultures. His intervention in Japan epitomizes the national and transnational dynamics of modern craft.

Acknowledgements

I am grateful to the Japan Foundation Endowment Committee and the Daiwa Anglo-Japanese Foundation for funding my

research in Japan and the USA. I would also like to express my thanks to the following people and organizations who provided information: Tazawa Yatarō, Mizutani Takashi, Ueda Tetsuya, Ōkubo Hiroshi and Katō Keiichi of Yamato China Co., Asai Reijirō of Shōwa Seitō Co., Itō Kōichi of Shigaraki Ceramic Technology Research Center, Koh Mitsuko of the Museum of Modern Ceramic Art, Gifu, Satō Kazunobu of the Aichi Prefectural Ceramic Museum, Miura Hiroko of the Shigaraki Ceramic Cultural Park, Tanaka Yoshinobu at Japan Industrial Design Promotion Organization (JIDPO), Kida Takuya of MOMA Tokyo, Kikuchi Suehiko of Kōgei Zaidan, Robin Schuldenfrei, and Russel Wright Archive at the Special Collections Research Center, Syracuse University Library, and Audrey Malachowsky of the Cooper-Hewitt Museum.

Notes

1 Nō Shōmushō Bijutsu Kōgei Tenrankai or Nōten (Ministry of Agriculture and Commerce Art Craft Exhibition) later changed to Shōkōshō Kōgei Tenrankai, 1913–1932, was succeeded by Yushutsu Kōgei Tenrankai (Export Craft Exhibition), later called Bōekikyoku Kōgeihin Yushutsu Shinkōten (Trade Bureau Craft Export Promotion Exhibition), 1933–1941. Yushutsu Kōgei Shinkōten (Export Craft Promotion Exhibition) and Yushutsu Kōgei Zuan Tenrankai (Export Craft Design Exhibition) were also organized 1939–1942.

2 Kappei Toyoguchi recalled his time under the instruction of Major Heeren S. Krusé of Design Branch at GHQ. He described the experience as marked by "tearful efforts and struggles with a hungry stomach" but also great inspiration by American designs and lifestyle (Toyoguchi 1946).

3 For GHQ's export policy and design projects, see *Kōgei Nyūsu* 14–1 2 3, 1946 and 15–2 3, 1947.

4 Italian and Scandinavian designs were introduced in Japan in the 1950s. Alvar Aalto was introduced independently in 1948 by Katsumi Masaru and Koike Shinji. See Masaru Katsumi "Gio Ponti no Sōgō Zōkei" (Gio Ponti's Total Design), *Kōgei Nyūsu* 23–5: 19–26, 1955; Shigeo Hattori "Hokuō no Modan Kurafuto (Modern Craft of Scandinavia)—Finland", *Kōgei Nyūsu* 23–4: 12–18, 1955); "Alvar Aalto," *Kōgei Nyūsu* 16–11: 5–11, 1948.

5 *The Japan Productivity News* wrote that Russel Wright submitted his report at the end of 1957 (Kankoku Repōto o Setsumei … 1958), but JETRO stated that it was submitted in 1955 when he visited Hisashi Murata, Consul-General of Japan in New York (Nihon Shukōgeihin Taibei Yushutsu Suishin Honbu/Headquarters of the Promotion of Japanese Handcrafts Export to the USA 1961: 3). It is not known which year is correct, since the actual document is not available either in Syracuse University's Russel Wright Archive nor in the organizations directly involved.

6 The five designers were Patricia Keller, Bernard McDermott, Luke Lietzke, Mort L. Rothenberg, and Robert von Neumann; the three merchandisers were Joseph Guillozet, Bernard Benjamin Zients, and Ralph Chipurnoi (Nihon Shukōgeihin Taibei Yushutsu Suishin Honbu/Headquarters of the Promotion of Japanese Handcrafts Export to the USA 1961).

7 Schmid International is a buying agent for Schmid Brothers, which imports and retails ornamental gift products, particularly "novelty" products such as Hummel dolls from Germany and their copies from Japan.

8 "Sato" perhaps refers to Seto, the center of the porcelain industry.

9 Schmid International in Nagoya was established in 1960.

10 I am grateful to Takashi Mizutani for a telephone interview on July 17, 2006 and subsequent communications by e-mail.

11 Shinkō Shikki was a lacquerware manufacturer in Nagoya. There are lists of products Russel Wright ordered from them in RWA.

12 The associations of designers such as Japan Industrial Designer Association (JIDA), Academic Society for the Science of Design, and Japan Designer Craftsman Association (JDCA) were established in 1952, 1953, and1956 respectively. Commercial exhibitions such as the Mainichi Industrial Art Design Competition began in 1955. The Craft Center Japan (CCJ) was established in 1959 and opened a permanent exhibition space in the Maruzen bookstore in 1960. Meanwhile, in 1963, the "New Craft Exhibition" at the Matsuya department store was organized by the JDCA and the "Japanese Export Design" exhibition at the Takashimaya department store was organized in conjunction with the Ministry of Trade and Industry.

13 Russel Wright and Emily Post exchanged views in the correspondence section of *Time* magazine. In one such exchange there was an interesting rebuttal by Emily Post, in which she questions Russel Wright's claim for "practicability," because his cup with a thick rim causes drooling (*Time* 1946).

14 Russel Wright was not related to Frank Lloyd Wright, but was a great admirer of the architect. An anecdote from 1964 finds him claiming that he was a cousin of Frank Lloyd Wright in order to strengthen his request to stay in the Imperial Hotel in Tokyo on his visit to Japan (Trip 1964b).

15 A Japanese gardener, Masami Maeda, was hired for one year from summer 1957 to summer 1958 for the monthly salary of US$100 (with an increase to US$120 after three months and US$140 after six months of employment, with accommodation and food provided). Russel Wright wanted to extend his contract for one more year but Maeda declined the request (Maeda 1958; Wright 1957).

References

Note: The materials collected in Russel Wright Archive in Special Collections Research Center, Syracuse University Library, Syracuse, NY are marked as "RWA" followed by the box number.

Akioka, Yoshio. 1990. Shinchūgun yō DH Kagu no Sekkei (Design for DH Furniture for the Occupation Force). In Kōgei Zaidan, ed. *Nihon no Kindai Dezain Undō Shi—1940 nendai–80 nendai* (The History of the Japanese Modern Design Movement 1940s–1980s). Tokyo: Perikansha.

Carter, Marjorie. 1956. American Designer Proposes Aid of New Kind for Southeast Asia. *Women's News Service* May 23.

Count on Bamboo. 1958. *House & Garden* June: 38–43.

Davies, Kevin M. 2003. Marketing Ploy or Democratic Ideal? On the Mythology of Scandinavian design. In Widar Halén and Kerstin Wickman, eds. *Scandinavian Design Beyond the Myth: Fifty Years of Design from the Nordic Countries*. Stockholm: Arvinius Förlag/Form Förlag.

Design: Isamu Noguchi and Isamu Kenmochi. 2007. New York: Five Ties Publishing in association with The Isamu Noguchi Foundation and Garden Museum.

Dower, John W. 1986. *War Without Mercy: Race and Power in the Pacific War*. New York: Pantheon Books.

Elegant Informal Dining Service of Japanese Good Products Styled by Russel Wright. RWA Box 39—Trip to Japan Personal File, n.d.

Forty-four Wonderful New Ways to Decorate with Screens. 1956. *House & Garden* (USA). October: 111–17.

From Japan's Great Folk Crafts: New Discoveries for Your Home. 1959. *House & Garden*. December: 118–23.

Going Places, Finding Things in Japan. 1959. *House & Garden*. December: 88–93.

Gold Mine in Southeast Asia. 1956. *Interiors* 116(1): 95–101.

Halén, Widar and Wickman, Kerstin, eds. 2003. *Scandinavian Design Beyond the Myth: Fifty Years of Design from the Nordic Countries*. Stockholm: Arvinius Förlag/Form Förlag.

Hughes, Alice. 1935. New Furniture Period. *New York American* July 13.

ICA. 1956. ICA Press Release on Asian Handcraft Show in N.Y. 25/6/56. RWA Box 43.

Japan's Fanciful Folk Toys. 1959. *House & Garden*. December: 84–7.

Kankoku Repōto o Setsumei, "Nihon Yūryō Kōgeihin no Suishin", Wright-shi Kankeisha to Kondan (Mr Wright Discusses his Proposal "The Promotion of Japanese Good Handcrafts" with Relevant Parties). 1958. *Nihon Seisansei Shinbun* (The Japan Productivity News). January 13.

Kashiwagi, Hiroshi. 1979. *Kindai Nihon no Sangyō Dezain* (Modern Japanese Industrial Design). Tokyo: Shōbunsha.

Kaufmann, Edgar, Jr. 1950. *Introductions to Modern Design*. New York: The Museum of Modern Art.

Kawashima, Shintarō. 1941. *Honpō Tsūshō Seisaku Jōyakushi Gairon* (An Outline History of Trade and Commerce Policies and Treaties). Tokyo: Ganshōdō Shoten.

Kenmochi, Isamu. 1954. Japanīzu Modan ka Japonika Sutairu ka – Yushutsu Kōgei no Futatsu no Michi (Japanese Modern or Japonica Style: Two Roads to Put Japanese Industrial Arts on Foreign Export). *Kōgei Nyūsu* (IAI News) 22(9): 2–7 (original); English translation in *Design: Isamu Noguchi and Isamu Kenmochi*. 2007. New York: Five Ties Publishing in association with The Isamu Noguchi Foundation and Garden Museum.

Kikuchi, Yuko. 2004. *Japanese Modernisation and Mingei Theory: Cultural Nationalism and "Oriental Orientalism."* London: RoutledgeCurzon.

Klein, Christina. 2003. *Cold War Orientalism: Asia in the Middlebrow Imagination, 1845–1961*. Berkeley: University of California Press.

Koizumi, Kazuko, ed. 1999. *Senryōgun Jyūtaku no Kiroku* (The Record of the Occupation Force's Dependents' Housing). Jō (vol. 1), Ge (vol. 2). Tokyo: Sumai no Toshokan Shuppankyoku.

Kōgei Nyūsu. 1946. *Kōgei Nyūsu* 14(2): 24–32.

Kunii, Kitarō. 1946. Mikaeri Busshi toshiteno Kōgeihin to sono Shinkō Hōshin (Craft as Collateral Products and Policies for its Promotion). *Bijutsu to Kōgei* (Arts and Crafts) 1(1): 13–16.

Kuramochi, Hiroshi. 1962. Amerika no Shōhin Senmonka ga mita Nihon no Tokusanhin (Japanese Native Products from the Viewpoint of American Merchandisers). *Chūshō Kigyō* (Small and Medium-Size Industry) 14(2): 2–7.

Kurusu, Yoshirō. 1961. Nihon Shuōgeihin Nyūyōku Naijikai" (The New York Exhibition of Japanese Handcrafts). *Kōgei Nyūsu* 29(5): 19–24.

Kurusu, Yoshirō. 1962. Shukōgeihin Taibei Yushutsu Suishin Keikaku no Hankyō to Seika (The Reaction and Result of the Program of Promotion of Japanese Handcrafts Export to the USA). *Chūshō Kigyō* 14(2): 18–21.

Lancaster, Clay. 1963. *The Japanese Influence in America*. New York: W. H. Rawls.

McDonald, Gay. 2006. Connecting/Reconnecting: Cultural Dialogues in Finnish and US Design. The proceedings of the papers at "Connecting" conference organized by the International Committee of Design History and Studies (ICDHS); fifth conference incorporating Nordic Forum for Design History Symposia, 1–14, 2006. ISBN 951-558-210-5.

Maeda, Masami. 1958. Letter to Russel Wright. RWA Box 47. August 26.

Meikle, Jeffrey L. 2005. *Design in the USA*. Oxford and New York: Oxford University Press.

MITI. 1949. *Tsūshō Hakusho* (Trade and Commerce White Paper). Tokyo: Asahi Shinbun.

Modern Maple Furniture: Extreme Simplicity Marks the Newest Maple Styles. 1935. *New York Herald Tribune*. August 19.

Mori, Hitoshi, ed. 2005. *Japanīzu Modan: Kenmochi Isamu to sono Sekai* (Japanese Modern: Retrospective Kenmochi Isamu). Tokyo: Kokusho Kankōkai.

Naigai Kōgei Sangyō Jōho (Domestic and Overseas News on the Craft Industry). 1934. *Kōgei Nyūsu* 3(6): 22–7.

Naigai Kōgei Sangyō Jōho (Domestic and Overseas News on the Craft Industry). 1935a. *Kōgei Nyūsu* 4(3): 30–33.

Naigai Kōgei Sangyō Jōhō (Domestic and Overseas News on the Craft Industry). 1935b. *Kōgei Nyūsu* 4(10b): 28–31.

Naigai Kōgei Sangyō Jōhō (Domestic and Overseas News on the Craft Industry). 1936a. *Kōgei Nyūsu* 5(3): 33–41.

Naigai Kōgei Sangyō Jōhō (Domestic and Overseas News on the Craft Industry). 1936b. *Kōgei Nyūsu* 5(5): 34–41.

Niimi, Ryu. 2005. A Utopia Called the Interior: An Introduction to Kenmochi Isamu. In Hitoshi Mori, ed. *Japanīzu Modan: Kenmochi Isamu to sono Sekai* (Japanese Modern: Retrospective Kenmochi Isamu). Tokyo: Kokusho Kankōkai.

Nihon Sangyō Dezain Shinkōkai (JIDPO: Japan Industrial Design Promotion Organization), ed. 1996. *Jidai o Tsukutta Guddo Dezain* (Super Collection—40 Years of the G-Mark). Tokyo: Japan Industrial Design Promotion Organization.

Nihon Seisansei Honbu (Japan Productivity Center), ed. 1957. *Kōgyō Dezain: Kōgyō Dezain Senmon Shisatsudan Hōkokusho* (Productivity Report 24: Product Design—Report of Product Design Inspection Mission). Tokyo: Nihon Seisansei Honbu.

Nihon Shukōgeihin Taibei Yushutsu Suishin Honbu (Headquarters of the Promotion of Japanese Handcrafts Export to the USA). 1961. Shōwa 35 nendo Nihon Shukōgeihin Taibei Yushutsu Suishin Keikaku Hōkokusho (1960 Report on the Program for the Promotion of Japanese Handcrafts Export to the USA). Tokyo: JETRO-Headquarters of the Promotion of Japanese Handcrafts Export to the US.

Nute, Kevin. 1993. *Frank Lloyd Wright and Japan*. London: Chapman & Hall.

Piece by Piece. 1957. *House & Garden* (USA) May 1957: 90–93.

Russel Wright Associates. 1956. *Survey and Recommendations for Advancing the Economic Welfare of Workers in Small Production Shops and Cottage Industries of Taiwan, Vietnam, Cambodia, Thailand, Hong Kong* (for International Cooperation Administration). RWA Box 40, 44.

Satō, Tarō. 1961. Nihon Shukōgyōhin no Taibei Yushutsu ni tsuite (On Export of Japanese Handcrafts). *Gekkan Chūshō Kigyō* (Small and Medium-Size Industry Monthly) 13(2): 15–19.

Selkurt, Clair. 2003. Design for a Democracy—Scandinavian design in Postwar America. In Widar Halén and Kerstin Wickman, eds. *Scandinavian Design Beyond the Myth: Fifty Years of Design from the Nordic Countries*. Stockholm: Arvinius Förlag/Form Förlag.

Shukōgeihin Yushutsu Saku, Wright-shi to Kentō, Hakkutsu ni Jūten o Oku, Sentaku ni Chomei Dezainā Hanichi (Discussions with Mr. Wright on Handcrafts Export Plan, Emphasis on "Excavation," Sending Eminent Designers for Selection). 1958. *Nihon Seisansei Shinbun* (The Japan Productivity News). January 27.

Sobotka, Walter. 1957. *Report on Japanese Export Goods in Wood, Bamboo, Lacquer* for International Cooperation Administration. RWA Box 44.

Sparke, Penny. 1998. The Straw Donkey: Tourist Kitsch or Proto-Design? Craft and Design in Italy 1945–1960. *Journal of Design History* 11(1): 59–69.

Time. 1946. RWA Box 40. August 19.

Tesaki no Kiyōna Nihonjin no Tokugi 'Tōki' Yushutsu Sūryō mo Sekai Zuiichi" (Dexterous Japanese Skills: Export Pottery Volume Becomes World No. 1). 1934. *Manshū Nippō*, November 1.

Toyoguchi, Kappei. 1946. Shinchūgun Kazoku yō Jūtaku Kagu no Sekkei ni tsuite (On Furniture Design for the Occupation Force's Dependents' Houses). 1946. *Kōgei Nyūsu* 14(2): 8–15.

Waga Tōjiki Haiseki Undō Gekika Bei Tōkō Taikai Jii Kankō (Escalation of the Boycott Movement Against Our Ceramic Products Demonstrated at the American Ceramic Manufacturers' Trade Union Assembly). 1936. *Hōchi Shinbun*, July 9.

Why the Japanese Look is Here to Stay. 1957. *House & Garden* June: 48–67.

Weisenfeld, Gennifer. 2000. Touring Japan-as-Museum: *NIPPON* and Other Japanese Imperialist Travelogue. In Gennifer Weisenfeld, ed. *Positions* 8(3): 747–93.

Wilson, Kristina. 2004. *Livable Modernism: Interior Decorating and Design during the Great Depression*. New Haven, CT and London: Yale University Press in association with Yale University Art Gallery.

Wright, Mary and Wright, Russel. 1950[2003]. *Guide to Easier Living*. Layton, UT: Gibbs Smith.

Wright, Russel. 1941. Industry Looks at Art. *Design* 42(7): 23.

Wright, Russel. 1956. The Southeast Asia Rehabilitation and Trade Development Survey (speech by RW at fashion press conference, 6/12/56). The longer version of this speech is also found in another document marked "not published" in the same box. RWA Box 43.

Wright, Russel. 1957. Letter to Masami Maeda. RWA Box 47, April 10.

Wright, Russel. 1958. Notes Concerning Far East Trip 1958. RWA Box 49.

Wright, Russel. 1959. Changeable House Photographs. RWA Box 39, October 7.

Wright, Russel. 1963. Letter to Paul Schmid, of Schmid International, Boston regarding "Food Service Group." RWA Box 48, November 6.

Wright, Russel. 1964a. Letter to Mr Mizutani of Schmid International Purchasing Corp. RWA Box 43, February 11.

Wright, Russel. 1964b. Trip to Japan Personal File. RWA Box 39.

Wright, Russel. N.d. *American-Way Sales Manual*. RWA Box 1.

Wright, Russel. N.d. Accessories File. RWA Box 1.

Wright, Russel. N.d. A Bamboo Bridge: Aid Where It is Needed Most. RWA Box 38.

Wright, Russel. N.d. Carts and Carriers Rattan File. RWA Box 23.

Wright, Russel. N.d. Not Published (no title). RWA Box 43.

Yushutsu Tōki no Dai Ichijin (The First Wave of Export Ceramics). 1947. *Kōgei Nyūsu* 15(9).

British Interventions in the Traditional Crafts of Ceylon (Sri Lanka), c.1850–1930

Robin Jones

Robin Jones is Principal Lecturer and Program Group Leader in the School of Visual Arts at Southampton Solent University. His article for *The Journal of Modern Craft* is based on his doctoral research, during which he examined the material culture of British-controlled Ceylon (Sri Lanka) from a design history perspective. This research particularly concentrated on the furniture and interiors of the island and assessed their place in the production of national and cultural identity, both local and British. Some of the results of this research have previously been published in Amin Jaffer, *Furniture from British India and Ceylon* (2001) and in the journals *Studies in the Decorative Arts* (2002), *Furniture History* (2004) and *South Asian Studies* (2004). His book, *Interiors of Empire: Objects, Space and Identity within the Indian Subcontinent, 1800–1947*, was published in 2007.

Abstract

This article examines British interventions in the traditional, hereditary crafts of Ceylon (Sri Lanka) during the colonial period. It assesses a set of Western assumptions in artistic and craft policy concerning local material culture in South Asia between 1850 and 1930. British interventions in local craft traditions are discussed in relation to Western conceptualizations of Ceylonese culture as being in a debased state (in contrast to a notional "golden age" of the distant past that was now lost). These assumptions are examined mainly through the writings of the prominent Euro-Sinhalese commentator, Ananda Coomaraswamy. This article also discusses the role of the vernacular crafts in relation to Ceylonese nationalism and the development of local cultural identity during the colonial era. The article concludes with an assessment of the legacy of local craft traditions (as well

as the historic debates that surrounded these crafts) at the present time in Sri Lanka.

Keywords: Ananda Coomaraswamy, Ceylon, vernacular crafts, crafts training, colonialism, cultural identity, South Asia.

In 1908, the "Anglo-Ceylonese geologist, art critic and philosopher," Ananda Coomaraswamy (Tarlo 1996: 10), offered a trenchant critique of the effects of Westernization on the vernacular material culture of Ceylon when he wrote:

> Of English influence on purely Sinhalese art, the less said the better. It has been characterized, from the English side, by almost complete indifference to indigenous culture, the result of an ideal of material prosperity; the destruction of indigenous crafts by the competition of cheap machine-made materials [and] the neglect of surviving architectural traditions and capacity for building. (Coomaraswamy 1956: 255)

Using the traditional crafts of Ceylon as a case study, this article describes and interprets a set of British colonial assumptions and dichotomies in artistic policy concerning local material culture in South Asia during the colonial period. Throughout the greater part of the nineteenth century, Western contemporary commentators located the East within a discourse of decline. They posited a series of binary oppositions between East and West—premodern versus modern, stagnating versus progressive, degraded versus enlightened—that served to justify British intervention in South Asia. Through this intervention, so the general argument ran, the arts, crafts, architecture, literature, in fact every aspect of the culture of the region, could be awakened from their benighted states. This article examines these Western cultural assumptions mainly through the prism of Ananda Coomaraswamy's writings on South Asian crafts, at the same time highlighting some methodological problems with this source. It will also discuss the role of vernacular crafts and design in relation to nationalism and the formation of local cultural identity in the colonial era.

The geographical focus of this article is the central, highland district of Ceylon, particularly the ancient capital of Kandy, rather than the so-called Low Country or Maritime Provinces. The latter, a coastal belt running from the southernmost part of Ceylon to the western side of the island, had experienced the most extensive and prolonged contact with the West (the Portuguese and Dutch, as well as the British).[1] Kandy and the Central Province of the island, by contrast, were characterized by Ananda Coomaraswamy and others as the repositories of traditional art and design on the island. However, this reading of local cultural traditions is open to question. Late nineteenth-century commentators, including Coomaraswamy, privileged the arts, crafts, and customs of Kandy for varying reasons including, among others, a romanticized perception of that region's resistance to colonial rule and the troubling hybridization evident in much of the material culture of the coastal regions of the island. The crafts, architecture, and social economy of Kandy were essentialized by those commentators and positioned within a colonial discourse

of authenticity to represent the material and cultural attributes of the island as a whole.[2]

Compared to the attention given to the traditional arts, crafts, and craft education in India, the situation in British-controlled Ceylon has been relatively neglected.[3] The present discussion of vernacular crafts and British artistic policy in Ceylon must therefore be located in relation to secondary literature about South Asia as a whole. A number of texts have addressed colonial policies with regard to indigenous crafts within the Indian subcontinent. Thomas Metcalf and Giles Tillotson discuss British architectural patronage in India and the shifting investments in traditional arts and architecture as a presentational strategy of power (Metcalf 1989; Tillotson 1989). Partha Mitter and Tapati Guha-Thakurta outline British craft policies and how these were framed within art school education within the Subcontinent (Mitter 1994, Guha-Thakurta 1992). Tirthankar Roy addresses the notion of both a destructive but also a creative impact of industrializing Europe on Indian industry. He argues that a perception of decline in local crafts masks more complex histories and that "artisanal activity survived in India" in the colonial and postcolonial eras (Roy 1999). Recently, Arindam Dutta and Saloni Mathur have discussed colonial interest in Indian crafts and design, locating this within British trajectories of aesthetics and politics (Dutta 2007; Mathur 2007).

The British first came to Ceylon in 1796 and, in 1815, finally captured the city of Kandy, the capital of the last independent Sinhalese kingdom and political and religious heartland of the island. With this event the whole of Ceylon came under a unified military and administrative control for the first time in its history. Prior to this, the Kandyan kingdom had been subjected to about 130 years of Dutch trade restrictions, which had led to the gradual impoverishment and stagnation of the city and its hinterland.

Patronage of local arts and crafts during the Kandyan period (the three centuries prior to the arrival of the British) lay with the king. Much of this work consisted of the rebuilding and refurbishment of Buddhist temples, including the production of artifacts and wall paintings (Figures 1 and 2). In relation to the traditional crafts

Fig 1 Temple of the Tooth Relic, Kandy, Ceylon (Sri Lanka). Anonymous photograph, c.1880.

within the Kandyan kingdom, prior to British intervention, there existed a subdivision of the *acari* or artificer caste into subgroups such as blacksmiths, silversmiths, carpenters, and jewelers (Coomaraswamy 1909: 32–3). Before the colonial period, the hereditary training of craftsmen, or familial apprenticeship system, was the mainstay of the provision of a pool of skilled craft workers (Coomaraswamy 1956: 64).

During the first half of the nineteenth century there was little to celebrate in

Fig 2 Interior of Lankatilaka Vihare (temple), Kandy, Ceylon (Sri Lanka). Photograph by Charles Scowen, c.1880.

Anglo-Sinhalese cultural relations. After Kandy had been captured in 1815, the buildings of the city were neglected and left to decay. In 1821, John Davy, a physician who accompanied the British forces during their incursion into the center of the island wrote:

> Though from the time of our entrance into Kandy our object has been to improve the town, what we have done has generally had the contrary effect. We have pulled down much and built up little; and, taking no interest in the temples, we have entirely neglected their repair: the consequence is, Kandy has declined very much in appearance during the short time it has been in our possession. (Davy 1821: 371)

However, as the local military threat declined, during the middle decades of the nineteenth century, Kandy and its landscape began to be perceived by the British in the romanticized image of preindustrial England (Duncan 1989: 192). As James Duncan has suggested, the "old and exotic landscape elements which played a part in the ideology of romanticism, in Kandy were drawn from a precolonial cultural tradition" (Duncan 1989: 196). The "romantic and picturesque qualities of Kandyan culture" were rediscovered by the British and affected all aspects of local material culture (Duncan 1989: 196).[4] For example, by 1900 the local secular and religious architecture of Kandy began to receive attention, especially from the prolific, knowledgeable and sympathetic English Government Agent for the Central Province, John Penry Lewis, who produced a number of scholarly publications on various aspects of the built environment of the Province, including an article on the generic form of Kandyan doors and on Kandyan architecture more generally (Lewis 1908a, 1908b). This interest on the part of the British also legitimized and validated Kandyan Sinhalese material culture for the local elite;

even though it was piecemeal and selective, the colonizers' reappraisal of local artistic traditions endorsed an area around which a nascent nationalist cultural identity could develop.[5]

From an epistemological perspective, the city of Kandy and its crafts appeared to be unproblematic. They were clearly separated from the present, from the modern, and could therefore be safely considered as authentic relics of an ancient and spectacular indigenous culture. Perhaps more importantly, they did not incorporate the many disconcerting and incongruous elements (of Western origin) found in most aspects of the material culture of the Low Country or coastal belt of the island, due to prolonged colonial contact. Moreover, these sites could be made into exemplars by the British administration against which the debased craft traditions of the present could be unfavorably compared, thereby justifying British intervention as the only means by which such traditions could be revived. The architectural historian, Swati Chattopadhyay, has also suggested that within the late nineteenth-century Indian context (and by extension, throughout South Asia), development of hybridity was disconcerting to the British "not just [because] it implied a changing native culture but that it also indicated the impossibility of generating a sovereign British existence untouched by native culture" (Chattopadhyay 1997: 8).

During the second half of the nineteenth century, British conceptualizations of the island's history and culture also inflected their understanding of local craft skills and design education. During the early years of the colonization of Ceylon, many commentators perceived a decline of local craftsmanship, in particular within the tradition of carving. There are a number of explanations for this perception. During the second quarter of the nineteenth century, British control was not fully realized throughout the island as a whole; for example, in 1848 a local uprising in the Central Highlands reminded the colonizers how tenuous their hold on power was. Many British residents on the island, particularly those in the Central Highlands, felt militarily insecure and gave voice to this unease by disparaging the local population and local products; in 1841, for instance, Mrs. Griffiths, a British resident at Kandy, wrote: "It is astonishing the perfection the natives have attained, or rather had attained, for their ancient productions surpass anything they do at present in their arts of carving."[6] There was also, as early as the 1820s, growing awareness of the impressive scale and high quality of carving which was being uncovered at the ancient cities of Anuradhapura and Polonnaruwa, as well as on the ancient structures in the city of Kandy itself.[7] But these structures were firmly located in the past. Another contemporary commentator, Henry Sirr, echoed the views of Mrs. Griffiths when he noted in 1850: "Like all else in Ceylon, the art of carving in wood is fast falling into decay, and now we never find executed by modern artists, the same exquisite description of delicate tracery, which is to be seen upon the wooden pillars supporting the roof of the Audience hall of the former Kandian monarchs" (Sirr 1850 vol. II: 266).

However, there was a more significant and pervasive reason for the British perception of decline in local crafts. This was rooted in a colonial discourse that

represented all of South Asia, including Ceylon, as being in a debased state compared to a notional golden epoch of the distant past that was now lost. The argument of Asiatic decline was a central justification for the imposition of British rule in this region. It was Britain's civilizing mission, so it was believed, to awaken Ceylon from this cultural stagnation. Britain had a duty to step in and rule, as it was only with this beneficial, external help that both the Indians and Ceylonese could wake from their stupor and restore their ancient and praiseworthy traditions.

Ananda Coomaraswamy also discussed the decline of Ceylonese (and South Asian) crafts, but from a different perspective. In his seminal text on local craft traditions, *The Indian Craftsman* (1909), he explicitly critiques the breakdown of local social relations caused by Western colonial interventions. He draws attention to the Ceylonese "royal craftsman" who, instead of making work "on the basis of personal relations and duties … is merely an agriculturalist, perhaps even working on a tea estate or he lives only to make brass trays and other pretty toys for passing tourists" (Coomaraswamy 1909: 4 and 81). This breakdown in social relations was also evident in the training of local craftsmen. In place of the workshop of the hereditary craftsman, with its system of apprenticeship, Coomaraswamy noted that the "great Technical Schools in London" were now the model for craft training in the East. The watchword of these schools was "efficiency," a concept that contrasted markedly with the "beautiful and affectionate relation between apprentice and master" of the premodern era in South Asia (Coomaraswamy 1909: 84–6).

Coomaraswamy occupied a unique position as a commentator on the demise of South Asian crafts. Of mixed parentage (his father was a Ceylonese Tamil and his mother European), he had also mastered the British educational and administrative hierarchies. He departed from the gatekeeping approach of British art officials in India, who tried to perpetuate colonial differences that served to buttress the superiority of the British colonial elite. During the period around 1905 to 1910, he redirected many of the ideas of William Morris and C. R. Ashbee to offer a social critique of the state of Eastern society in the modern colonial age. He was, in a similar manner to these Arts and Crafts theorists, concerned with the effects of industrialization and the damaging imposition of Western "efficiency" on Asian society. Coomaraswamy's concern for the plight of the traditional hereditary craftsman in the East echoes Ashbee's contemporaneous concern for the state of the "B. W. M." or British working man. Later in his career, other concepts informed his writings. After leaving Ceylon, he became associated with the romantic, aesthetic nationalism of Rabindranath Tagore and his followers in Bengal, a connection which has been regarded as a rejection of Western materialism and rationalism. In later life, he became curator of Indian art at the Museum of Fine Arts in Boston. By absenting himself altogether from the European colonial context, he was perhaps further indicating his anti-imperialist stance.

Notions of Sinhalese vernacular design within the applied arts and crafts, in a similar fashion to the Kandyan built environment and landscape, were also subjected by the British to critique and intervention. In addition to

the issue of progress or "improvement" within the local crafts, another aspect of British attitudes to these crafts concerned the identification and preservation of authenticity in local design. The European search for authenticity, especially during the great social and economic upheavals of the nineteenth century, combined with the rise of commodity culture and consumption in the West, has been described as: "a conceptualization of elusive, inadequately defined, other cultural, socially ordered genuineness" (Spooner 1986: 225). Although there existed objective criteria for authenticity within local design and production and a significant aspect of those criteria was cultural distance, nonetheless authenticity was defined according to western cultural concepts rather than those of local societies (Spooner 1986: 223). British officials in Ceylon responsible for the collections sent to the international exhibitions in the 1850s and 1860s would, at best, have possessed a hazy understanding of local traditional design and crafts.

British notions of authenticity in Ceylonese craft design were given expression in a series of promulgations issued by the colonial administration on the island during the nineteenth century. In order to encourage local craftsmen to produce objects which could represent the island at the Great Exhibition of 1851, the colonial administration placed notices in *The Ceylon Times* seeking "the best designs for carving in wood and ivory." Premiums were to be paid to local craftsmen for designs that met certain criteria laid down by the British. The newspaper notices stated that: "(1) The designs must be the production of natives of Ceylon. (2) The works executed must be ornamented with figures, flowers, fruit etc., strictly Ceylonese."[8] These criteria were open to broad interpretation, but the fact that Ceylonese vernacular design was being prescribed at all by the colonial administration indicates a desire to extend British intervention into every aspect of the cultural, political, and social life of the island, and also attests to British anxiety about the effects of modernization on the island's social economy. Many local craftsmen, especially wood carvers, followed these prescribed attributes in objects that they made for a number of international exhibitions during the nineteenth century. An imposing carved ebony cabinet in the collection of the Victoria and Albert Museum, whose surface is carved with representations of local peoples and flora, communicates British forms of knowledge outlined in *The Ceylon Times* with regard to its surface decoration (Jones 2004: 122–4) (Figure 3).

One early and direct intervention by the British administration in relation to local design and crafts in Ceylon came with the appointment of the artist Andrew Nicholl as the first teacher of scientific drawing and design at the recently founded Colombo Academy in 1846 (Angelsea 1982: 139).[9] Nicholl's post had been secured by the civil secretary to the colonial government in Ceylon, Sir James Emerson Tennent, a fellow Ulsterman, who had previously demonstrated his interest in commodity design by publishing his *Treatise on the Copyright of Design* in 1841 and had played an important role in getting the Copyright of Designs Bill through Parliament in 1842 (Angelsea 1982: 139). Nicholl's role at the Colombo Academy was similar to that of instructors appointed at the newly

founded schools of design in England, although modified to the conditions on the island; drawing was taught to students with a view to improving the quality of draughtsmanship and thereby enhancing the design and production of artifacts. One specimen of Nicholl's design work is in the Ulster Museum's collection and consists of a decorative floral pattern in pencil, the intertwining stalks embellished with crawling snails and butterflies. It is inscribed "Ceylon 1846" and provides some idea of the type of work Nicholl would have been teaching in Colombo (Jones 2006: 39).

Fig 3 Carved ebony cabinet, Galle District, Ceylon (Sri Lanka), c.1890. Courtesy Victoria and Albert Museum (museum number IS.18-1986).

Education of the local population on the island, including craftsmen, preoccupied many British administrators. In the second half of the nineteenth century, the British administration in Ceylon and several missionary groups, including the Wesleyan Mission, established industrial schools on the island, initially to alleviate poverty and, at the same time, to foster indigenous craft skills (Figure 4). These schools came to be regarded by the British as agents of colonial government policy; they delivered education to the local population, inculcated Christian beliefs, and helped maintain the social status quo by encouraging the local youth "to devote themselves to various branches of industry without scrambling for Government office."[10] A report of 1860 on industrial education in the island noted:

> It would be difficult to overestimate the beneficial results of young men returning to their different villages, thoroughly trained to habits of industry and forethought; whilst the ease with which they obtain situations, shows the value attached to the training they have received. We think institutions of this kind well calculated to encourage habits of industry generally and to improve the condition of the people.[11]

Industrial schools were also perceived, by some administrators, as vehicles for the improvement of indigenous design along the lines promoted in Britain at this time. Another aspect of British attitudes to local crafts and the education of craftsmen related to the distinction between creative and mimetic ability. In an *Education Report* on the island of 1876 it was noted by a civil servant, S. Hawkins, that: "Industrial Schools

ought to be schools of design on a small scale." He continued, "The native artisans here copy things for you very creditably, but they cannot invent or design for you, and it is the inventive faculty which we should try to develop and this could be done in the Industrial School."[12] In the same report another commentator, John Capper, wrote of the beneficial possibilities of industrial schools on the island:

> I consider that the tastes of the people of Ceylon might be greatly improved and their character advantageously affected by the gradual introduction of Drawing Classes into the Schools, embodying a few of the features of the Government School of Design at Kensington, and which would tend to foster an appreciation of the graceful and beautiful and find development in the manufactured productions of the country.[13]

One of the earliest industrial schools on the island was established at Kandy in 1854 by Archdeacon Wise. It maintained twenty-five boys and trained them in various manual skills, including carpentry, printing, and bookbinding.[14] A larger industrial school, with sixty students, was founded in Cinnamon Gardens, Colombo in 1859 by the Reverend Thurstan.[15] Here seven hours were devoted to labor in the various departments and four hours were spent in "intellectual improvement," which included learning a "portion of the earlier history of England" and reading passages from the Bible. Craft skills were taught in various departments, including carving and cabinet work; the making of tats or blinds for doors, windows or verandahs; and weaving and thread lacework. Clearly these activities were situated in a Western discourse of industriousness and Western categories of production, rather than being drawn from a vernacular heritage and local taxonomies of craftwork. A number of products of the industrial school were exhibited at international exhibitions, including a carved ebony davenport at the London exhibition of 1862, as well as other examples of cabinet work (Jones 2004: 117).

By the early 1900s there existed a number of industrial schools throughout the island. These included weaving schools at Rajagiriya, Piliyande, and Horetuduwa; carpentry schools at Nugawela and Kadgannawa; lacquer workshops at Leliambe; pottery workshops at Waragoda and the technical school in Colombo; and stone and woodcarving workshops at Trinity College, Colombo. In 1931, a report was prepared by Lionel Heath (former principal of the Mayo School of Arts, Lahore) entitled *Upon Industrial Education in Ceylon* (Heath 1931). When addressing the needs of Ceylon, Heath suggested:

> The decorative or art crafts are most suitable for inclusion in a school course for several reasons—they are traditional home industries in the East and tend to keep the people on the land and in rural areas; they are inseparable from artistic beauty of design, proportion and color and the work depends on soundness of construction and quality of material and for these combined reasons they have an educative value to a very high degree. (Heath 1931: 4)

Heath also took a more positive view of an issue that had exercised the British with regard to Western influence on the arts and

crafts of Ceylon and the notion of hybridity when he noted: "Most important of all is the quality that comes from the character of national traditions joined to and harmonizing with the [local] people's changing life." He continued, "It follows that to keep the handicrafts of a country alive the training of prospective craftsmen must … follow traditional lines because these have been born in the country and are understood by its people" (Heath 1931: 5). The report, however, revealed the persistence of many of the attitudes of nineteenth-century colonial administrators with regard to local traditional crafts; the schools were still, in many ways, viewed as vehicles of government policy.

As British rule in Ceylon became increasingly secure during the second half of the nineteenth century, the perception of local crafts among the small group of British residents on the island changed from being critical, patronizing, or disparaging to a more sympathetic and informed appreciation. In 1882, during the tenure of Sir John Dickson, Government Agent of the Central Province, the Kandyan Art Association was formed. Members of this association were British colonial elites who were interested in the traditional crafts of the island; the organization was supported through annual subscriptions. As Ananda Coomaraswamy wrote of the association in 1908, "The services of the best workmen in silver, brass and pottery were employed in making articles of Kandyan art and workmanship" (Coomaraswamy 1956: 262). In the 1890s, Hugh Nevill, Assistant Government Agent of the Central Province, undertook supervision of the workmen; orders were placed with him and executed by workmen from Kandy and Matale.[16] The association had a number of premises in Kandy, including a room in the *kaccheri* or government offices behind the *Dalada Maligawa* or Temple of the Tooth Relic, indicating its overt patronage by the British administration. This new interest on the part of the British administration in the traditional crafts of the Kandy region also helped to reinforce a sense of national pride and cultural identity, particularly among the Kandyan Sinhalese, who a contemporary commentator noted had been "glorifying in their primitive nationalities" since the 1850s (Roberts 1989: 70).

The association's craftsmen were often depicted in photographs carrying on their traditional occupations for the benefit of visitors. In 1904, Henry Cave noted of these craftsmen, "The traveler may see articles of silver and brass work in process of manufacture, may even select a design for any article he fancies and see it in its stages of fabrication" (Cave 1908: 315) (Figure 5). As well as metalwork, the craftsmen of the association produced handwoven cloths, Dumbara mats and lacquerwork. Around 1900 there was a vogue for all sorts of craftsmen and women from different parts of the island, especially metalworkers, jewelers and lacemakers, to be photographed in the process of their labors (Falconer 2000: 82–3) (Figures 6 and 7). This process of visualizing Eastern craft production culminated in the incorporation of South Asian artisans within the late nineteenth-century international exhibitions and world's fairs. At the "India and Ceylon Exhibition" held in London in 1896, groups of local artisans were required to "perform" their craft in a range of small, theatrical cubicles.[17] These theatrical "acts" of craft, performed in person by artisans from South Asia, evoked for the European

Fig 4 *Wesleyan Industrial Home, Wellewatte, Colombo.* Anonymous photograph, c.1880.

audience the absent world (in both a temporal and spatial sense) from which the craft objects had been extracted; at the same time, they presented reassuring evidence of the continuation of a living tradition during the period of its supposed dissolution. In Ceylon itself, numerous European tourists on their way through Kandy on the standard itinerary or Asiatic "Grand Tour" to the ancient cities, also purchased art wares from the very visible craftsmen of the Kandyan Art Association.[18]

There had been no equivalent publication about Ceylon to compare with B. H. Baden Powell's *Handbook of the Manufactures and Arts of the Punjab* of 1872. However, this situation changed in 1908 with the publication of *Medieval Sinhalese Art*. The latter work was written by the most significant and influential commentator on the traditional arts, crafts, and architecture of the island, Ananda Kentish Coomaraswamy (1877–1947) (Lipsey 1977). Of mixed Ceylonese and English parentage, Coomaraswamy received a first-class degree from London University in geology and botany, and was commissioned by the colonial government of Ceylon to conduct a mineralogical survey of the island. He had married Ethel Partridge in June 1902 and the couple settled briefly in Chipping Campden in the Cotswolds, due to their friendship with C. R. Ashbee and his wife Janet. Ashbee was one of the most influential figures in the British Arts and Crafts movement and leader of the Guild of Handicraft which had that year (1902) moved from Essex House in the East End of London to the Cotswolds (Harrod 1999: 178).

The Coomaraswamys left for Ceylon in 1903 (remaining there until 1906) and, after a few days in Colombo, traveled to the Central Province of the island and rented Rock Villa, a bungalow outside Kandy.[19] During their stay there the couple conducted numerous field trips throughout the Central Province; it has been suggested by Margot Coatts that due to Ethel's influence, the couple also began to record the arts and crafts of each village through which they passed (Coatts 1983a: 16).[20] Ethel Coomaraswamy also took numerous documentary photographs of the crafts she saw, making a particular study of local weaving, and kept a detailed account of their journeys in a number of notebooks, with each item photographed, cataloged and

Fig 5 *Craftsmen of the Kandyan Art Association* and *Kandyan Silversmiths*. From Henry Cave, *The Book of Ceylon* (1908).

Fig 6 A Ceylonese laceworker. Anonymous photograph, c.1900.

the processes and materials of each craft carefully observed and recorded. This wealth of material, gathered during the three years of their residency in Ceylon, formed the basis of *Medieval Sinhalese Art*; this text was published after their return to England.

In common with other followers of the Arts and Crafts movement, Ananda Coomaraswamy turned his back on industrialization and held the traditional crafts in the highest esteem. In Ceylon he and his wife found a culture which, in their view, had to an extent preserved some of its social and

cultural integrity. The island had not been industrialized and there was still no apparent disjunction between the fine and decorative or applied arts (as there was in the West). They became deeply interested in the social status of craftsmen in Ceylon, the integration of these craftsmen into their communities, their organization (into guilds and castes) and their training (Coatts 1983b: 22). They were, however, shocked at the apparent decline of the traditional crafts there and laid the blame for this on the flood of Western goods brought into the island during the nineteenth century as well as the introduction of a British educational model and the debased (i.e. Westernized) taste of the local middle class.[21] In 1905, Ananda Coomaraswamy wrote an open letter to the Kandyan chiefs in *The Ceylon Observer*, which expressed his concerns in this regard:

> During the last two years, I have given my spare time to studying old Kandyan work in architecture and all the crafts that flourished in those times that seem now so far away. I have seen old buildings and new; and in the minor arts it has not been once or twice only that I have attempted to get made for myself some one or other of the wares that were once produced so easily and so well and of which a little of the wreckage survives in a few museums and private collections; and it has been again and again borne in upon me as the result of bitter experience both in the remotest villages and in Kandy itself, that the character of steady competence which once distinguished the Kandyan artist craftsman has gone forever; a change such as the Industrial Revolution brought about almost all over the world.[22]

Ananda Coomaraswamy was also a vociferous critic of government and missionary training of craftsmen. In 1909 he wrote of the benefits of traditional craft training in his book, *The Indian Craftsman*:

> The important facts are these: *the young craftsman is brought up and educated in the actual workshop and is the disciple of his father.* No technical education in the world can ever hope to compensate the craftsman for the loss of these conditions. In the workshop technique is learnt from the beginning and in relation to real things and real problems and primarily by service and personal attendance on the master. (Comaraswamy 1909: 84)

During their time on the island (and also subsequently), both the Coomaraswamys wrote numerous articles on the traditional arts and crafts of the island, including among others: "Kandyan Hair Combs," 1905 in *Spolia Zeylanica*, "Two Kandyan Brass Boxes" in the *Ceylon National Review* of 1906, and "Old Sinhalese Embroidery" for the *Ceylon National Review* published in July 1906 (Coatts 1983b: 28). They also taught classes and lectured widely to different groups on the island. It is, however, in Ethel Coomaraswamy's notebook entries, which meticulously describe their travels through the Central Province of Ceylon, that one gains an immediate sense of their perceptions of the traditional crafts, as well as an insight into their methods of observation and recording, all of which distinguishes their observations from those of previous commentators. In the Durai Raja Singham collection at Cambridge University are two handwritten notebooks by Ethel Coomaraswamy entitled "Notes Made in

Fig 7 A Sinhalese metalworker and apprentice, Kandy. Photograph by Charles Scowen, c.1880.

Ceylon," the first of which is dated March 7, 1903[23] (Figure 8). Most of the entries for the year 1903 deal with metalwork and jewelry. For example, on September 12 in Colombo, she carefully noted the working methods of a local silversmith:

> Very primitive in his way of doing things but very good worker … after a preliminary dividing up of the whole circle into parts, he draws the design on with a sharp-pointed tool; the only thing he thinks about is the kind of pattern he shall use and how many lines he shall draw on … This flowed out of him quite mechanically. Another band had animals drawn on—birds, elephants, horses—these were drawn quite indiscriminately, no regular order but apparently whatever

came into his head first. The actual form was very pliable and was made to fit whatever space there was, although the character was always kept.[24]

In addition to admiring the designs and working methods of local craft producers, at the same time she also decried the effect of European fashions on local crafts. For example, on the October 15, 1903 she recorded an entry in her notebook for Bandarawela, a small town in the highlands of the island:

> An interesting town—railway terminus—a great many native shops along the high road … only saw one jeweler and he had succumbed to "new art." He had no old work and evidently despised it.

Fig 8 Lower section of a traditional Ceylonese spoon rack or *hendi-ana-val*, decorated with *hamsa puttuva* pattern. Drawing by Ethel Coomaraswamy, 1903. Courtesy Cambridge University Library.

He showed me with great pride a gold necklace of the "new art" Sinhalese style ... the work was altogether flimsy and extremely ugly.[25]

The notebooks also contain references to local artwork in temples. Her discussion of the decoration in these buildings is framed with reference to the writings and products of William Morris. For example, an entry for May 15, 1903 for the paintings on the walls of a Buddhist temple, built out of the rock at the foot of Bambaragala Hill, is noted as being "very Morrisy with foliage and birds very well fitted in." Other walls in a second shrine at the temple were "most perfect in [their] decoration. Bright colors, a great deal of yellow and red and a lot of it very minute and perfect. On the walls were larger designs—(reminding of Morris) with white background."[26]

Descriptions of weaving and embroidery in Ceylon figure more prominently in later journals and reflect a growing interest in these crafts that were to dominate her later life (Figure 9). It was Ethel Coomaraswamy, in fact, who wrote the chapter on Sinhalese embroidery in *Medieval Sinhalese Art*. Her

Fig 9 *Sinhalese Devil Dancer's Dress*. Notes and drawing by Ethel Coomaraswamy, 1904. Courtesy Cambridge University Library.

notebook entry for November 4, 1903 is one of many which provides a detailed description of these crafts:

> The weavers came from Uda Dumbara.[27] They stayed until the 29th … They of course have no design to go by, but they see it evidently before they begin; they don't even measure, yet seem to get the pattern quite evenly distributed. The first design put on the central panel … was two *hamsa* [sacred fowl] with necks interlocked. The second panel there was much consultation over. At last it was decided it should be flowers. They seem quite able to carry out each other's ideas even in a fresh design.[28]

The notebook then records the process of putting up the loom (over eleven pages) and the commencement of the weaving: "Irregular patterns such as the birds were done by threading the colored threads in by hand. But the regular patterns were done in a different way. A thin, light lathe pointed roundly at the end was threaded in next in the work according to the pattern. This was again transferred to a thin strip of cane for further use."

Ethel Coomaraswmy's notebooks attest to her aversion to the apparent hybridity of much contemporary local craftwork and the supposedly deleterious effect of Western art and craft training. Part of this aversion was connected with the Westernization of the island during the British colonial era. An entry for July 7, 1904 reads:

> About a mile from Pelmedulla on the Ratnapura road was an old interesting *vihare* [Buddhist temple] (Ganegoda *vihare*). The painting on the roof of the shrine was very fine … On the walls of the outer shrine enclosure [however] were paintings of the most horrible description evidently being done by some Sinhalese who had a touch of board school drawing. There were traces of the old tradition mixed up with perspective and European figures and furniture.[29]

One of the key texts written during the colonial era on South Asian crafts, Ananda Coomaraswamy's *The Indian Craftsman*, discusses a number of themes including the place of the craftsman within the local village community, the functioning of craft guilds within the cities of the subcontinent, the survival of the feudal system of craft and patronage, the regulation of standards in design and making, the relation of craft and religion, and the education of the local craftsman. With a foreword by Ashbee and appendices which include the writings of Morris and A. J. Penty, Coomaraswamy's indebtedness to the theories of the English Arts and Crafts movement is apparent—especially the tendency to contrast the modern (and in many cases unsatisfactory) present with the medieval past.

Ananda and Ethel Coomaraswamy were not the first commentators to describe in regretful terms the destruction of South Asian craft industries (Lipsey 1977: 30). The Coomaraswamys' book had been preceded by Sir George Birdwood's *The Industrial Arts of India*, published in 1880 for the South Kensington Museum. In this work Birdwood described how "Indian [artifacts] are now also seen to be more and more overcrowded with mongrel forms, the result of the influences on Indian art of European society, European

education and above all the irresistible energy of the mechanical productiveness of Birmingham and Manchester" (Birdwood 1880: 132). Furthermore, in 1890 an article had appeared in the *Journal of Indian Art* entitled "The Decline of South Indian Arts" (Natesa Sastu 1890).[30] Roger Lipsey has suggested that *Medieval Sinhalese Art* differs from such previous publications through its greater engagement with the processes of thought and methods of operation of the craftsmen, its deep interest in craft processes (not merely in products) and their use of illustrations to show craft processes and objects alike (Lipsey 1977: 36).[31] The Coomaraswamys made connections and comparisons in their writings between the Eastern present and the premodern (usually medieval) West (Spencer 1995: 245). Out of Ananda Coomaraswamy's study of the premodern also came a formidable social critique for his own time. He attacked the increasingly Westernized taste of the Ceylonese middle class as an integral part of the problem of the decline of traditional crafts. His writings should also be considered within the context of the Buddhist revival that took place on the island in the last quarter of the nineteenth century, including, for instance, the Anagarika Dharmapala's diatribes against the local elite's consumption habits in terms of their adoption of Western dress and life-ways.[32]

In the words of Jonathan Spencer, Europe—and in particular Britain—was not encountered in South Asia solely as "a discourse, an epistemology or even politics." Rather, the West was encountered in the form of things or items of consumption (Spencer 1995: 252). Ananda Coomaraswamy was not the first commentator to offer a critique of the impact of Western goods and consumption habits on the island. From the 1850s, members of the Low Country Sinhalese elite had expressed their unease "with the Portuguese and Dutch habits, manners and customs they [had] adopted, and the British ones they [were] acquiring."[33] In addition to documenting much of the history of the traditional crafts of the island through fieldwork, research, collecting, and recording, Coomaraswamy also set these crafts within a broader social and cultural context, which he outlined in 1906 in the opening manifesto of the Ceylon Social Reform Society, of which he was president. This society, he wrote, was formed to:

> educate public opinion amongst the eastern races of Ceylon, with a view to encouraging their development on the lines of Eastern culture … The Society is [also] anxious to encourage the revival of native arts and … especially to re-create a local demand for wares locally made, as being in every respect more fitted to local needs than any mechanical Western manufactured goods are likely to become. (Lipsey 1977: 25)

In conclusion, debates about local craft training and the maintenance of a Ceylonese vernacular in design, although they might appear peripheral in comparison to weightier issues of colonial governance or economic policy, were in fact central to issues of nationalism and identity in late nineteenth-century Ceylon. As James Duncan has suggested, even when debased and trivialized, the art and craft forms of Kandyan (or "authentic" Ceylonese) culture acted as a focus for nationalist sentiment;

British interventions within the traditional crafts of the island and interest in local culture helped legitimize such culture for the local elite. However, this process was problematic because it was largely the British who were engaged in the preservation and documentation of local architectural and craft traditions.

The arrival of the modern world into the colony of Ceylon and the representation of this intervention in the cultural life of the local people, including its crafts, was the subject of an acclaimed documentary film, produced in 1934 and entitled *Song of Ceylon*.[34] This film could be viewed as another attempt by the British to assuage their concerns regarding the impact of European technologies on the traditional life of the island. As Jamie Sexton has suggested, the arrival of modernity towards the conclusion of the film "implies that nature and tradition are endangered by advanced industrialism"; however, this concern is mitigated by the film's very last sequence—the depiction of locals engaging in a traditional ceremony, "whilst industrial sounds become merged with 'traditional' sounds."[35]

The heirs to Coomaraswamy's manifesto of 1906 are pre- and post-independence twentieth-century Sri Lankan artists, craftsmen and women, and architects who have looked to surviving although interrupted vernacular sources of design or building for inspiration.[36] These include the architect, Minette de Silva, who tempered her European modernist tendencies with many informed references to local decorative forms and techniques; the textile designer Ena de Silva, whose manufacture and decoration of batik panels reflect a knowledge and understanding of local traditions of textile designs and techniques of dyeing; and Geoffrey Bawa, whose domestic architecture reveals a profound understanding of and sympathy with Sinhalese vernacular traditions of building, the so-called "wood, tile, stucco" tradition.[37] Local Sri Lankan craft designs and techniques are now promoted in a global market. The textiles commissioned by Barbara Sansoni and produced for her shop, Barefoot, in Colombo are marketed as authentic local products which emanate from ancient traditions of vernacular design and production.[38] Essential elements of the traditional crafts of Sri Lanka, in terms of design, materials, and making, are manifest in the work of all these designers and architects. Ceylonese vernacular design and hereditary craft traditions continue to inform present practice.

Acknowledgments

I acknowledge, with thanks, the constructive feedback received on different versions of this article from participants at the conference "Traditional Arts of South Asia: Past Practice, Living Traditions," PRASADA, de Montfort University, June 2002; and the Art History Research Seminar, Department of Art History, University of Sussex, February 2003. I would also like to thank Crispin Branfoot, Adam Hardy, Dan Rycroft and the anonymous reader of this article for *The Journal of Modern Craft*.

Notes

1 The United (Dutch) East Indies Company captured the coastal regions of the island from the Portuguese in about 1658 and remained in control of these areas until 1796, when they were

expelled by the forces of the English East India Company. After 1802 Ceylon became a Crown Colony and was administered by a governor appointed by Parliament. British Government forces captured the Kandyan Kingdom in the center of the island in 1815, bringing the whole country under a unified administration for the first time in its history.

2 This form of representation arose because of the troubling mixture (from a European point of view) of Eastern and Western elements within individual objects or buildings evident in the southwestern coastal region of the island during the colonial period. Kandyan material culture, on the other hand, was represented as untouched and authentic, and reassured the British that colonial contact was not having a uniformly disruptive effect on local culture.

3 The majority of postindependence scholars in Sri Lanka who are interested in art and design address either the precolonial or postcolonial material culture of the island. See, for example, Godakumbara (1966), Bandaranayeke (1974) and Chutiwongs (1990). Ismeth Raheem is one of the few writers to discuss art and design in Ceylon during the colonial era (see Raheem 1982, 2000).

4 The rediscovery of picturesque aspects of Kandyan culture has exact parallels in India, for example in the romanticization of the palaces of Tipu Sultan after his defeat and death at the hands of the British in 1799. These palaces were visualized in a Romantic idiom by Thomas and William Daniell and are discussed in George Michell (1998).

5 A related romanticism which led to a reappraisal, by the British, of Kandyan precolonial material culture also informed the creation and content of a local publication, *Young Ceylon*, first issued in 1850. The journal was inspired by Mazzini's Young Italy movement and the spirit of romantic nationalism of the time, but these sentiments were tempered by expressions of loyalty to the British administration. *Young Ceylon* included several articles on "The Fine Arts of Ceylon" (see Roberts 1989).

6 The Library, University of Peradeniya, Sri Lanka, MSS: Major and Mrs. G. Darby Griffiths, "Ceylon during a Residence in the Years 1841–2," vol. 1: 104—entry for April 12, 1841.

7 One of the first European written accounts of the ancient cities was produced by Lieutenant Mitchell H. Fagan of the 2nd Ceylon Regiment and was published in *The Ceylon Government Gazette* on August 1, 1820. Cited in Falconer (2000: 20).

8 *The Ceylon Times*, April 2, 1850; cited in Jones (1996: 37).

9 The Colombo Academy was founded in 1835. Further information about Nicholl's residence in Ceylon is found in *Exhibition of Andrew Nicholl Watercolors at the National Museum, Colombo* (Colombo: Department of National Museums, Sri Lanka, 1998).

10 Ceylon Leglislative Council, Sessional Papers for 1876, *Education Report*. Colombo: William Skeen, 1876, p. 351.

11 Ceylon Leglislative Council, Sessional Papers for 1860, V. *Education. Industrial School*. Colombo: William Skeen, 1860, p. 41.

12 Sessional Papers for 1876, *Education Report*, 1876, Appendix to Report on Education: cccxxviii.

13 Sessional Papers for 1876, *Education Report*, 1876, Appendix to Report on Education: cccclix.

14 *Peterson's Ceylon Almanac for 1870*. Colombo: E. H. Peterson, 1870, p. 315.

15 Sessional Papers for 1860, V. *Education. Industrial School*: 42

16 Hugh Nevill formed a large collection of Sri Lankan craft artifacts, now in the collections of the Victoria and Albert Museum and the British Museum, London (see de Silva 1975).

17 Saloni Mathur has discussed colonial desires to put Indian artisans on display, both through the use of photographs and in person at exhibitions (see Mathur 2007). An album of photographs at the British Library, London (PDP Photo 888)

is entirely devoted to images of South Asian craftsmen at the "India and Ceylon Exhibition," each performing their craft in raised, stage-like workshops, including an image of Don Andris Dewapura Wimalaratna Jayesingha, chief carpenter of Galle, with examples of his workmanship displayed.

18. One wealthy European tourist who made purchases from the association was Frederick John Horniman, the tea merchant. He visited Ceylon in 1894–5 and on January 29, 1895 bought a number of artifacts from the Kandyan Art Association, which are presently in the collection of the Horniman Museum, London (see Levell 2000: 176–7).

19. For details of Ananda and Ethel Coomaraswamy's activities in Ceylon also see Coatts (1983: 15–17) and Harrod (1999: 177–79). The Coomaraswamys separated shortly after they returned from Ceylon. Ethel later married one of C. R. Ashbee's draughtsmen, Philip Mairet.

20. Margot Coatts suggests that it was through his wife's influence that he became interested in recording the arts and crafts of Ceylonese villages through which they traveled.

21. Ananda Coomaraswamy viewed the traditional crafts of Ceylon through the lens of the Arts and Crafts movement. To be consistent with the theories of Ruskin, Morris, and Ashbee, Coomaraswamy had to situate Kandyan traditional crafts in a previous (medieval) era and make a case for the decline of such crafts.

22. "An Open Letter to the Kandyan Chiefs" by Ananda K. Coomaraswamy, *The Ceylon Observer*, February 17, 1905; cited in Lipsey (1977: 20–1).

23. Another two journals or notebooks are located at Princeton University, USA (see Coatts 1983b: 23).

24. Cambridge University Library, Durai Raja Singham—Ananda Coomaraswamy Collection: Ethel Coomaraswamy, "Notes Made in Ceylon," Book I (from March 7, 1903).

25. "Notes Made in Ceylon," Book I. "New art" refers to the fashionable style of decoration within the applied arts and architecture in Europe around 1900, comprising the incorporation of stylized, sinuous, and attenuated vegetal forms.

26. Ethel Coomaraswamy, Notes Made in Ceylon, Book I, May 15, 1903.

27. This place is specially mentioned by Ananda Coomaraswamy in *Medieval Sinhalese Art* as a location for the weaving of mats (1956: 243).

28. Cited in Coatts (1983b: 19–20).

29. Ethel Coomaraswamy, Notes Made in Ceylon, Book II, July 7, 1904.

30. The article read in part: "When we compare the arts in South India now with those which existed in the younger days of our own generation, we cannot but regret the calamity that has come over them in so short a time. Can any of the arts be shown not to have declined, either by the poverty of the people or by the invasion of the European market, sometimes by want of assistance from the helping hand of government but mostly by want of encouragement from ourselves?"

31. Although there was a whole series of government craft monographs produced in India from the 1890s, which directly addressed craft processes and techniques, these were published by province, with every part of British India conducting a survey on a specific activity. For example, Percy Brown, "The Artistic Trades of Punjab and Their Development," *Report of the Fourth Industrial Conference held at Madras* (Madras, 1909).

32. Anagarika Dharmapala was founder of the Maha Bodhi Society, whose aim was to restore to Buddhists the four sacred sites under Hindu control in India, including Buddhagaya or Bodhgaya. He also edited the English *Maha Bodhi Journal* and *The Sinhalese Buddhist* (see Wright 1907: 119–20 and 284–90).

33. Michael Roberts quotes from the writings of John Prins in 1850 (see Roberts 1989).

34 This film was a John Grierson Production, directed by Basil Wright, produced by the GPO Film Unit and sponsored by the Ceylon Tea Propaganda Bureau and Empire Tea Marketing Tea Board. Thanks to Tanya Harrod for drawing this film to my attention.

35 British Film Institute, Screenonline, *Song of Ceylon* (1934); http://www.screenonline.org.uk/film/id/442428/index. (Accessed 13/11/2006.)

36 See Robson (2007).

37 For an account of non-elite domestic architecture on the island, see Boyd (1947) and Robson (2002).

38 To emphasize this "authenticity," visitors to Barefoot in August 2002 were able to watch a weaver producing cloth on a fixed upright loom in the courtyard of the shop (rather than the horizontal looms of Ceylonese weavers depicted in Coomaraswamy's *Medieval Sinhalese Art*).

References

Anglesea, Martyn. 1982. Andrew Nicholl and his Patrons in Ireland and Ceylon. *Studies*. Belfast: Ulster Museum.

Baden Powell, B. H. 1872. *Handbook of the Manufactures and Arts of the Punjab*. Lahore: Government Printer.

Bandaranayeke, Senake. 1974. *Sinhalese Monastic Architecture*. Leiden: Brill.

Birdwood, Sir George. 1880. *The Industrial Arts of India*. London: Chapman and Hall.

Boyd, Andrew. 1947. A People's Tradition—An Account of the Small Peasant Tradition in Ceylon. In: *MARG (Modern Architectural Research Group)*, vol. I, no. 2: 25–40.

Brown, Percy. 1909. The Artistic Trades of Punjab and Their Development. *Report of the Fourth Industrial Conference Held at Madras*. Madras.

Cave, Henry. 1908. *The Book of Ceylon*. London: Cassell.

Chattopadhyay, Swati. 1997. A Critical History of Architecture in a Post-Colonial World: A View From Indian History. *Architronic: The Electronic Journal of Architecture*.

Chutiwongs, N., Prematilaka, L. and Silva, R. 1990. *Paintings of Sri Lanka: Sigirya*. Colombo: Central Cultural Fund.

Coatts, Margot. 1983a. *A Weaver's Life—Ethel Mairet, 1872–1952*. London: Crafts Council.

Coatts, Margot. 1983b. *A Weaver's Life—Ethel Mairet, 1872–1952: A Selection of Source Material*. London: Crafts Council, (n.d. but c. 1983).

Coomaraswamy, Ananda. 1908. *Medieval Sinhalese Art*. Broad Campden: Essex House Press; republished New York: Pantheon Books, 1956.

Coomaraswamy, Ananda. 1909. *The Indian Craftsman*. London: Probsthain.

Davy, John. 1821. *An Account of the Interior of Ceylon and of its Inhabitants with Travels in that Island*. London: Longman, Hurst, Rees, Orme and Brown.

de Silva, Kingsley M. 1981. *A History of Sri Lanka*. Oxford: Oxford University Press.

de Silva, P. H. D. H. 1975. *A Catalogue of Antiquities and other Cultural Objects from Sri Lanka (Ceylon) Abroad*. Colombo: National Museums of Sri Lanka.

de Silva, Rajpal. 1998. *Nineteenth-Century Newspaper Engravings of Ceylon (Sri Lanka)*. London: Serendib Publications.

Duncan, James. 1989. The Power of Place in Kandy, Sri Lanka: 1780–1980. In: John Agnew and James Duncan, eds. *The Power of Place: Bringing Together Geographical and Sociological Imaginations*. London and Winchester, MA: Unwin Hyman.

Dutta, Arindam. 2007. *Bureaucracy of Beauty: Design in the Age of its Global Reproducibility*. London: Routledge.

Falconer, John. 2000. *Regeneration: A Reappraisal of Photography in Ceylon 1850–1900*. London: British Council.

Godakumbara, C. E. 1966. *Sinhalese Doorways*. Colombo: Archaeology Department.

Guha-Thakurta, Tapati. 1992. *The Making of a "New" Indian Art*. Cambridge: Cambridge University Press.

Harrod, Tanya. 1999. *The Crafts in Britain in the Twentieth Century*. New Haven, CT and London: Yale University Press.

Heath, Lionel. 1931. Ceylon Sessional Papers, 1931, Sessional Paper VII-1931. *A REPORT upon Industrial Education in Ceylon with Suggestions for its Development into Training in Arts-Crafts in Order to Improve the Indigenous Cottage Industries on a Basis of Traditional Ceylonese Art*: 1–9.

Jones, Robin. 1996. Nineteenth-Century Carved Ebony Furniture from Sri Lanka: Suggested Methods of Interpretation. *Regional Furniture* X: 27–41.

Jones, Robin. 2004. Furniture from Ceylon (Sri Lanka) at International Exhibitions and World's Fairs, 1851–1904. *Furniture History* XL: 113–34.

Jones, Robin. 2006. An Englishman Abroad—Sir James Emerson Tennent in Ceylon, 1845–50. *Apollo* November: 36–43.

Levell, Nicky. 2000. *Oriental Visions—Exhibitions, Travel and Collecting in the Victorian Age*. London: Horniman Museum and Gardens.

Lewis, John Penry. 1908a. The Kandyan Door. *Spolia Zeylanica* V(XIX) (August): 127–9.

Lewis, John Penry. 1908b. Kandyan Architecture. In: Henry Cave, ed. *The Book of Ceylon*, pp. 325–77. London: Cassell.

Lipsey, Roger. 1977. *Coomaraswamy: His Life and Work*. Princeton, NJ: Princeton University Press.

Mathur, Saloni. 2007. *India by Design: Colonial History and Cultural Display*. Berkeley: University of California.

Metcalf, Thomas. 1989. *An Imperial Vision: Indian Architecture and Britain's Raj*. Berkeley: University of California.

Michell, George. 1998. *Oriental Scenery: Two Hundred Years of India's Artistic and Architectural Heritage*. New Delhi: Timeless Books.

Mitter, Partha. 1994. *Art and Nationalism in Colonial India*. Cambridge: Cambridge University Press.

Natesa Sastu, Pandit. 1890. The Decline of South Indian Arts. *Journal of Indian Art* III.

Raheem, Ismeth. 1982. *The Dutch in Ceylon*. Colombo: Department of National Museums.

Raheem, Ismeth. 2000. *Images of British Ceylon: Nineteenth-Century Photographs of Sri Lanka*. Singapore: Times Editions.

Roberts, Michael, Raheem, Ismeth and Colin-Thomé, Percy. 1989. *People In Between: The Burghers and the Middle Class in the Transformations Within Sri Lanka, 1790s–1960s*. Ratmalana: Sarvodaya.

Robson, David. 2002. *Geoffrey Bawa: The Complete Works*. London: Thames and Hudson.

Robson, David. 2007. *Beyond Bawa: Modern Masterworks from Monsoon Asia*. London: Thames and Hudson.

Roy, Tirthankar. 1999. *Traditional Industry in the Economy of Colonial India*. Cambridge, New York and Melbourne: Cambridge University Press.

Seneviratna, Anuradha. 1983. *Kandy—An Illustrated Survey of Ancient Monuments with Historical, Archaeological and Literary Descriptions including Maps of the City and its Suburbs*. Colombo: Central Cultural Fund.

Sirr, Henry Charles. 1850. *Ceylon and the Cingalese*. 2 vols. London: William Shoberl.

Spencer, Jonathan. 1995. Occidentalism in the East: The Uses of the West in the Politics and Anthropology of South Asia. In: James Carrier, ed. *Occidentalism: Images of the West*. Oxford: Clarendon Press.

Spooner, Brian. 1986. Weavers and Dealers: The Authenticity of an Oriental Carpet. In Arjun Appadurai, ed. *The Social Life of Things: Commodities in Cultural Perspective*. Cambridge: Cambridge University Press.

Tarlo, Emma. 1996. *Clothing Matters: Dress and Identity in India*. Chicago: University of Chicago Press.

Tillotson, G. H. R. 1989. *The Tradition of Indian Architecture: Continuity, Controversy and Change Since 1850*. New Haven, CT and London: Yale University Press.

Wright, Arnold, ed. 1907. *Twentieth-Century Impressions of Ceylon*. London, Durban, Colombo, Perth, Singapore and Hong Kong: Lloyd's Greater Britain Publishing Company.

Statement of Practice

Introduction: Ena de Silva and the Aluwihare Workshops

David G. Robson

David G. Robson is a former professor of architecture of the University of Brighton in the UK and the National University of Singapore.

Abstract

In 1962, 40-year-old Ena de Silva moved into the unique courtyard house that architect Geoffrey Bawa had built for her in Colombo and started to experiment with batik making. Assisted by Laki Senanayake and her son Anil, she established Ena de Silva Fabrics and went on to produce such masterpieces as the ceiling of Bawa's Bentota Beach Hotel and the banners that hang in front of Sri Lanka's parliament. In 1982 she returned to her ancestral home in the hills above Matale and founded a women's cooperative to make batiks and needlework along with a brass foundry and wood-carving workshop. The cooperative has now existed for more than a quarter century and continues to make modern fabrics and carvings, which are inspired by traditional Sri Lankan designs.

Keywords: Sri Lanka, Aluvihara, Ena de Silva, Matale Heritage Centre, batiks.

Ena de Silva was one of a group of designers who were closely associated with the architect Geoffrey Bawa during the 1960s and who would later exert a profound influence on the lifestyle and self-image of the people of Sri Lanka. The group initially included the weaver and colorist Barbara Sansoni, who established a weaving company called Barefoot, the artist Laki Senanayake, the architect Ismeth Raheem, and later took in the architect C. Anjalendran.

Ena de Silva was born in 1922 into a high-ranking Kandyan family. Her father was Richard Aluwihare, whose ancestors had acted as guardians of the famous Aluvihara temple, and her mother was Lucille Moonemalle. Richard Aluwihare was a civil servant under the British who became the first "native" Inspector General of Police and was later given a knighthood. In 1941, at the age of 19, Ena shocked polite society by marrying out of caste, having eloped with Osmund de Silva, a police officer who later rose to be Inspector General.

Ena was renowned as a classical Sinhalese beauty and in 1948 was selected to play the role of the Spirit of Lanka in Deva Suriya Sena's huge Pageant of Ceylon, which was staged to mark Ceylon's independence. A year later she was one of the organizers of a Festival of Arts, an event held to mark the first anniversary of independence, which sparked off her interest in traditional crafts. Encouraged by her husband, who had already assembled a large collection of traditional printed cloths and flags from Sri Lanka and South India, she started to collect examples of traditional craftwork. Throughout the 1960s she traveled extensively around the Kandyan region visiting villages that were associated with specific crafts such as weaving, wood carving, and lacquerwork, encouraging craftsmen to develop new designs and commissioning works to sell to friends.

In 1955 her husband Osmund was appointed Inspector General in succession to her father, but was later criticized for not dealing forcefully enough with the ethnic riots of 1958. Osmund was pushed into retirement by the prime minister, S. W. R. D. Bandaranaike, shortly before the latter was assassinated in 1959. In the same year the couple bought a modest piece of land in Alfred Place and commissioned the pioneering architect Geoffrey Bawa to build a house for them. Ena and Geoffrey became close friends and she played an important role in designing what became the most important single project of Bawa's early career. She had very particular demands—an open-plan living space around a large courtyard, an office for her husband, a studio for her son, a small Buddhist shrine room—and it was she who found the four huge grinding stones which occupy the four corners of the courtyard and had them carried to the site by elephant. It was in her new house that Ena began seriously to experiment with the ancient art of batik, assisted by her young son Anil Jayasuriya and the artist Laki Senanayake, and here that she established the firm of Ena de Silva Fabrics Ltd., or E-Fab, as it later came to be known.

In 1961 Ena held her first "pavement sale" under the front porch of the house in Alfred Place. She had sold a piece of land which she had inherited and used the proceeds to buy and commission products from Kandy craftsmen, which she sold alongside her own creations. Though she failed to cover her costs, the sale was a great success. Hitherto people could only buy imported cloth, while here for the first time they could buy traditional Dumbara weaving and startling new designs printed in bright, modern colors.

The batik business grew quickly during the 1960s and Ena was able to open a shop in Colpetty selling cloth, clothing, and soft furnishings. Her main designer during these early years was her son, Anil Jayasuriya. One of his early commissions had been to make giant concrete reliefs for a school

Fig 1 Batik artists at work at Aluvihara.

by Geoffrey Bawa (1961), and later the firm worked collaboratively with Bawa to produce the batik panels for the Bentota Beach Hotel (1969) and the pennants for the Ceylon Pavilion at the Osaka Expo (1970).

It soon became clear that the studio and courtyard in Alfred Place were not equipped to make large pieces or meet big orders, and so Ena set up a *wadapola* or workshop at Kotte on the eastern edge of Colombo, with five other subsidiary workshops. At its peak the company employed over 100 people and was run by a board of three directors.

One satellite workshop was established at her father's home on the hillside above Aluvihara near Matale. He had by this time retired from public life and she thought that he would enjoy managing part of her business. The workshop employed about twenty women from neighboring villages and produced batiks and embroidery.

In 1968, when Anil was 24, he was badly injured in a car accident. He had recently obtained a first-class honors degree in Zoology and was preparing to leave to study at Oxford, but the accident nipped his academic career in the bud. Against the odds, he remained the firm's principal designer until the beginning of the 1980s. Ena's father died in 1976, to be followed by her husband Osmund two years later. The tragedy of her son's accident and the deaths of her father and husband came as a big blow. Although the firm continued to function, Ena took more of a back seat and

Fig 2 Needleworkers at Aluvihara.

Fig 3 A typical batik design by Anil Jayasuriya.

ceased to be one of its directors. In 1979 she left Sri Lanka on a British Commonwealth contract to train batik-makers in the Virgin Islands, and let her Colombo house to Geoffrey Bawa, who used it as his project office when he was designing Sri Lanka's new parliament.

When she came back to Sri Lanka in 1981, Ena found that Ena de Silva Fabrics had been mismanaged, and so it had to be closed down. She decided to continue to let her Colombo house in order to provide her and her son with incomes. Henceforward she would live in the British-styled bungalow that her father had built in the 1950s on their ancestral land above Aluvihara, with its panoramic views of the Gammaduwa-Pittakanda Hills. She converted this to suit her particular needs, transforming its interiors into an Aladdin's cave of bright colors and hidden treasures.

It was here, at the age of 60, that Ena embarked on a new chapter in her life and set about establishing the craft cooperative that came to be known as the Aluwihare Workshops, reviving traditional skills of wood carving and brass-casting as well as batik and embroidery. Her first dyeing sheds had been built by her artist-collaborator, Laki Senanayake, during the 1960s, while

Fig 4 Ena de Silva in the garden at Aluvihara (2006).

Fig 5 Ena de Silva with architect C. Anjalendran.

her architect friend Anjalendran built the carpentry workshop and the forge. Later she set up Aluwihare Kitchens in a delightful building designed by Anjalendran, where she served traditional Kandyan food to those travelers fortunate enough to track her down in her mountain lair.

Her workforce consisted mainly of women from the surrounding villages and grew from a small core of ten to a peak of about seventy-five. Most of them were paid on piece rates and, as the cooperative grew, many worked from their own homes. No men were employed in senior positions, though she employed youths from the village as carpenters and brass founders working under the supervision of craftsmen who came from further afield. During this period the cooperative benefited from various grants from the Canadian and British governments and from private benefactors.

Ena continued to undertake large architectural commissions and her later projects included the huge wooden elephants at the Kandalama Hotel and the ceiling of Dutch East India Company in the bar of the Lighthouse Hotel. She also made the massive flags that hung for nearly thirty years in the great atrium of the Oberoi Hotel, and the banners that flew in front of the Kotte Parliament on all state occasions.

Ena continues to run her cooperative at the age of 85, though she now employs only a core staff of around thirty women. In a strange way, her success has contributed to her current difficulties. Her workshops have spawned a whole industry and the road from Matale to Naula is now lined with her imitators—batik emporia, restaurants, craft shops—some of them run by her former employees. These all offer products at discounted prices and pay massive bribes to tour drivers. Ena refuses to lower her standards, cut her prices, or pay commissions, and her workshops, though beautifully situated with fantastic views, are far from the main road. Today's tour operators pass her by and she has come to rely on private commissions from architects and friends.

Ena has made an enormous contribution to the rebirth of craftsmanship in modern independent Sri Lanka and has offered vital support to her local community. In 2006 this contribution was recognized when the Aluwihare Heritage Centre was invited by the Daskari Haat Samithi to participate in an interactive workshop as part of the annual craft fair that is held in Delhi. Ena traveled to Delhi with a group of men and women, all of whom were traveling abroad for the first time. The event was such a success that she was invited to return to India with four of her colleagues in the following year to run a batik workshop in Madhya Pradesh.

Interview

Interview conducted by David G. Robson at Aluvihara on June 25, 2007.

Note on Spelling

Ena de Silva spells her family name "Aluwihare," though the conventional spelling of the place name is "Aluvihara."

Note on Names

Ena's married name is de Silva, which is a Portuguese name. Many Sinhalese adopted Portuguese names during the Portuguese period, often when they converted, sometimes temporarily, to Catholicism. However, families hung on to the memory of their traditional ge or "household" name. The de Silvas' ge name was Jayasuriya, and was adopted by both of their children. Ena has said that she in fact disliked both names and often regretted having to give up the name Aluwihare.

DGR: Why did you choose to make batiks—they are not indigenous to Ceylon?

ES: I was looking for a way of producing something novel and interesting and wanted to harness the design skills of my son, Anil. Then Laki looked up "batik" in the *Encyclopedia Britannica* and on the strength of a two-line entry—"Place a lump of wax in a pot and heat it"—we embarked on our first experiments. There were already one or two batik makers in Ceylon, but they were making studio batiks, pictures to hang on a wall, rather than fabrics. At first we started to experiment with our own vegetable dyes—onion skins, gentian violet etc. Then Soma Udabage, who started making Indonesian-styled batiks at about the same time, introduced us to synthetic dyes.

Fig 7 Ganesh batik.

DGR: How did you come to start your first business?

ES: We started Ena de Silva Fabrics soon after we moved into the new house in Alfred Place and set up the batik studio. We held our first "pavement sale" in the front loggia in 1961 to sell a mixture of our own designs

Fig 6 Cushion cover.

and things that we had commissioned from craftsmen in the hills around Kandy. I had inherited some paddy land, which I sold for 92,000 rupees, a lot of money in those days, and I used this to buy the stock. In fact our total receipts came to 85,000, but there were lots of really nice things left over so I was happy. Then we set up a workshop in my father's garden at Aluvihara and built up a core team of women from the neighboring villages. Laki and I would travel up to train the women and supervise the work. The pavement sales were a great success and we later opened a permanent retail outlet in Colpetty, not far from my home, and established a workshop at Kotte on the eastern outskirts of Colombo.

DGR: You yourself never had any formal training in design, in accounting, or in business management.

ES: Nothing, not a thing. I used to sneak out of the art classes at Ladies' College because I preferred botany and zoology. We learned as we went.

DGR: How do you run the workshop?

ES: In the 1970s, Ena de Silva Fabrics had four directors: Laki, our friend Regi Siriwardene, my son Anil, and me. Anil did not draw a salary. After 1981, I employed one of the Aluvihara women, Chandra, as the general manager. The women were paid on piece rates: after our running costs had been deducted, the income from sales was distributed by Chandra on the basis of what had been sold. At first the women were all self-employed, but later the government insisted that we registered as a company. We now run everything in compliance with all the labor laws and pay EPF for all the employees. We have no shareholders and nobody is paid a salary: everybody draws according to what they have produced and sold. After 1981 I didn't draw a single rupee for myself from the workshops—it was my whole life, you see.

DGR: How did you recruit people to work with you?

ES: The women all came from the neighboring village. They are our people, and many of them bear our name. We trained them and they passed on their skills to others. We made it a rule not to employ men from the village in senior positions, though youngsters from the village worked in the carpentry and brass workshops. These were trained and supervised by skilled craftsmen from much further afield, men from whom we had bought things in the past, men who had heard about the *ayathune* (workshop) and come here asking for work.

DGR: How has the workshop affected the lives of those who have worked there?

ES: The women essentially provided a second income for their families. It is true that they earned less than they would working in a modern garment factory, but the conditions here were more pleasant and they were free to manage their own time and to take work home with them. I think we have given our women a sense of independence and helped them to set up new social support networks. We have also contributed considerably to the economy of the village. Some of our women have started small enterprises of their own; some have moved to work with rival workshops. I also think that we helped to break down some of the caste barriers, which fractured the life of the village. In

the beginning the women refused to sit in my presence, and I had to tell them that in the workplace we are all equals. Recently I took a group to India. One young man in the party was low caste and I was so happy when the women sat down to eat with him and referred to him as malli or "younger brother"—something they would never have done in those days.

DGR: How have you set about marketing your products?

ES: In the beginning we reached our local clientele by taking our products to Colombo. Instead of running pavement sales we would run house sales. When we had accumulated enough stock we would descend on Colombo and run a one- or two-day sale from somebody's empty house, or we would hire somewhere like the Lionel Wendt Theater.

Then we started the Aluwihare Kitchen. This was intended partly to offer the delights of traditional village cooking to tourists who usually had to make do with badly cooked European food or bland versions of basic "rice and curry," but partly also to attract clients into our emporium. Once they had eaten a lunch prepared by the village women from local produce and spices, we hoped that they would also buy our products. At one time we ran a small guesthouse and restaurant down beside the main road, and that helped to draw in the tourists, but my cousins (who owned the property) thought I must be making a bomb and tripled the rent. Then the tour operators refused to bring people to lunch because we weren't paying commissions. For this reason, even the bigger and more reputable tour companies bring people here for lunch but actually prevent us from selling our products to their tourists.

But increasingly we have come to rely on our private clients—friends and friends of friends, in Sri Lanka and abroad, to buy our products. And we have benefited from the patronage of architects: first Geoffrey (Bawa), then Ismeth (Raheem), Anjalendran and Nela (de Zoysa), and now younger architects like Channa (Daswatte), who have specified our products in their public buildings and bullied their private clients on our behalf.

DGR: How do you see your contribution within the broader context of craft and production in Sri Lanka?

ES: When we started out forty-five years ago, there was nothing here. Coomaraswamy (1908) had pointed out that, after four centuries of colonial rule, local craft traditions were on the point of extinction. Of course there had never been a great tradition of weaving in Ceylon and in the past most of our printed cloths came from South India and even from Burma. I think that with Mrs. Lyn Ludowyk and Barbara Sansoni and a few other artists and impresarios, we were responsible for helping to start a revival of local crafts, and also for validating them in the eyes of independent Sri Lanka's new middle classes. We were also able to inject new designs into what had become a rather moribund situation and, with the help of people like Geoffrey Bawa, we were able to show how handicrafts could contribute in a positive way to modern environments and new ways of living.

DGR: What has been the impact of the workshops on your own life?

ES: After the death of Ossie, the workshop became my whole life. I am so lucky: it has exposed me to so much, it has enabled me

Fig 8 Ceiling panel from the Bentota Beach Hotel (1969).

to travel, it has brought me into contact with so many people. And the members of my cooperative are like my family. I remember when one foreign ambassador came here he was astonished that I knew all the women by name. What did he expect, I wonder? That I would address them all by number? We are not a factory. I don't think he would have asked such a silly question in Europe!

DGR: A number of your important pieces, like the flags which you made for the parliament, have been replaced with copies made by other people. This seems to suggest that for public clients what you produce is not a work of art—it's simply a manufactured object like an ashtray.

ES: This nearly happened first when Keells were refurbishing the Bentota Beach Hotel in 1996, and they were going to replace Anil's ceiling with cheap copies. I screamed, but fortunately Geoffrey intervened and we were asked to produce a new set using the original cartoons. Then the government had the cheek to ask me to tender in a competition to replace the parliament flags. I refused and they gave the job to someone else who made inferior copies of our designs. Now they've pulled down the banners in the Oberoi Hotel and replaced them with huge hanging lampshades. I don't claim to be an artist, or a designer—I don't know what I am. But I do know that those designs came from us—they were conceived by my son Anil with my guidance: they were a part of my life.

Further Reading

Coomaraswamy, Ananda. *Mediaeval Sinhalese Art*. New York: Pantheon, facsimile 1956; orig. pub. 1908.

Dvivedi, Abilasha and Pradip Putni. *A Batik Yatra from Bhairavagarh Ujjain*. Delhi: Daskari Haat Samithi, 2007.

Jai Jaitly. *Elephant Tales, India—Sri Lanka, International Crafts Design Workshop*. Delhi: Daskari Haat Samithi, 2006.

Robson, David. *Bawa: The Complete Works*. London: Thames & Hudson, 2002.

Robson, David. *Beyond Bawa: Modern Masterworks of Monsoon Asia*. London: Thames & Hudson, 2007.

Rajiva Wijesinha (ed.). *Gilding the Lily: Celebrating Ena da Silva*. Colombo: Lunuganga Trust, 2002.

Primary Text

Commentary

Alla Myzelev

Alla Myzelev is a Postdoctoral Fellow at the Paul Mellon Foundation for the Studies in British Art. Her coedited volume, *Collecting Subjects*, was published by Ashgate in 2008. She is currently writing a book on the collecting practices and preservation strategies in the British and Russian peasant revival communities.

Princess Maria Tenisheva, an artist, art patron, musician, and scholar, is well known to those interested in Russian art, culture, history, and design. Her family estate, Talashkino, became an artistic and educational center providing an exciting creative atmosphere and employment to numerous Russian artists and scholars including Nikolai Roerich (1874–1947), Mikhail Vrubel (1856–1910), and Sergei Maliutin (1859–1937).

She founded the College of Artisans, several elementary peasant schools, courses for teachers, and together with realist artist Ilia Repin (1844–1930), organized drawing schools. In 1893 Tenisheva and her prosperous industrialist husband purchased Talashkino, the family estate of Maria's closest friend, Princess Sviatopolsk-Chetvertinskaya (Kitu). All three of them worked on the realization of the theory of the "moral estate," also developed by Leo Tolstoy, which included education, development of agriculture, and the revival of traditional national culture. By the first decade of the 1900s, Talashkino had become not only a cultural but also a spiritual respite for artists and scholars interested in Russian nationalism in arts and culture, a style that later became known as "Neo-Russian."[1]

Tenisheva continued to look for a new way of educating the peasant farmers that would not only provide specialized knowledge, but also instill in them a patriotic spirit and an aspiration to practice the traditional crafts. In 1894, the Tenishevs acquired the village Flionovo near Talashkino, where they founded an agricultural school that used the very latest

machinery. She organized craft workshops where students could combine the learning of agriculture with the learning of crafts. Repin, Roerich, Vrubel, and Konstantin Korovin (1861–1939) designed objects and ornamental motifs for the workshops. Tenisheva opened a store called Rodnik (the Source) in Moscow to sell the objects created in Talashkino, with an interior designed by Vrubel in the Neo-Russian style.

In 1911 Tenisheva donated her important ethnographical, decorative, and applied arts collection, "Russian Antiquity," to the town of Smolensk. Tenisheva was also a craftsperson herself; she specialized in enameling. Her work was exhibited in Paris, Italy, London, Brussels, and Prague. She defended a dissertation at the Moscow Archaeological Institute and was invited to become a professor there. In 1907, Tenisheva brought her collection of Russian antiques and some of the objects from the already closed workshops in Talashkino to Paris and exhibited them at the Louvre, which was greeted with a significant response in the press and among artistic circles. Due to the revolutionary events in Russia, Tenisheva, who widowed in 1903, moved to France where she lived near Paris until her death in 1928.

Her *Vpechatlenia Moei Zhizni* (My Life Impressions) was written and published in Paris in 1933. Since then the book was edited again at least twice in Russia, where Tenisheva's work and writing are now subjects of increasing interest and scrutiny because of her connection to such important Russian artists as Ilya Repin and Nikolai Roerich. The book presents exactly what its title promises: impressions of life, time spent with influential people, the author's outlook on artistic freedom, national revival, women's role in society and in the arts, and episodes related to her life and work. This partial translation serves to introduce her writing to English-speaking audiences. What follows are the excerpts related to her work in Talashkino, a family estate that also became a center for the revitalization efforts of Russian traditional handicrafts.

Note

[1] See Wendy Salmond, *Arts and Crafts in Imperial Russia: Reviving the Kustar Art Industries*. Cambridge: Cambridge University Press, 1996.

Primary Text

My Life Impressions

Princess Maria Tenisheva (1867–1928)

Princess Maria Tenisheva, *My Life Impressions* (Paris, 1933), pp. 143–4, 197–200, 247, 263–5, 275–6.

Kitu had a house in Smolensk where we usually stayed when we came by horse to the city [from the estate outside of Smolensk]. I turned it into a school, adapting the building for that purpose, with classrooms located upstairs and an apartment downstairs for Kurennoi [an assistant to Repin in Tenisheva's school, hired as the principal of the school].

The goal of the school was to attract as many craftspeople as possible and teach them to draw, a skill that is very helpful in their work. In Smolensk, for instance, ceramic industries were flourishing, and craftspeople who knew how to draw could decorate their vessels more tastefully and, thus, not only raise the prices of their products but also elevate the profile of their industries. The same was true for the carpenters, woodcarvers, and others.

Yet, very few craftspeople applied for acceptance. Aside from two or three boys aged fifteen or sixteen, the group mainly consisted of young ladies who due to boredom were entering various conservatories and classes and courses without any calling or talent.

Next spring when I came back to Smolensk, I was sad to see that my school reminds me of the school of Shtiglitz or one affiliated with the Society for the Encouragement of the Arts, where, for example, the sisters Teliakov were taking classes. The age of these two sisters combined was almost 200 years. I decided that it was because of Kurennoi's inability to attract local craftspeople in spite of all my letters and recommendations. My impression of the school was very unfavorable, which considerably reduced my motivation to continue. In addition, I found Kurennoi himself to be comical. He became poetic in front of this group of sighing, romantic young women who surrounded him in spite of his constantly red face and deeply seated small, cunning eyes. His demeanor

became falsely sweet as he was wearing a light grey suit with very long ends of a white tie, probably to add to the image of an old art master.

Exactly at this time [1895], when I was so disappointed, my husband opened his craft school on Mohovaia [a street in St. Petersburg] and just as Repin had once passed Kurennoi to me, I passed him on to my husband as a drawing teacher for his school. That was the end of my involvement with the school in Smolensk, which existed only two or three winters.

Our school also gave me many artists. The students turned out to be great woodcarvers, and draftsmen. In the Russian peasant one can find anything, one just needs to dig it out. The children come to school as instinctive savages—they cannot even walk properly, yet little by little the children can be licked into shape, the roughness disappears and the human being emerges. There are many capable and even talented people in the masses. I liked to read these personalities, work on educating them, point them into the right direction … Yes, I like my people and believe that the future of Russia depends on them. We need to honestly direct their energies and skills.

[…]

For a long time I wanted to carry out yet another plan in Smolensk. The Russian style, as it was interpreted in the past, was totally forgotten. Everyone perceived it as something out of date, obsolete, dead, incapable of being revived and becoming part of contemporary art. Our grandfathers used to sit on wooden benches, and sleep on feather beds. Of course, such interiors are not satisfactory for my contemporaries. But why can't we create our armchairs, sofas, screens, dressers in the Russian style, not copying the old style but instead being inspired by it? I wanted to try to test my energy in this direction and needed an artist with the greatest imagination who worked from this ancient fairy-tale Russian past. I wanted to find a person with whom I could create the artistic ambiance that I was missing.

I was surrounded by wonderful people who were dear to me, but who were not affiliated with art at all. In addition, I could not totally give myself to the set goal because my husband did not like the countryside; only if the weather was fair could he survive there for two or three months. Once the nights

became longer and darker, he used all kinds of excuses to run away to St. Petersburg or abroad, giving me the opportunity to stay in the countryside for a while longer. In general he did not like it when I was absent for too long. Yet, it was impossible to leave my workshops without management.

Vrubel, when he visited Talashkino, referred me to the artist Maliutin, who had the right combination of style and creativity to help me bring my artistic ventures to life.

Just then Kitu was in Moscow on business, and I asked her to find Maliutin, talk to him and offer him a position in Talashkino. She found him living unimaginably destitute with his wife and several children. He willingly accepted and moved with his family. He turned out to be very useful and became interested in my problems and goals.

Talashkino became a whole special little world, where on every corner artistic life was booming, the mood was enthusiastic, something was created, the complicated chain was forged and tied into a knot link by link. We gathered many capable boys, partly from my students in whom I noticed some artistic talent (for example Mishonov) and partly from outsiders who have heard that in Talashkino they could study the arts.

Not far from the future church, on the slope of a hill, on the background of elms and pines, I wanted to build a special, Russian-style house based on the designs of Maliutin. I commissioned a pretty, cozy *temeremok* [small tower] with a redwood carved facade, which was made in our workshops and had a well-balanced coloring. The windows of this house faced a beautiful landscape of an orchard by the foot of the hill; further away farm fields surrounded by forests. *Temeremok* housed a teacher's study, a piano, and downstairs a study for the students.

[…]

Abroad, the artist of independent means, either male or female, who belongs to high society, is recognized by this society and within artistic circles. In Russia, unfortunately, the artistic realm is hostile to people from different social milieus, especially to those of means, and to women. A woman from the upper classes, therefore, has to work very hard to establish a reputation, to break through indifference, bias, or open malevolence. She is often looked at as a conceited and willful person, and it is suspected that her work is done by someone else. In her own social circles she is considered an eccentric oddity who is pretending to be an artist. She is not forgiven for her strivings and is judged much more strictly than professionals.

[…]

For a long time now, I have been thinking about disseminating *kustar* crafts in the Smolensk area and gradually, little by little, I have been preparing for that. I always thought how great it would be to give the peasants the opportunity to earn money during the winter months, especially women. In fact, peasant women during the long winter months are either idle or go to the cities and factories to earn a living, leaving behind their families, which always has a detrimental effect on their health and order of their family life. I decided to utilize the skills of embroidery and fabric- and yarn-dyeing,

which still survived among Smolensk women peasants.

Antique peasant costumes in our area are very beautiful, but unfortunately, they are not "in fashion" anymore, as peasant women put it. The traditional dress is forgotten, and instead women adapt city fashions using tasteless, mass-produced printed cottons. Yet, old women still keep in their chests all the accessories of the old-fashioned attire, which they will willingly sell. Not only old women know how to embroider in the traditional technique, easily copying any kind of antique pattern—young women can as well. Therefore, without imposing any outside tastes or ideas, we gradually started to get them used to applying their art to our contemporary products. We did not need aprons or *poliaki* [the embroideries on the shoulders of the blouses]; we started from embroidered serviettes, gradually increasing their sizes and then adopting increasingly complex, intricate patterns. The indigenous embroideries feature only very bright red, blue and yellow yarns; we suggested making the patterns using softer, complementary colors. At first, local peasants did not like our colors. They called them "muddy," but gradually they got used to them.

Initially, peasant women resisted the undertaking. They are generally conservative, distrustful of any innovation, and stubborn; but they undertook work timidly and reluctantly, left the workshops, and then came back. We had to overpay in order to get them interested. At first, only the bravest women took the risk of taking the work home. Then, after some time, we were flooded with requests. As far as fifty miles away, women came to ask for work.

All raw materials were bought from peasant women: cloth, yarns, canvases. All these materials were dyed and cut. The correct yarns and threads were chosen, and all was sent back to the peasants. Without leaving her hut, a good needlewoman could easily earn ten, twelve or even more rubles a month in winter, which was a significant amount for them. Among them there were real artists, masters with inborn talent, who worked with colors well and understood easily what needed to be done. In the end we achieved great results; every successful item consisted of intricate patterns, rich in colors, cleanly and precisely executed. Their work became the pride and joy of the workshop. We started making large items: drapes for the windows and doors; upholstery for furniture, which was produced at our woodworking workshop; tablecloths; covers for pianos; and smaller items such as narrow strips for trimming dresses, pillows, and towels, sold by the yard. We employed about 2,000 women in the area and it was hard to find servants or women day-laborers because they made significantly more living at home and working for us. I started dreaming about expanding my enterprise and creating connections with outlets abroad to send our production to Paris and London, especially since foreigners have become interested in our *kustar* industries. Meanwhile, to sell off our production, I opened a store called Rodnik in Moscow.

[…]

Talaskhkino became completely reorganized. No matter where one went within the estate, there was a great deal of lively activity. In the workshop students

were shaving, cutting wood, and decorating carved wooden furniture with stones, fabrics and metals. In the corner there were standing muffle ovens and here, quietly, I was trying to fulfill my dream, which I was afraid even to mention out loud. I was doing experiments, trials, working on the enamels.

In the other workshops young women were sitting with their tambours and loudly singing songs. Older women went by with their knapsacks. They were bringing their completed work and are going to receive new assignments. My heart warmed when I saw all this work.

Exhibition Review

Jean Prouvé: The Poetics of the Technical Object[1]

Design Museum, London, December 7, 2007–April 13, 2008

Reviewed by Christopher Wilk

Christopher Wilk is Keeper of Furniture, Textiles and Fashion at the Victoria and Albert Museum, London.

This intelligent and well-designed exhibition, consisting of furniture, full-scale architectural elements, architectural models, and photo blowups and film, covers the work of Jean Prouvé (1901–84), mainly from about 1931 until the 1960s. It starts with objects from the year he founded Ateliers Jean Prouvé to produce metal furniture and architectural elements, and ends at a time when Prouvé had been pushed out of his own factory by investors and was working exclusively as a designer and as a teacher.[2] Although the Pompidou Center in Paris organized a retrospective in 1993, this is the first large-scale exhibition since then and the first to be shown in Britain.

The exhibition began with the statement, "Jean Prouvé was one of the greatest French designers of the twentieth century." Allowing for the hyperbole that universally infuses museum texts these days, anyone seriously considering Prouvé's work would have to agree that it was highly original and possessed consummate integrity. And yet, until Prouvé's furniture (and, more recently, architecture) began to achieve exceedingly high prices in the marketplace, carefully guided by a small group of French dealers, the literature on French furniture and architecture in the twentieth century did not reflect the view that Prouvé belonged among the pantheon of French designers. Prouvé simply did not figure in the story of French modernism, let alone European modernism, before the 1990s.[3] In terms of the period 1930–53, Prouvé had critical and at least sufficient financial success as a manufacturer and designer to stay in business; but his lack of formal qualification as an architect and the

independence acquired by owning his own factory meant that he stood outside the highly formalized, and hierarchical, structures of the French design world.[4] It is perhaps for that reason that Prouvé is nowadays (and in the exhibition) characterized as difficult to categorize. Prouvé, a socialist who once served as Mayor of Nancy, called himself "a factory man." Both in his own lifetime and later he was variously described as an "architect-engineer" by Le Corbusier (von Vegesack et al. 2006: 244), an "artisan/engineer,"[5] and as a "*constructeur*." This latter term, which Prouvé clearly approved of, was meant both literally—Prouvé as a builder of things—and, uniquely in the French context, was a clear reference to the early twentieth-century opposition between the *constructeurs* and the *coloristes* in French furniture c.1900.[6] *Constructeurs* were trained as craftsmen and made solid, well-crafted pieces, much more sober than the highly colored work of the *coloristes*, who were not trained as makers and who emphasized the appearance of the ensemble over the well-made individual object.

While it was true that Prouvé became a factory man, dedicated to seeking manufactured solutions to architectural and design problems almost exclusively in bent, pressed, and welded sheet steel and aluminum, his work was also fundamentally grounded in his experience of handmaking metalwork. This topic is mentioned at the beginning of the exhibition but not at all developed. This is not merely a matter of excluding from the exhibition his earliest work from the 1920s, his pre-factory years, but of omitting the clear evidence of his craft-based approach in virtually all of his later work.

The reference to Prouvé's craft background in the exhibition consists of a prominent, near life-size photograph of Prouvé, standing in the workshop of "artistic" blacksmith Emile Robert, where Prouvé was apprenticed from 1916 to 1919. Wearing clothing that underlines his artisanal status, the teenager hammers a piece of decorative ironwork held in a vise. This powerful image of the craftsman at work hangs next to a large text panel entitled "Craft to Technology," in which we are told that Prouvé's father Victor was a painter and sculptor, one of the founders of the Art Nouveau School of Nancy. Indeed, as explained in the publication, the Prouvé family had been close to the Gallé family since the time of Jean's grandfather, an embroidery designer, and were part of what Le Corbusier called "the Nancy Dynasty"

(von Vegesack et al. 2006: 365). After his apprenticeship, Prouvé worked in another metalworking/blacksmith's shop until he opened his own workshop in Nancy in 1923 making ornamental and wrought iron work.

The same text panel explains that, once established, Prouvé, who longed to work as an engineer and "embrace the modern movement," introduced steel, aluminum, and arc welding to his workshop and in 1926 installed Nancy's first electric welding machine, followed in 1930 by a metal-folding machine. From this point at the very beginning of the exhibition, all reference to craft in Prouvé's work is abandoned. The relationship between a practice literally forged in the workshop and one based in the factory is not explored. This is surprising on numerous counts. In the exhibition catalog, Catherine Coley (a long-standing and rigorous documenter of Prouvé's work) writes that in establishing his "artist-blacksmith" workshop, the designer recruited "artist-locksmiths and ironsmiths," some of whom spent their entire careers with him (von Vegesack et al. 2006: 110). This offers more than a strong suggestion of a meaningful continuity of craft-based practice. Prouvé's partner in his last company, Les Constructions Jean Prouvé, wrote that "Prouvé was a man out of the Middle Ages, a man who worked with his hands" (von Vegesack et al. 2006: 158). It surely is significant that this was a description of Prouvé in the 1950s, decades after the purported shift from craft to technology.

Most tellingly, in terms of the actual objects on show, Prouvé's earliest handmade furniture (1926–30) differs surprisingly little in terms of appearance from that of subsequent decades. The earliest furniture is rawer, more rough-edged than later productions, but this is more to do with the distinction between his handmade pieces—which might usefully be viewed as crafted prototypes—and those successfully manufactured in a factory. We do not see Prouvé fundamentally transform his approach to design through the years; instead we see his gradual mastery of engineering, and of the tools and machines available to him during the later 1930s, 1940s and 1950s, which allowed him to arrive at more sophisticated and complex designs.

One of the great successes of the exhibition is that the architectural exhibits allow the visitor to gain a sense of the materiality of Prouvé's architecture. They include the complete Maison Tropicale (1951), looking newly made and shown outside the Tate Modern, a complete and pleasingly worn 19¾ × 19¾ ft. (6 × 6 m) prefabricated house (1945) shown in the Design Museum, as well as a display of numerous full-size building panels and other architectural elements, which are well related to photo blowups, drawings, and models. Although there are some photographs showing the manufacture or assembly of his buildings, as well as of the furniture, there is insufficient detail, either photographic or textual, to allow the visitor to conclude anything other than that Prouvé turned his back on craft in favor of the factory. However, in considering the full range of the objects on view, it is hard not to notice that the strongly suggested turn away from the handmade to the machine-made did not result in architectural elements or furniture that differed conceptually or at least substantially from the handmade work.

It is worth stating that, among modernist furniture designers and architects, Prouvé was unique in that he actually produced his own designs, and did so over many decades, both for furniture and architecture. This (indeed, any) sort of contextualization is lacking in both exhibition and book. Some modernist furniture designers, such as Rietveld, handmade their own furniture until they were busy or successful enough to be able to pass on the making to others. Others, such as Marcel Breuer, were involved in making prototypes, but most worked with craftsmen and/or manufacturers who had the technical and material-based expertise required to develop designs for manufacture and then to make them efficiently. Prouvé, like Michael Thonet in the nineteenth century, designed his furniture, created the means to make it himself, and then produced and sold the end product in very large quantities. He knew intimately the processes of cutting, folding, and welding sheets of steel and of aluminum—reflected in the appearance of his designs—and was deeply immersed in the craftsmanship of factory production. This central aspect of his work should be of interest not only to readers of this journal but to anyone trying to understand the significance of craft, or an artisanal attitude, for the machine-made in the modern era.

Notes

1 Alexander von Vegesack, Catherine Dumond d'Ayot and Bruno Reichlin, eds., *Jean Prouvé: The Poetics of the Technical Object*. Weil am Rhein: Vitra Design Museum, 2006.

2 The exhibition was seen at the Design Museum, London (December 7, 2007–April 13, 2008) at the end of a tour of Europe and Japan. The installation was designed by Graphic Thought Facility and Michael Marriott. The exhibition was organized by the Vitra Design Museum, Weil-am-Rhein, Germany, in cooperation with Deutsches Architektur Museum, Frankfurt, and Design Museum Akihabara, Japan.

3 The earliest monographs were B. Huber and J. C. Steinegger, eds., *Jean Prouvé: Architektur aus der Fabrik* (Zurich: Artemis, 1971); W. A. L. Beeren et al., *Jean Prouvé, constructeur* (Rotterdam: Boymans–van Beuningen Museum, 1981); and D. Clayssen, *Jean Prouvé: L'Idée constructive* (Paris: Dunod, 1983). A full bibliography is published in what is called the catalog of the exhibition, but which is, in fact, a large monograph—Alexander von Vegesack, Catherine Dumond d'Ayot and Bruno Reichlin, eds., *Jean Prouvé: The Poetics of the Technical Object*.

4 This topic is not discussed in the accompanying publication, despite its having sixty-five separate chapters by forty-four authors. Even at the end of his career, when Prouvé notably served as chairman of the jury for the new Pompidou Center, he was the victim of snobbish attacks for his lack of formal degrees and qualifications. Although the book has a section on "reputation and legacy," the fascinating topic of Prouvé's shifting reputation and acknowledgment, and his place within the architecture and design professions in France, remains unexplored.

5 Kenneth Frampton, *Modern Architecture: A Critical History*, p. 303. London: Thames & Hudson, 1987.

6 On the distinction between *les constructeurs* and *les coloristes*, see Nancy Troy, *Modernism and the Decorative Arts in France*, pp. 67–70 and passim. New Haven, CT and London: Yale University Press, 1991.

Exhibition Review

Hands on Movement: A Dialogue with History

Reviewed by Christina Zetterlund

Christina Zetterlund is lecturer at Konstfack University College of Arts, Crafts and Design, Stockholm.

Hands on Movement—Crafted Form in Dialogue was a thought-provoking exhibition held from June 18 to August 22, 2007 at Liljevalchs Konsthall in Stockholm.[1] The title of the exhibition was vague and hardly qualifies as a selling point. One immediately asks "what does 'hands on movement' mean?" And "what is 'crafted form'?" Vagueness was, however, an appropriate quality in this context as the exhibition portrayed dynamic practices in the midst of change. Its participants included craftspeople and designers who cannot be defined in the traditional way, by reference to material or technique. They are operating in an elusive and expanded field.

Zandra Ahl and Päivi Ernkvist, the curators of the exhibition, are both trained ceramists but are working within various other practices as well. The exhibition under review and their previous experimental project *Craft in Dialogue*, which they carried out for the Swedish Art Grant Foundation between 2003 and 2006, are just two examples of their numerous border-crossing activities.[2] They are themselves active representatives of the expanded field that they showed in the exhibition.

At Liljevalchs each of the twelve participating artists were given an exhibition room of their own (apart from Enzo Mari, whose pieces were shown in an adjoining garden). The design gave each artist a lot of space although it should be said that the fact that the artists were physically separated made dialogs between them compromised. When walking

through the rooms the visitor came across such different areas of practice as graphic design, jewelry, interior design, industrial design and Manga-inspired clay sculptures. What all the artists had in common is a critical and investigative approach towards their work. They question general concepts and stretch the limits of their own practice.

A literal way of expanding our understanding of these practices was offered by the graphic designers Hjärta Smärta (Heart Ache) and the jeweler Dine Besem. They invited us to experience their craft both visually and physically. By showing a sculpture in the shape of an 'o' Hjärta Smärta let two-dimensional typography grow into a large three-dimensional form. Similarly, we could walk through Dine Besem's labyrinth formation made out of paper beams. Though she began her career as a jeweler she has let her ornaments grow into sculpture with architectonic qualities.

Front Design, with four members that are all trained industrial designers, presented a poetic investigation of the design process itself. Within current industrial design practice this process is often assumed to entail carefully monitored steps that are necessary in order to arrive at all the complex details of the future product. Front skips that whole process. They let the first sketch become the final version. Like magicians, but with the help of advanced technology, Front transform their initial drawings directly into furniture.

Like Front, the common perception of practice constituted part of ceramist duo Claydies' working material. Under the title *True Feelings* they addressed notions and biases that are present in contemporary pottery. Their room was filled with blue vases, jugs and bowls displayed on white pedestals. As all the pieces were made using a simple pinchpot technique they had

Fig 1 Claydies, *True Feelings*, 2007. As installed at Liljevalchs Konsthall, Stockholm, Sweden. Photo: Jan Almerén, 2007.

a childish quality. On the blue painted walls hung photographs of the two ceramists in the nude, blindfolded, lustfully crafting the pieces that were exhibited in the room. *True Feelings* offers a sharp and humorous observation on the ceramics discourse's notions of presence and authenticity.

One of the best contributions of the exhibition was a section where the curators explored historical precedents. In Sweden, the current border-crossing practice displayed by the participating artists is often described as something unique to our time. By pointing towards some forerunners and researching the history of Liljevalchs's craft and design exhibitions, the curators anchored the contemporary discourse in the past, thus rendering that discourse more complex and nuanced. Liljevalchs has been the site for several exhibitions, such as *The Home Exhibition* (1917) and *Form Fantasy* (1964), which have iconic status in Swedish design history. By digging into the archives, though, Ahl and Ernkvist discovered traces outside the mainstream. One of these paths is that of handicraft, which has been given a marginal role in Swedish design history. The impact of the functionalist movement, which gained momentum in the 1930s, was devastating for the reputation of the handmade, but the Liljevalchs material shows that the interest in craft remained strong in subsequent decades.

In the historical material we were also reminded of the experimental and politically engaged craft movement that developed during the 1960s, which was displayed in the 1970 *Mao* show at Liljevalchs. This experimental spirit has been lost in histories that focus on objects and materials, but it is a character that is shared and now forcefully displayed by the artists participating in *Hands On Movement*. These historic links were revealed by including international and Swedish forerunners from the 1960s and 1970s in the current exhibition: Ettore Sottsass' *Monument Over Mustard* was shown alongside Margareta Hallek's monumental and interactive textile *Two Floors—a Starry Sky*. In the garden the visitors could drink their tea sitting in furniture made after open source drawings by the postwar Italian designer Enzo Mari.

In addition to these predecessors from the postwar era, Ahl and Ernkvist also looked at the early twentieth-century textile designer Elsa Gullberg, who was presented as a multi-skilled artist who worked within various practices such as curating, entrepreneurship, design and craft promotion, as well as a whole range of textile production from handicraft to mass production. By making this choice of perspective in describing Gullberg's career Ahl and Ernkvist illustrate that border crossing is not unique for our time. The reason this fact has been lost has more to do with the Swedish design and art history's paradigmatically Modernist perspective than with historical reality. The example of Gullberg definitely questions fetishizing of genre within historical writing. It is evident that the examination of such archival material is a complex process, as the course of events (in craft history and other histories alike) is disparate, vague, and difficult to capture. All too often they are not as linear as they are portrayed. *Hands On Movement* demonstrated that it is not just our current practice that exists in the expanded field. It indicated that the understanding of Swedish design history is also slowly moving in that direction.

Notes

1 The exhibition included the work of Dutch artists Jurgen Bey, Sophie Krier, Dinie Besems and Ted Noten; Andreas och Fredrika, Pontus Lindvall, Margareta Hallek and Front Design, all from Sweden; the Danish partnership Claydies; Takashi Hinoda (Japan) and the Italian designers Ettore Sottsass and Enzo Mari.

2 Christina Zetterlund, *Craft in Dialogue 2003–6* (Stockholm: Konstnärsnämnden, 2007).

Bibliography

Wickman, Kerstin, ed. 1995. *Formens rörelse: Svensk form genom 150 år.* Stockholm: Carlsson.

Widenheim, Cecilia, ed. *Utopia & Reality: Modernity in Sweden 1900–1960*, New Haven, CT: Yale University Press, 2002.

Widman, Dag. 1975. *Konsten i Sverige. Konsthantverk, konstindustri, design 1895–1975.* Stockholm: AWE/Geber.

Zetterlund, Christina. 2007. *Craft in Dialogue 2003–2006.* Stockholm: Konstnärsnämnden.

Book Review

What Do Pictures Want? The Lives and Loves of Images
W.J.T. Mitchell

Chicago: University of Chicago Press, 2005. US$22.50 (paperback), US$35.00 (cloth cover). ISBN: 978-0-226-53248-6 (paperback), 978-0-226-53245-5 (cloth cover)

Reviewed by Justin Clemens

Justin Clemens teaches at the University of Melbourne. He has published extensively on contemporary philosophy, psychoanalysis, art and craft. His most recent book is *Black River* (re.press, 2007), illustrated by Helen Johnson.

The title of this book might lead an innocent reviewer into presuming that W.J.T. Mitchell has succumbed to one of the worst of all the errors of aesthetic judgement: the anthropomorphic fallacy—thinking of inanimate, fabricated objects as if they suffered from the same psychological impulses as human beings. This would be a mistake, for Mitchell is after something else, which is not so much anthropological as virological. The peculiar status that he wishes to assign to "pictures" is more that of undead and inhuman life (see pp. 44–5). As he puts it, "Images are not just passive entities that coexist with their human hosts, any more than the microorganisms that dwell in our intestines. They change the way we think and see and dream" (p. 92). Like such microorganisms, images are indispensable to their human hosts, who cannot seem to live without them; images, moreover, divide and multiply and relate and mutate in extraordinarily complicated ways.

Mitchell is out to track some of these complications and to do so beyond the methods and concepts familiar from modern aesthetics. To this end, the question of aesthetic "evaluation" here becomes a question of transaesthetic "vitality," whereby the desires of images become an enigmatic,

affective affront to their spectator-hosts—and not just the inert material for the exercise of a sovereign human will and judgment. On the other hand, images are not simply to be given an independent power of their own, as if they functioned like malevolent inhuman forces from an absolute outside. This conviction about the uncanny ambivalence of images leads Mitchell naturally to the abiding problems of iconoclasm, to the peculiarly monotheistic abomination of idols, for which the golden calf of Exodus stands here as emblem (see pp. 16, 31, 32n10, 90, 102, 102n57, 103, 105) as well as to the classical examples of Narcissus, Tantalus, Pygmalion and Medusa, in which images literally kill or come to life. It is, then, our inextricable *implication* in images that interests Mitchell—and the consequences this has for the ways in which we can talk about them at all.

The book is divided into three major sections titled "Images," "Objects" and "Media," comprising sixteen chapters and a preface. Most of the chapters were written for specific occasions over a period of nearly a decade and many have been previously published in a number of eminent academic anthologies or journals such as *October* and *Critical Inquiry*. Yet the chapters do evince certain recurrent thematic obsessions, just as Mitchell's approach is governed by a certain theoretical attitude. For Mitchell, contemporary attitudes to images are as "magical" as they have ever (supposedly) been; images are inherently and irreducibly volatile insofar as they seem to call simultaneously for belief and criticism, heady enthusiasm and skeptical resistance; this volatility is best thought of under the analogy of a vital organism, with all that implies (affects, motivations, functions, actions, etc.); this vitality cannot *simply* be explained by recourse to economics, materials, or technologies. In other words the alleged "superstitions" about images are not mere superstitions; on the contrary, images really do make people do things because images are an integral part of social practices and not just add-ons that can be ignored or reduced.

What is now denominated (and sometimes still denounced) as "theory" is an amalgam of a variety of concepts drawn from a range of preexisting disciplines—including anthropology, psychology, theology, sociology, philosophy, aesthetics and history—whereby one picks and chooses one's terms under conditions that range from personal taste to institutional restriction. Theory therefore almost invariably unfolds according to topical problems of application ("how do I, here, account for that, there?"). As such, it is constitutively impure and ideologically pragmatic. One problem with this is that it tends to blur the clarity of concepts, as it occludes the irreducibility of antagonism. This double movement becomes very clear in Chapter 3, "Drawing Desires," in which Mitchell discusses two dominant tendencies in the theorizing of desire: Plato is opposed to Aristotle, psychoanalysis to William Blake and Gilles Deleuze. This is phrased in the terms, respectively, of lack versus positivity, disjoint hierarchy versus immanent totality, mathematical discrimination versus biological dynamism. Mitchell's preference is for the second option because it is "more flexible" when dealing with images. Perhaps this is true, but it doesn't stop him from drawing on psychoanalytic concepts—or those from any other discipline—when it suits him, as if there were no difficulty with doing so, or

as if any such difficulty were no real difficulty at all.

This approach renders Mitchell at once too theoretical and not theoretical enough. Too theoretical in that he is not always adequately attentive to the labor, techniques and situations that shape different regimes of image production, the very specific material circumstances that effect, affect and inflect their appearing at all. In his attempt to complicate traditional conceptions of image and object production, Mitchell at times comes to implicitly treat spectators as if they were the true makers. This means that he often does not look at the material constitution of works in detail, simply preferring to list the complexities in some kind of general way.

What eludes such an approach is any serious account of the status of those who, in particular circumstances, are assigned the role of image production, not to mention the consequences thereof for understanding what's going on. Let's take a suggestive example from Jacques Lacan, that of the role of artisans in Plato's dialogs.[1] For Lacan, these personages don't appear *simply* under the heading of the notorious Platonic iconophobia but rather as serfs; and not just as any kind of serf, either, but as a peculiar function inscribed at the very heart of the *polis*, in the economy of the home. In the dialogs the serfs are there to be mocked, certainly, to give the right answers to the questions of their talkative masters—but also to have their *savoir faire* extracted to the benefits of abstracted *savoir*, to be forced to participate through dialogue in their own further subjection. "How do you do this?" asks Socrates. "What do you *really* know about what you're doing? How is it you can keep on doing it without knowing?" His interlocutors will be forced to answer in words, to explain their movements and motivations and finally to have to admit that there is a lapse in their ability to account for their actions. You've made a pot? How? Why? What is the good of it? It turns out that the practice is faulty, as are its ground and ends. The heady enthusiasm of poets, the delusory dissimulations of painters, the hard craft of making will be revealed as regional not universal activities, derivative not primary, illusory not real. In the great metaphor offered in the *Republic*, such practices are merely shadows thrown upon the wall of the cave for the prisoners in chains. As this revelation is taking place the embodied skills of the serfs are turned into discourse able to be reapplied elsewhere. So not only will such craftspersons be ridiculed, not only will their products be denounced, not only will they bear the brunt of the discussion but they will be forced to be grateful to their masters for relieving them of their livelihoods. Moreover, what occludes itself is the very *function* of the philosopher's discourse: that it is an extraction device for rulers.

It is the complexity of such labor practices that Mitchell does not want to deal with in detail. Sure, it's not his project; sure, he's trying to displace or shift the discussion elsewhere. But such shifts have consequences for what you make of what you see, as for the function of your own account. In other words, Mitchell ignores the status of the crafts *per se*, the hardship of working with materials, the antagonisms and exploitations seething in technologies of training, production, exchange, prestige, significance. If he is often very good on the interpretation of aspects of the implicit ideologies of

famous works of art (for example his short analysis of the imperial elements in John Milton's *Paradise Lost*, pp. 165–6), Mitchell is not so good on the details of making itself. He essentially takes these elements for granted rather than examining them as real problems for action. For Mitchell, images pose problems in their interpretation, not their creation, and Mitchell participates in this obscurantism of the problem at the very moment that he is very attentive to it, for example in the creation of the Biblical Golden Calf which leaps out of the fire by itself. I can understand his dislike of too-easy accounts of "the male gaze" or "class oppression." But this dislike ends up trying to neutralize or sideline some very real and very specific antagonisms.

But Mitchell is also not theoretical enough in that he is unable or unwilling to attain the extremity of concepts. What looks like admirable flexibility and ecumenical openness from one point of view can suddenly appear careless, facile and irrelevant from another. Hence Mitchell can assimilate C.S. Pierce's semiology to Jacques Lacan's psychoanalytic account and run together "desire," "pleasure," "demand" and "love" without doing the hard work of establishing the distinctions or the place from which such distinctions might make sense. It really isn't the case that when "an object becomes sublime it is the all, the totality, the incomprehensible" (p. 121) for one post-Kantian philosophical take on the sublime is that it puts the notions of "all" and "totality" and "incomprehensible"

into question or, at least, radically resignifies them. As for the table proffered on p. 195, outlining "with some trepidation" the "historical and synchronical relations among totemism, fetishism, and idolatry," it's a taxonomic mess. The point is that impure theory performs its own ideals, which return as naturalized affairs, without outside. But this means that theory never really tests itself and its limits but rediscovers its own presuppositions as if they were virtues wherever it looks. As it does so, it throws up mixed metaphors and confused notions. The book is indeed—Mitchell himself admits the validity of the charge—perhaps "too promiscuous."

Yet these difficulties are neither eradicable nor fatal but are constitutive and productive. Mitchell's book is itself testament to the benefits of complication, ambivalence and hesitation. *What do pictures want?* is, as Mitchell puts it, "an invitation to a conversational opening or an improvisation in which the outcome is somewhat indeterminate, rather than an ordered series of steps" (pp. 48–9). This pleasant invitation should not, as I've tried to imply, prevent us from strenuously conversing with him and others. Nor, for that matter, should it prevent us from arguing about just what might hold such conversations up.

Note

[1] See J. Lacan, *Seminar XVII: The Other Side of Psychoanalysis*, trans. R. Grigg (New York: Norton, 2007), esp. pp. 21–2.

Book Review

The Craftsman
Richard Sennett

London: Allen Lane/Penguin, 2008. £25.00 (cloth cover). ISBN: 978 0 71399 873 3 (cloth cover) [Published in the United States by: New Haven, CT: Yale University Press, 2008. US$27.50 (cloth cover). ISBN: 978 0 30011 909 1 (cloth cover)]

Reviewed by Emmanuel Cooper

Emmanuel Cooper is a potter, Editor of *Ceramic Review*, and Visiting Professor in Ceramics and Glass at the Royal College of Art, London.

I was both drawn to and made uncomfortable by the title of philosopher and sociologist Richard Sennett's book, hoping for discussion of the concept of the craftsman, but suspicious that it would be little more than a romantic threnody for lost skills and trades. Twenty-five years or so ago the pioneering environmentalist potter Harry Davis gave a talk and wrote a paper along the lines of "Whither Craft,"[1] a theme immediately suggesting that hope was lost and a return to past values essential. Sennett's title provoked much the same sort of response: its bald, gender-specific title seeming to belong to a past era. In the event, both Davis's talk and Sennett's book, in the scope of their argument and the extent of their passion, confounded and affirmed expectations, although both assert, in their own way, the value and satisfaction of making things.

Davis had a clear—even a rigid—understanding of what craft meant to him, one firmly rooted in a Morrisian tradition. As a craftsman he felt that he was responsible for all stages of production, from which he expected to make a modest living. Sennett has no such clear-cut concept, but, taking an all-embracing global view, sees craftsmanship as "an enduring, basic human instinct, the desire to do a job well for its own sake." This, he argues "serves the computer programmer, the doctor, and the artist," which gives some indication of the breadth of his concerns. The book, he says, is about material

culture, focusing on "the intimate connection between hand and head," encompassing "hand skills such as [those of] glass blowers, carpenters and cooks" as well as "mind or head skills" like computer programmers working on the Linux operating system, whose satisfaction lies in contributing to it as an "open source."

In the first of three sections, Sennett takes a fascinating look at the craftsman in a communal workshop, where apprentice and master operate in a strict hierarchy, with skills passed on as much by watching and practice as teaching. He cites as examples the guilds of medieval goldsmiths, the ateliers of musical instrument makers, and modern laboratories. Ironically, he argues, it was in the goldsmithing workshop of Benvenuto Cellini that the fatal division between art and craft first emerged. Cellini's dazzling talent to create ornate and brilliant work was, he states, recognized by the wealthy and powerful, and he was acknowledged as an individual author distinct from the more anonymous workshop where he worked—a view that simplifies a complex change in perception. Sennett's belief in the satisfaction of the "job well done for its own sake" puts a nostalgic gloss on often poorly paid physical labor. Quoting Hannah Arendt, he uses the terms "*Animal laborens*" and "*Homo faber*" to distinguish between sheer physical toil and work that is thoughtful and satisfying in its own terms, a distinction that does not acknowledge any of the problems with such a simplistic division.

There is no disputing mankind's skill or its ability to invent, the theme of the second part of the book. Kant's remark "The hand is the window on to the mind" is cited as evidence of the importance of craft, a neat, and earlier, take on Freud's dictum that dreams are the highway to the unconscious. As an example of skill and invention, Sennett relates The Brickmaker's Tale, describing the ingenious variations in bricks and how they literally helped shape the progress of civilization. While applauding the variety and range of the brickmaker's art, he does not highlight the sheer physical slog involved in collecting clay, mixing it with a suitable temper such as straw, and successfully firing it. Bringing us into more modern times, unlike his hero, Ruskin, Sennett welcomes the machine, but fails to point out that while it reduced physical labor, workers were expected to toil just as hard to increase production.

Motivation rather than talent is the theme of the third and final section. Taking up the view widely expressed by Enlightenment thinkers, that everyone possesses the ability to do good work, and that there is a craftsman in all of us, any failure is attributed to poor motivation rather than to lack of innate ability. This leads Sennett to make his claim that "Almost anyone can become a good craftsman." He points to the ability of children to play, and its importance in developing sociable skills, cognitive competence, and discipline in following rules while offering the opportunity to create and experiment. All, argues Sennett, are early examples of craftsmanship.

Unfortunately, work replaces play and, try as we might, the freshness and freedom in inventing and making without fearing failure, so evident in children's work, gets lost along the way. When Picasso admired the immediacy and spontaneity of children's drawings, saying how much he longed to capture those qualities, he knew full well that it lay beyond his reach.

In setting out to reaffirm the value of making things, placing such activity in the center of a satisfying contemporary life, Sennett pays little attention to the confusing contemporary picture. In twenty-first-century Britain (and many other developed countries), huge numbers of people are involved in "craft" in some form—far more than art, sport, or other pastimes. Home crafts such as sewing, quilting, and knitting are as popular as ever.[2] Makeover TV series promote programs on creating your own home interiors and designer gardens, while cooking remains a firm favorite. Alongside this is the dramatic rise of ersatz "craft" widely available on the Internet or presented and defined by television shopping channels, which have, for millions, reduced craft skills to ready-made "peel off" and "stick on" kits. I doubt that these are the craftsmen Sennett is discussing, though many take an element of pride in their achievements, far exceeding any feeling of satisfaction they may experience at work.

In a society where the notion of craft has taken on many meanings—ranging from heavy commercialization to the exclusive territory of a small group of artist-makers, it is clear that "craft" is a problematic term, while the concept of the craftsman is a modern rather than a historical concept, which can be almost anything we want it to be.

Despite Sennett's engaging and wide-ranging account, and his assertion, following Ruskin, of the moral as well as practical value of craftsmanship, craft remains a tricky subject. Sennett fails to establish and maintain a clear identity for it, or one that takes into account issues around class, economics, or even fashion. Yet, in affirming the value of understanding material and process, Sennett opens up a welcome debate on what is often seen by artist-craftsmen as the "craft crisis." For, in the end, we all want the craftsman rather than the cowboy.

Notes

[1] Harry Davis (1910–86) gave the talk "An Assessment of the Craft Movement" at a weekend conference organized by the Craftsmen Potters Association at Dartington Hall, UK, in September 1981. A version of the talk was subsequently published in *Ceramic Review* 67 (1981): 32–3.

[2] A headline in the *Daily Telegraph* declared "Sewing Back in Fashion," citing a 50 percent increase in sales of sewing machines (April 21, 2008). *The Guardian* (May 5, 2008) reported that, in the "garden revolution" sweeping Britain, the British public spend £4 billion on flowers, plants, garden tools, and garden accessories every year.

Book Review

The Intangibilities of Form: Skill and Deskilling in Art after the Readymade
John Roberts

London: Verso, 2007. £16.99 (paperback), £60.00 (cloth cover). ISBN 978 1 84467 167 0 (paperback), 978 1 84467 163 2 (cloth cover)

Reviewed by Joshua A. Shannon

Joshua A. Shannon is Assistant Professor of Contemporary Art History and Theory at the University of Maryland, College Park.

By the 1980s, the critique of the author was so successful that it had become an artistic style in its own right. Even outright copying of other artists' work, such as Sherrie Levine's rephotography of Walker Evans's iconic images of the 1930s, was recuperated by the market for the celebration of its individual makers. In the decades since, many complicated varieties of artistic subjectivity have proliferated. Indeed, as John Roberts is careful to say in the introduction to his compelling new book, *The Intangibilities of Form: Skill and Deskilling in Art After the Readymade*, artistic subjectivity has always been a rather elaborate and contradictory set of concepts, particularly since Marcel Duchamp's signed urinal, *Fountain*, of 1917. Roberts takes up the topic of artistic subjectivity over the past century, seeking to articulate the ways in which art-making has managed to operate as a critical engagement with labor more generally.

It is a crucial and ambitious topic. Although art historians have trained careful attention on subjectivity in the past couple of decades, there has until now been no major account connecting art-making to Marxist understandings of

labor. Roberts locates a new interdisciplinary territory beside the art historical work of Caroline Jones, the meta-criticism of the editors of the journal *October*, and the manifesto-like art writing of Nicolas Bourriaud.[1] Of course, the book is also conceived as an answer to scholars of Duchamp, especially Thierry de Duve and David Joselit.[2] To all these, Roberts promises to add an investment in the history and form of *social technique*, as he puts it—recasting Duchamp and his followers as "critic[s] of *the separation of artistic labor and productive labor*" (61, emphasis original).

The first part of the book, then, devotes itself to a close theoretical examination of Duchamp's readymades as the works that brought art-making into promising critical conjunction with the industrial production of consumer objects. (*In Advance of the Broken Arm*—the snow shovel the artist labeled and displayed in 1915—appears on the cover, but this is not a book engaged with individual works of art; none are reproduced in its pages.) Roberts is interested in the readymades not so much for their intervention in our understanding of commodities per se, nor for their critique of the category of art; rather he considers these works for their location at the crossroads of artisanal and industrial labor, even for their engagement with the transformation of these modes over the recent history of capitalism. He nimbly identifies Duchamp's careful hand-coloring of photographs in *The Green Box*, too, as a further representation of the ways in which categories such as craft and manufacturing inevitably interpenetrate and confound each other.

This framing of the problem leaves Roberts about 125 pages to explore various practices adopted by—to quote his fourth chapter title—"the post-Cartesian artist." Here problems get framed in exciting ways. Picking up on the history sketched in the introduction, Roberts asks, "How is it possible to think in terms of the critique of the author and defend the authorship of the artist?" (113) This is a pressing question, since it seems imperative that we hold onto Barthes's and Foucault's dislodging of the myth of authorial autonomy (certainly all the things we produce are as much *found* by us as made) even while we recognize, of course, the persistence of individual human subjects and their sometimes quite particular products. Art history has preferred to ignore the problem of having to believe both these things at once.

Roberts makes a compelling promise, too, at the start of chapter six: "Since the 1980s and the assimilation of Conceptual art as the determining framework for the critique of modernist subjectivism, the critique of the author has diversified in a number of directions … I want to explore some of the avenues this labor has opened up, as it connects with the technological, social and political transformations over these decades" (165). Roberts convinces us that such a task is crucial—what, indeed, are the modes in which artists credibly work now? And what *do* those modes have to teach us about the rapidly transforming nature of labor in a globalizing world?

The book operates, however, primarily at a single, high level of abstraction. One result is that the important questions Roberts is always framing sometimes get answers that are more vague than we might like. Chapter five, for example, which advertises itself in part as a comparison of different

modes of diffused authorship (mentioning Rembrandt and Rodin as well as Moholy-Nagy and Andre), ends not far from where it began, seeing the twentieth-century cases as "provid[ing] a shared understanding of the social limits of Cartesian modernism" (161). I am certain this is right, but a closer attention to what each of these workshops rejected in Descartes's philosophy of the self would have given Roberts's inquiry a far sharper point.

Put differently, the book's chief weakness is an occasional reluctance to get its hands dirty when most necessary. *The Intangibilities of Form* is by no means a lightweight effort—Roberts speaks authoritatively on topics ranging from theoretical anthropology to Objectivist poetry—but important concepts are sometimes put under insufficient pressure. Certainly, one of the book's major interests is in articulating how artists have modeled versions of subjectivity that have the potential to radically reform our notions of work. Why then, is there so little discussion of what in Cartesianism is and is not still persuasive? And why so little direct engagement with Barthes and Foucault, or with the ways Roberts believes subjectivity to have changed since the 1960s? Further possibilities, too, could have been opened up by asking individual works of art to speak more precisely (and in ways more varied from one to the other) about the conditions they engage.

This is a boldly interdisciplinary book, and as such, it runs the risk of leaving readers from various quarters dissatisfied. Those who read primarily in Marxist cultural criticism rather than in art history will likely feel most at home here. Unfortunately, there are weaknesses in writing—long, meandering paragraphs, gleefully impenetrable section headings (following page 95, we read about "Latent Totipotentiality of Negative Labor-Power")—problems that are endemic to some of the most important writing of our time. Finally, Roberts might have lingered productively in history (here I think, for example, of Julia Bryan-Wilson's current engagement with art and American notions of labor in the 1970s).[3] In its rather elevated view of things, however, this important book trains our attention on one of the most pressing concerns in contemporary art. Rejecting the glib binaries that now plague weaker instances of scholarship in the tradition of Theodor Adorno, it is a model for theorists wishing to ask grand questions in a subtle and capacious mode.

Notes

[1] See especially Caroline Jones, *Machine in the Studio: Constructing the Postwar American Artist*. Chicago: University of Chicago Press, 1996; Rosalind Krauss et al., "The Reception of the Sixties," *October* 69 (1994): 3–21; Nicolas Bourriaud, *Esthétique relationelle*. Dijon: Les Presses du Réel, 2001.

[2] Thierry de Duve, *Kant After Duchamp*. Cambridge, MA: MIT Press, 1996; David Joselit, *Infinite Regress: Marcel Duchamp, 1910–1941*. Cambridge, MA: MIT Press, 1998.

[3] Julia Bryan-Wilson, "Hard Hats and Art Strikes: Robert Morris in 1970," *The Art Bulletin* 89(2) (2007): 333–59; Julia Bryan-Wilson, *Art Workers: Radical Practice in the Vietnam War Era*. Berkeley: University of California Press, forthcoming.

American Art
SMITHSONIAN AMERICAN ART MUSEUM

... a peer-reviewed journal dedicated to exploring all aspects of the nation's visual heritage.

American Art, sponsored by the Smithsonian American Art Museum, is a peer-reviewed journal dedicated to exploring all aspects of the nation's visual heritage from colonial to contemporary times. Through a broad interdisciplinary approach, *American Art* provides an understanding not only of specific artists and art objects, but also of the cultural, political, and social factors that have shaped the nation and its art.

THE UNIVERSITY OF CHICAGO PRESS
JOURNALS DIVISION

Three issues/year
ISSN: 1073-9300

Print and Electronic, $45
Member (Print + Electronic), $35
Student (Print-only), $30

Individual Subscription Rates valid through December 31, 2008. Additional shipping and taxes applied to international orders.

Executive Editor
Cynthia Mills,
The Smithsonian American Art Museum

To Subscribe
Phone: 1.877.705.1878
1.773.753.3347
Fax: 1.877.705.1879
1.773.753.0811
www.journals.uchicago.edu/AmArt

Log_On **CHICAGO** JOURNALS
WWW.JOURNALS.UCHICAGO.EDU

THE JOURNAL OF MODERN CRAFT
Notes for Contributors

Articles should be of a length between 5,000 and 6,000 words including notes and references, with 8 to 10 images. They should include a three-sentence biography of the author(s), an abstract and 5–8 keywords. Interviews should not exceed 15 pages and do not require an author biography. Exhibition and book reviews are normally 500 to 2,000 words in length. The Publishers will require a disk as well as a hard copy of any contributions (please mark clearly on the disk what word-processing program has been used). Berg accepts most programs with the exception of Clarisworks.

The Journal of Modern Craft invites persons wishing to organize a special issue devoted to a single topic to submit a proposal comprising a 100-word description of the topic, together with a list of potential contributors and paper subjects. Proposals are accepted only after review by the journal editors and in-house editorial staff at Berg.

Manuscripts

Manuscripts should be submitted to the *The Journal of Modern Craft*, c/o Glenn Adamson (email: g.adamson@vam.ac.uk). Manuscripts will be acknowledged by the editor and entered into the review process discussed below. Manuscripts without illustrations will not be returned unless the author provides a self-addressed stamped envelope. Submission of a manuscript to the journal will be taken to imply that it is not being considered elsewhere for publication, and that if accepted for publication, it will not be published elsewhere, in the same form, in any language, without the consent of the editor and publisher. It is a condition of acceptance by the editor of a manuscript for publication that the publishers automatically acquire the copyright of the published article throughout the world. *The Journal of Modern Craft* does not pay authors for their manuscripts nor does it provide retyping, drawing, or mounting of illustrations.

Style

US spelling and mechanicals are to be used. Authors are advised to consult *The Chicago Manual of Style* (15th Edition) as a guideline for style. *Webster's Dictionary* is our arbiter of spelling. We encourage the use of major subheadings and, where appropriate, second-level subheadings. Manuscripts submitted for consideration as an article must contain: a title page with the full title of the article, the author(s) name and address, a three-sentence biography for each author, and a 200-word abstract. Do not place the author's name on any other page of the manuscript.

Manuscript Preparation

Manuscripts must be typed double-spaced (including quotations, notes, and references cited), one side only, with at least one-inch margins on standard paper using a typeface no smaller than 12pts. The original manuscript and a copy of the text on disk (please ensure it is clearly marked with the word-processing program that has been used) must be submitted, along with color original photographs (to be returned). Authors should retain a copy for their records. Any necessary artwork must be submitted with the manuscript.

Footnotes

Footnotes appear as "Notes" at the end of articles. Authors are advised to include footnote material in the text whenever possible. Notes are to be numbered consecutively throughout the paper and are to be typed double-spaced at the end of the text. (Do not use any footnoting or end-noting programs that your software may offer as this text becomes irretrievably lost at the typesetting stage.)

References

Each article should include a list of references that is limited to, and inclusive of, all those publications actually cited in the text. References are to be cited in the body of the text in parentheses with the author's last name, the year of original publication, and page number—e.g. (Rouch 1958: 45). Titles and publication information appear as "References" at the end of the article and should be listed alphabetically by author and chronologically for each author. Names of journals and publications should appear in full. Film and video information appears as "Filmography." References cited should be typed double-spaced on a separate page. References not presented in the style required will be returned to the author for revision.

Tables

All tabular material should be part of a separately numbered series of "Tables." Each table must be typed on a separate sheet and identified by a short descriptive title. Footnotes for tables appear at the bottom of the table. Marginal notations on manuscripts should indicate approximately where tables are to appear.

Figures

All illustrative material (drawings, maps, diagrams, and photographs) should be designated "Figures." They must be submitted in a form suitable for publication without redrawing. Drawings should be carefully done with black ink on either hard, white, smooth-surfaced board or good quality tracing paper. Computer-generated drawings of publishable quality can also be submitted, ideally saved as high-resolution TIF or maximum quality JPG files. Color photographs are encouraged by the publishers.

Whenever possible, photographs should be 8 × 10 inches. The publishers also encourage artwork to be submitted as scanned files (600 dpi or above) on disk or via email. All figures should be clearly numbered on the back and numbered consecutively. All captions should be typed double-spaced on a separate page. Marginal notations on manuscripts should indicate approximately where figures are to appear. While the editors and publishers will use all reasonable care in protecting all figures submitted, they cannot assume responsibility for their loss or damage.

Authors are discouraged from submitting rare or non-replaceable materials. It is the author's sole responsibility to secure images, as well as rights to those images for both print publication (UK and North American distribution) and web publication. All reproduction costs charged by rights holders must be borne by the author.

Any queries about the preparation or submission of artwork should be referred to the editors.

Criteria for Evaluation

The Journal of Modern Craft operates on a single peer-review basis. Articles will be reviewed anonymously by a qualified academic reviewer. Detailed feedback will also be provided by the Journal's editors. Keep in mind that this process may be time consuming, so it may some time for an article to be published following the initiation of the peer-review process.

Offprints

On publication, first-named authors will be sent a PDF eprint (with nonprinting watermark) of the final, published version of their article for personal use, and will be able to order a free copy of the issue in which their article appears.